INDONESIAN TEXTILES

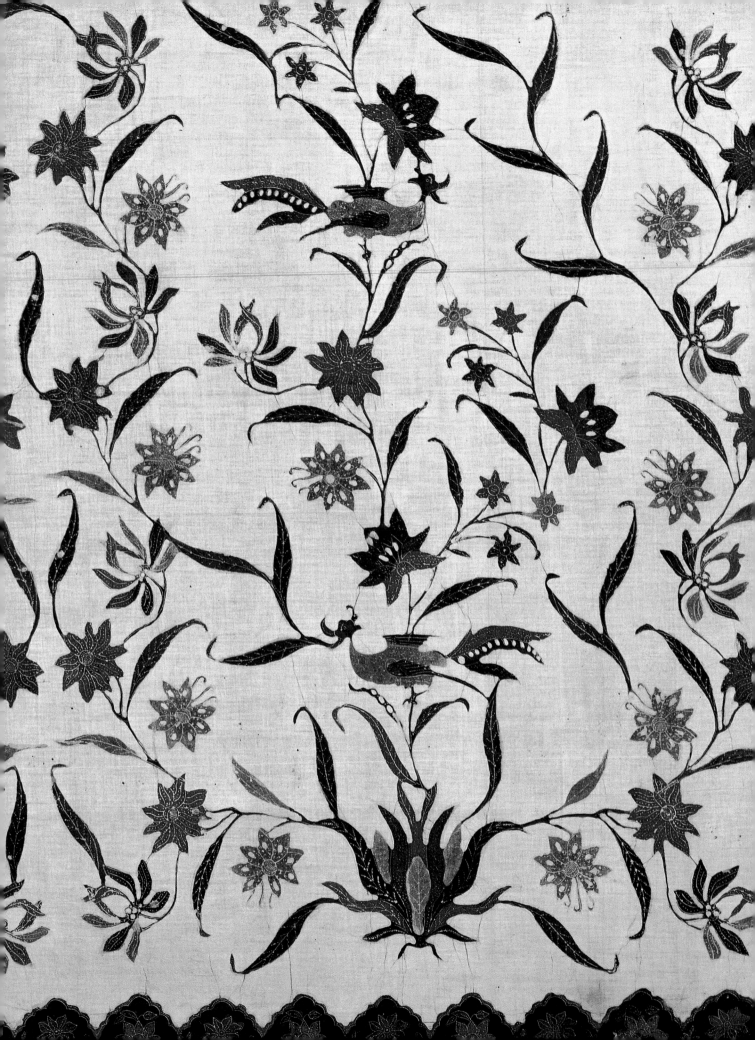

INDONESIAN TEXTILES

MICHAEL HITCHCOCK

IconEditions

An Imprint of HarperCollinsPublishers

The author and publishers are grateful to the Centre for South-East
Asian Studies, University of Hull, for their generous assistance in
providing colour photographs of textiles from the University of Hull
Collection of South-East Asian Art and Traditional Craftsmanship

FIRST U.S. EDITION

Library of Congress Catalog Card Number: 91-50429
ISBN 0-06-430217-2
91 92 93 10 9 8 7 6 5 4 3 2 1

Designed by Harry Green

Printed and bound in Hong Kong

Page 1 Detail of a Balinese weft-ikat fabric.
Horniman Museum.

Cover, pages 2–3 Early 20th-century cotton
batik sarong from the Pekalangan area, Java.
The floral designs on these north coast
batiks were often adapted from Indian and
European sources. The main,
lighter-coloured section is known as the
badan, body, whereas the panel delineated
by darker hues is referred to as the *kepala*,
head. British Museum.

Contents

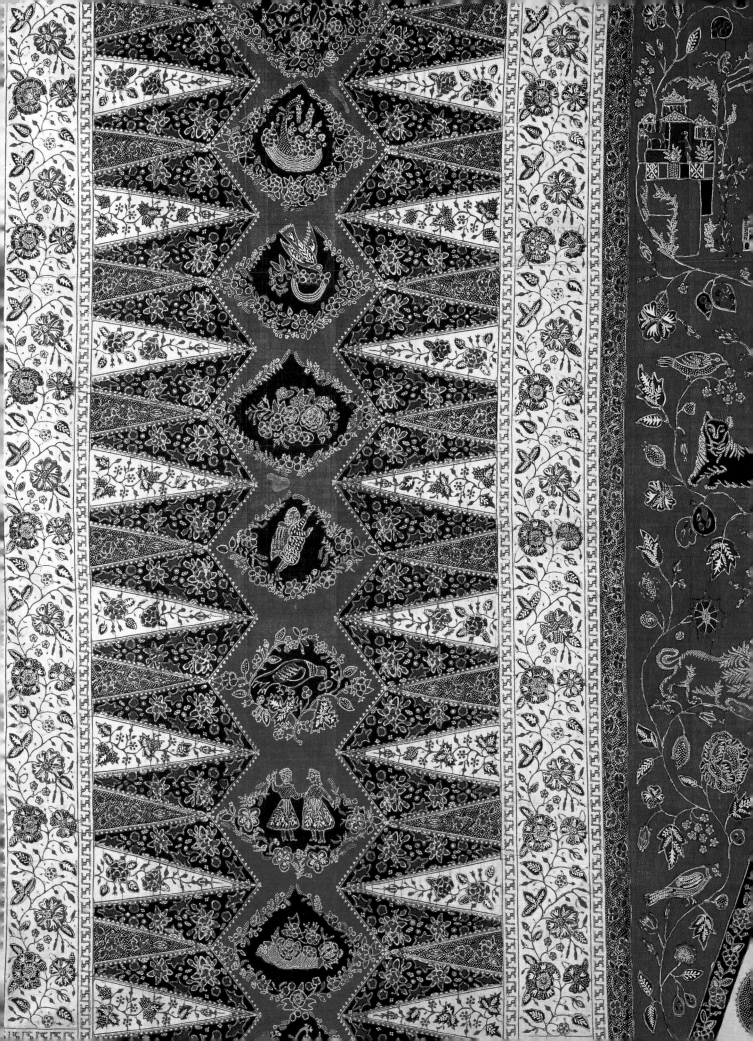

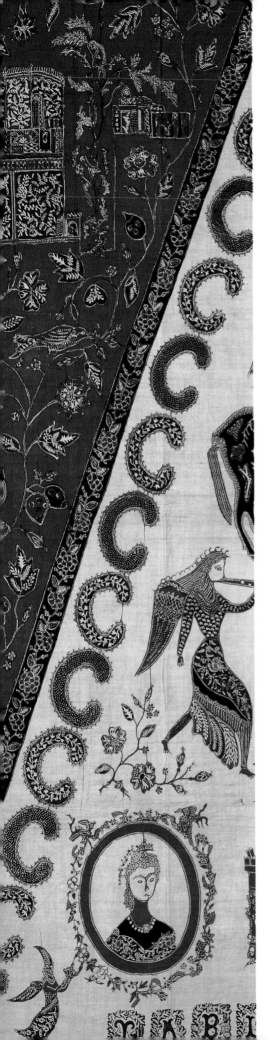

Preface

The Indonesian Archipelago occupies an esteemed place in the world of textiles. The peoples of this vast chain of islands use a wide variety of woven, embroidered and resist-dyed techniques to prepare fabrics of great ingenuity and beauty. In many Indonesian societies textiles are ritually important, as well as being items of trade and inheritance, and great care and skill are invested in their manufacture. Although the textiles made by different ethnic groups can be distinguished from one another, common stylistic and cultural themes can be detected. These traditions are also seldom static, and new ideas and methods, often from abroad, are constantly being absorbed and reinterpreted to satisfy changing social and economic circumstances.

The majority of Indonesians have light brown complexions, dark, straight hair and dark eyes. They speak numerous languages belonging to the Austronesian group, one of the world's largest language families. Along the coastlines of many Indonesian islands can be found fishing and trading communities who share a common culture with other sea peoples. Some, like the Malays and Buginese, have spread throughout the archipelago, mingling with members of other ethnic groups and founding powerful mercantile empires. Where there is sufficient rainfall inland dwellers may cultivate up to three crops of rice a year through intensive irrigation schemes. Historically

Late 19th-century cotton batik sarong made in the style of the Javanese north coast. Traditional Javanese motifs, such as the *tumpal* (isosceles triangle), are combined with more modern pictorial images including wild animals, heavenly figures and cartouches depicting royalty. British Museum.

7

the large surpluses achieved by these methods facilitated the growth of large court and bureaucratic systems, especially in Java and Bali. Today the old royal capitals usually support national administrations, though traditional rulers remain a force to be reckoned with in certain regions. Developing industries are also found in the cities, many of which have grown through migration from rural areas.

The members of centralised Indonesian societies have long professed world religions such as Islam and Hinduism; in more remote areas, however, there are also peoples who possess distinctive systems of knowledge and belief, though many are under pressure to assimilate. These small-scale cultures are found in the more isolated islands and in the inaccessible forests and mountains of the interior. Some still practise shifting cultivation and rear livestock; others may be engaged in hunting, fishing and the collection of woodland products; many are known for their distinctive handicrafts, especially textiles.

Strictly speaking only citizens of the Republic of Indonesia should be called 'Indonesians', though in practice the term is often used in a more general sense. When considering textiles it is helpful to define 'Indonesian' as broadly as possible to draw attention to cultural themes that transcend modern national boundaries. The term 'Indonesian' is also used to refer to the Indonesian national language, which is based on Malay, the old trading lingua franca, and is closely related to the national language of Malaysia. The use of this contact language has helped to unite peoples of diverse linguistic and ethnic backgrounds. Although this book is principally concerned with Indonesia, the world's fifth most populous state, reference will be made to peoples of neighbouring countries, especially Malaysia, Brunei and the Philippines, all of which possess fine textile traditions.

Acknowledgements

The research on which this book is based was made possible with grants from the British Academy, the Economic and Social Research Council (formerly the Social Science Research Council) and the Hull University Travel Fund.

For their generosity and professional help I am deeply indebted to Haji Djafar Amyn, Dr R. H. Barnes, Prof. Dr A. J. Bernet Kempers, Rita Bolland, Bernard Brandham, Dorothy Burnham, Ben Burt, Dr Peter Carey, Prof. Dr De Casparis, Jenny Chattington, Dr Chua Soo Pong, Prof. John Clammer, the late B.A.L. Cranstone, Dr Brian Durrans, Dr John Edmondson, Prof. Dr A. Gerbrands, Lewis Hill, Dr Angela Hobart, Dale Idiens, Prof. Dr I. Gusti Ngurah Bagus, Sian Jay, the late Princess Kalisom, Prof. V. T. King, Dr Ulrich Kratz, the late Dr Peter Lienhardt, Robyn Maxwell, Peter Narracott, Prof. Rodney Needham, Keith Nicklin, Dr Sandra Niessen, Dr Max Nihom, Rodric Owen, Edward Parker, Dr Nigel Phillips, Stella Rhind, John Rotheroe, Delphine and Geoffrey Saba, Ny H. Siti Maryam Rachmat Salahuddin S. H., Jennifer Scarce, Ir Fachrurrozie Sjarkowi, John Spencer, Dr Deborah Swallow, Ken Teague, Itie van Hout, Zoë Wakelin-King, Deborah Wakeling, Susan Walker, Dr Roxana Waterson, Roland Wheeler-Osman, Helen Wolf.

I should like to thank in particular all my colleagues in the Centre for South-East Asian Studies and the Department of Sociology and Social Anthropology at Hull University, and my former colleagues at the Horniman Museum and Liverpool Museum.

During the course of my research I made use of the facilities of a wide range of institutions and organisations, and I am especially grateful to the Association of Social Anthropologists, Australian Museum, Sydney; Australian National Gallery, Canberra; Balfour Library, Oxford; British Museum Photographic Service, London; Brynmor Jones Library, Hull; Cambridge University Museum of Archaeology and Anthropology; Deutsches Textilmuseum Krefeld; Horniman Library and Museum, London; Indonesia Circle, School of Oriental and African Studies, London; Koninklijk Instituut voor Taal-, Land- en Volkenkunde, Leiden; La Mbila, Lembaga Ilmu Pengetahuan, Indonesia; Linacre College, Oxford; Museum Ethnographers Group; Museum Negeri Nusa Tenggara Barat, Mataram; Museum of Mankind, London; Pitt Rivers Museum, Oxford; Rautenstrauch-Joest-Museum, Cologne; Rijksmuseum voor Volkenkunde, Leiden; Royal Anthropological Institute, London; Royal Museum of Scotland, Edinburgh; Het Technische Hogeschool, Delft; Tropenmuseum, Amsterdam; Universitas Gajah Mada, Yogyakarta; Universitas Mataram, Mataram; Universitas Udayana, Denpasar.

Numerous published and un-published studies were consulted during the preparation of this volume, and a list of sources by chapter has been included in the Bibliography. I also generally acknowledge the contributions made in this field by Dr Ruth Barnes, Sylvia Fraser-Lu, Dr Mattiebelle Gittinger and Dr Jan Wisseman Christie whose work I found especially invaluable when writing this account.

My warmest thanks go to my host in Leiderdorp – Jaqueline Palsma; my hosts in Bima – Abubakar M. Sidik and Jawariah; my two 'highlanders by adoption' – Peter and Anne Just; my great friend and companion – Daina Griva; and, finally, the spinners, weavers and dyers of the Indonesian Archipelago.

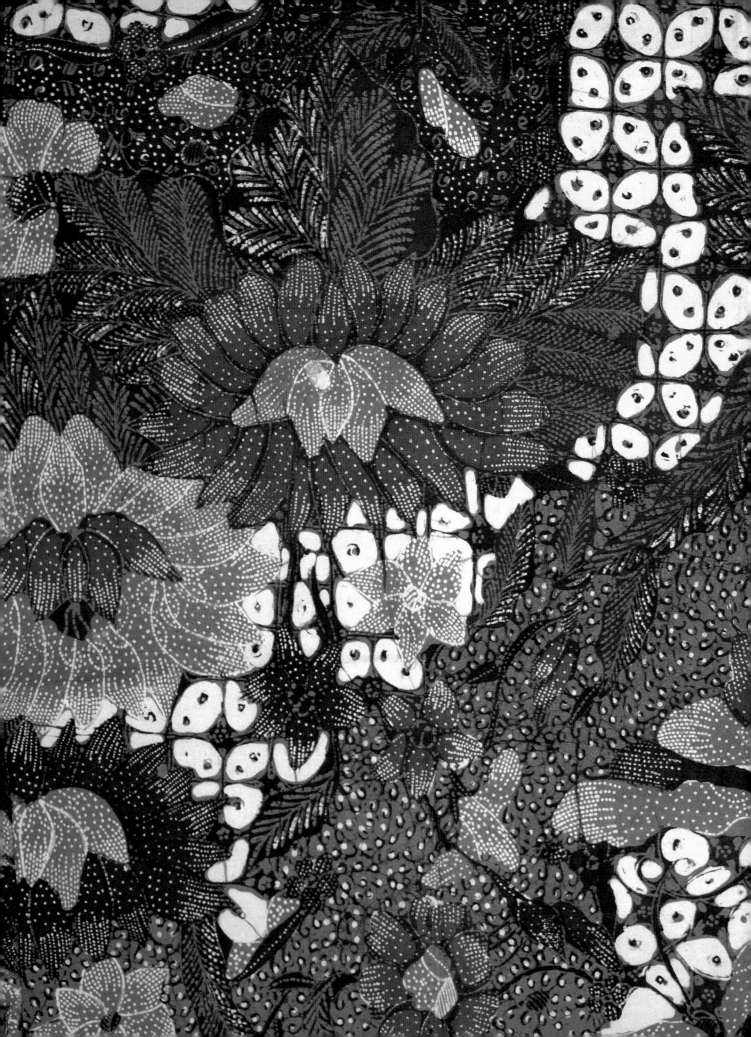

1

Introduction

The great archipelago that lies between the western tip of Sumatra and the island of New Guinea is called Nusantara in Indonesian. Historically these islands were known to Europeans as the 'Spice Islands', a source of prized cloves and fragrant timbers, part of the fabled East Indies. Foreign merchants often came into contact with Malays, who had established themselves as traders and middlemen throughout much of the region, and consequently the islands are sometimes referred to as the 'Malay Archipelago'. The expression 'Indonesian Archipelago' is today more widely used, not least because the largest state within this region calls itself Indonesia.

The Indonesian Archipelago extends for almost 5,000 kilometres from east to west and – if the Philippines are included – measures approximately 2,000 kilometres from north to south. If placed over a map of Europe this chain of islands would stretch from Dublin to Moscow and could easily cover the United States of America between San Francisco and New York. It includes islands, such as Sumatra and Borneo, which are larger than Britain, as well as islands that are roughly the same size as Ireland – Java and Luzon. Another eighteen islands are on average the size of Jamaica, whereas there are more than a hundred as large as the Isle of Wight; there are thousands of

Fragment of a cotton batik cloth decorated with *kawung*
and botanical designs. Overlaying patterns were
developed in Java during the Second World War to
combat the shortage of cloth. Collected by
C. L. Wisseman in Singapore, 1951.

11

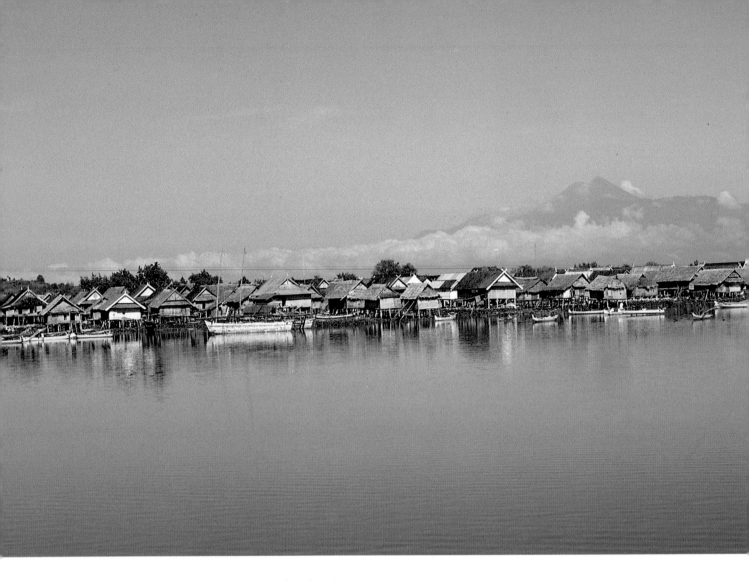

Coastal settlement with houses built on raised piles in the Straits of Alas. Sumbawa, 1980.

smaller land masses and islets. Much of this territory is, however, sea, and the actual amount of land is not greater than that of western Europe.

Lying close to the Equator, between 20°N and 10°S, the archipelago experiences a tropical climate with average daily temperatures of around 80° F (27° C). Most places are within 200 kilometres of the coast and the sea exerts a moderating influence with the result that there are no great fluctuations in temperature. Rainfall is abundant, particularly close to the Equator, and the natural vegetation is lush rainforest. There is, however, a pronounced dry season between May and October to the east of Java where the islands are affected by winds from the arid continent of Australia. As one travels east through Nusa Tenggara (Lesser Sunda Islands), rainforest gives way to woodland and savannah.

The archipelago lies along an extremely active seismic zone, which was responsible for the world's largest recorded volcanic eruption, that of Tambora on Sumbawa Island in 1815. The second largest, though better-known, eruption, that of Krakatau, took place in 1883 in the Straits of Sunda. A volcanic belt, marked by both active and extinct cones, can be traced through Sumatra and Java and the islands of Nusa Tenggara. The line curves north towards Ternate and then

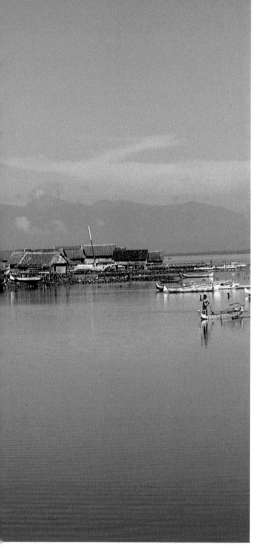

re-emerges in northern Sulawesi where it continues on into the Philippines. This volcanic activity has produced a distinctive terrain, creating marked contrasts between the scenery of volcanic and non-volcanic islands. The fertility of many Indonesian islands, especially Java, owes much to these periodic eruptions that have coated the land in layers of rich ash.

There are many unresolved questions pertaining to the earliest settlement of the Indonesian Archipelago. During the Ice Ages when the polar ice-caps grew and sea-levels fell the islands were linked by dry land, though wide straits still separated continental Australia from Asia. The remains of *Homo erectus* in the Solo river valley show that Java was inhabited at least a million years ago; it remains unclear, however, whether or not these ancient hominids were the forebears of the modern people of South-East Asia. Modern humans, who were hunter-gatherers and possessed relatively advanced stone tools, also travelled down the Indonesian land bridge. Some of them possessed seafaring skills and went on to settle Australia and New Guinea between 40,000 and 60,000 years ago. The populations that remained in the archipelago began to diverge from their proto-Australian neighbours as they mingled with later arrivals from the Asian mainland, developing a distinct hybrid culture.

It used to be held that much Indonesian early history could be understood in terms of waves of migrations from the Asian main-land. Both linguistic and material-cultural features have been attribu-

Sailing ships, known as *pinisi*, from southern Sulawesi in the port of Sunda Kelapa near Jakarta. Copra and timber are among the wide range of goods transported by these ships and, though the traditional dyes trade is in decline, some still bring dyestuffs to Java from eastern Indonesia.

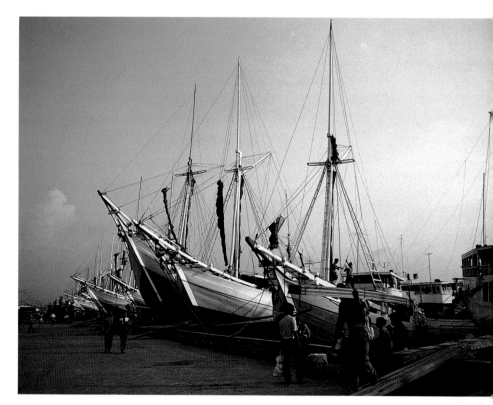

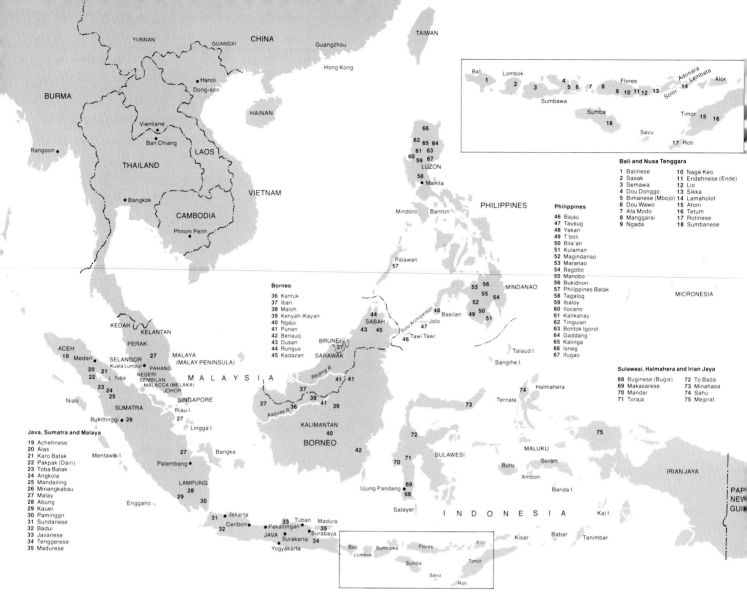

The Indonesian Archipelago showing distribution of ethnic groups.

Bali and Nusa Tenggara

1 Balinese		10 Nage Keo	
2 Sasak		11 Endehnese (Ende)	
3 Semawa		12 Lio	
4 Dou Donggo		13 Sikka	
5 Bimanese (Mbojo)		14 Lamaholot	
6 Dou Wawo		15 Atoni	
7 Ata Modo		16 Tetum	
8 Manggarai		17 Rotinese	
9 Ngada		18 Sumbanese	

Philippines

46 Bajau
47 Tausug
48 Yakan
49 T'boli
50 Bila'an
51 Kulaman
52 Magindanao
53 Maranao
54 Bagobo
55 Manobo
56 Bukidnon
57 Philippines Batak
58 Tagalog
59 Ibaloy
60 Ilocano
61 Kankanay
62 Tinguian
63 Bontok Igorot
64 Gaddang
65 Kalinga
66 Isneg
67 Ifugao

Borneo

36 Kantuk
37 Iban
38 Maloh
39 Kenyah-Kayan
40 Ngaju
41 Punan
42 Benauq
43 Dusan
44 Rungus
45 Kadazan

Sulawesi, Halmahera and Irian Jaya

68 Buginese (Bugis)
69 Makasarese
70 Mandar
71 Toraja
72 To Bada
73 Minahasa
74 Sahu
75 Mejprat

Java, Sumatra and Malaya

19 Achehnese
20 Alas
21 Karo Batak
22 Pakpak (Dairi)
23 Toba Batak
24 Angkola
25 Mandailing
26 Minangkabau
27 Malay
28 Abung
29 Kauer
30 Paminggir
31 Sundanese
32 Badui
33 Javanese
34 Tenggerese
35 Madurese

ted to immigrants from southern China who ventured across the Pacific around 3000 BC. These peoples, who have been associated with a rectangular axe culture, are thought to have settled in the Philippines before moving on to Java (2000–500 BC) and the other Indonesian islands. They were skilled farmers and craftsmen who knew the arts of woodworking, pottery and probably weaving.

The distribution of the rectangular axe culture coincides roughly with that of the Austronesian languages, and Robert von Heine-Geldern (1932) has argued that peoples who brought these skills also spread the Austronesian languages, which today cover a vast geographical area from Madagascar to Easter Island, and from Hawaii to New Zealand. The eastern branch of this family embraces the languages of Micronesia, Melanesia, Polynesia and coastal New Guinea, whereas the western group includes the languages of the Philippines, Indonesia, Malaysia (excluding Mon Khmer languages) and Madagascar. Speakers of western Austronesian languages are found in the highlands of Formosa (Taiwan), south-west Thailand, parts of Micronesia (Chomorro and Palauan), the western tip of New Guinea and in Vietnam-Cambodia (the Chams). The origins of these lan-

guages remain obscure, and H. R. van Heekeren (1957) has warned against identifying the spread of languages with migration. Both technological and linguistic skills could have been spread throughout the archipelago by interaction between different peoples, especially through trade, rather than via large-scale migrations.

Interaction between the peoples of the islands and the Asian mainland may also have led to the adoption of specific designs. The angular and maze-like patterns on certain Indonesian textiles have been compared to the geometric designs on bronze kettledrums of the so-called Dong-son type. These drums are associated with a culture which flourished in northern Vietnam approximately 2,000 years ago. Von Heine-Geldern (1937) was the first person to link the Dong-son finds to designs that survive today. Recent archaeological research has helped to place the Dong-son site – now seen as part of a continuum – within a wider South-East Asian context. Ornamental patterns that pre-date those of Dong-son have, for example, been found on pottery from the Philippines (Kalanay Cave), Palawan (Manunggul Cave) and Timor (Lie Siri Cave).

Aspects of Indonesian textile technology, as well as design, have also been linked to the Asian mainland. Ruth Barnes (1989) has compared a copper-alloy statue of a weaver found in east Flores with metal figures on a bronze container from Shizhaishan in Yunnan. (The site of Shizhaishan has been identified with a Bronze–Iron Age culture which existed on the south-western borders of the Han Empire, 206 BC–AD 8.) Both Indonesian and Chinese figures are shown using foot-braced body-tension looms. In this kind of loom

Sumatran weaver demonstrating the use of a body-tension loom in Taman Mini. Jakarta, 1989. Each of the provinces of the Republic of Indonesia is represented by a reconstruction of a traditional house or palace in this open-air park (see Museums to Visit).

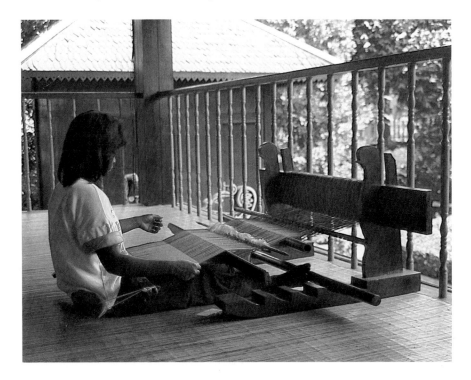

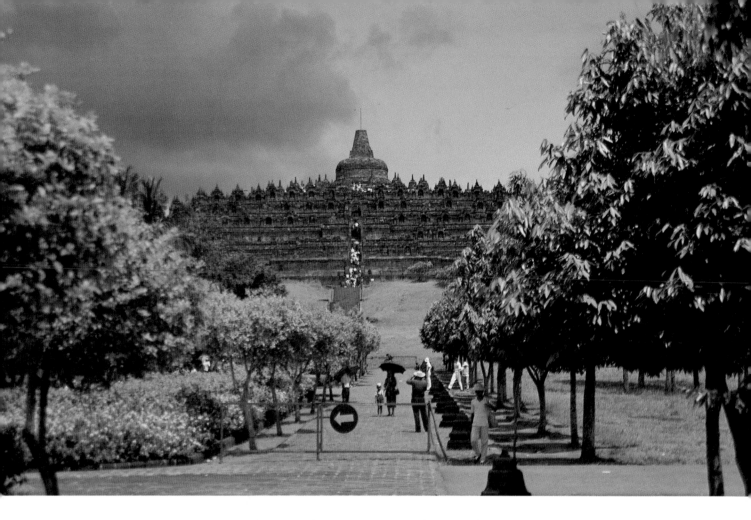

The 9th-century Buddhist temple complex of Borobudur, central Java.

the seated weaver secures the warp beam with her feet and holds the warp yarns in tension by leaning back on a strap. Although this type of loom has been reported elsewhere in South-East Asia, it is not found today in eastern Indonesia. It may, however, represent an older version of the Indonesian body-tension loom, since the Flores figure does appear to have links with the present culture of Flores and Lamaholot.

What is significant is that looms which resemble those found in the Indonesian Archipelago are found outside this region. Weaving skills were almost certainly taken to Madagascar by Austronesian seafarers who ventured across the Indian Ocean during the first millennium AD. According to John Picton and John Mack in *African Textiles* (1989) certain aspects of Malagasy textile technology are derived from South-East Asian rather than African sources. The distribution of looms cannot, however, invariably be linked to the spread of Austronesian languages, particularly with regard to the Pacific. Although looms are known in New Britain and Santa Cruz, and perhaps as far east as Rotuma, they are not found throughout Polynesia, despite the ubiquity of Austronesian languages. Furthermore, 'Indonesian-style' body-tension looms are found elsewhere in South-East Asia and neighbouring areas among peoples who do not speak Austronesian languages.

Much more is known about the history of Indonesian textiles after the establishment of island empires espousing the South Asian

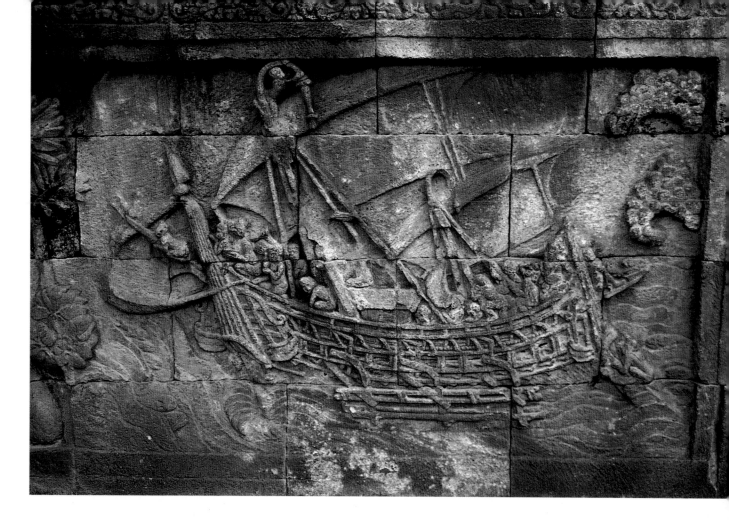

Above Relief carving showing a woman drawing off yarn from a skein on a weaver's swift. 9th century, Borobudur, central Java.

Top Relief carving depicting a ship with outriggers and sails on the walls of Borobudur.

religions of Hinduism and Buddhism. Indian influence can be detected in fifth-century inscriptions in Java and Borneo, though it seems likely that trading links were established well before this period. Both Indonesian and Indian seafarers were probably involved in this trade, though the kinds of vessels they used remains uncertain. Carved reliefs, however, on the walls of Borobudur, Java's ninth-century Buddhist complex, provide an insight into the scale of ships that could be built with local technology. The panels show large ships with outriggers and numerous billowing sails. A swift, a device for winding skeins of yarn, is also depicted on the temple walls.

Buddhist pilgrims also made their way home to China via the Indonesian islands, and it is clear that direct communications had been established across the South China Sea by the fifth century. Chinese records from the sixth century mention cotton-weaving in Sumatra and refer to silk clothes worn by the king of the northern part of that island, though it is not clear whether or not these garments were imported.

One of the most important of these early Indonesian empires was that of Srivijaya, which grew up around a river port in south-east Sumatra. Lying astride the trade routes between India and China, Srivijaya became an important commercial centre and was described as 'a great fortified city' by a Chinese Buddhist pilgrim in the seventh century. Indian cotton fabrics, which were purchased by Chinese merchants, were among the goods traded in Srivijaya.

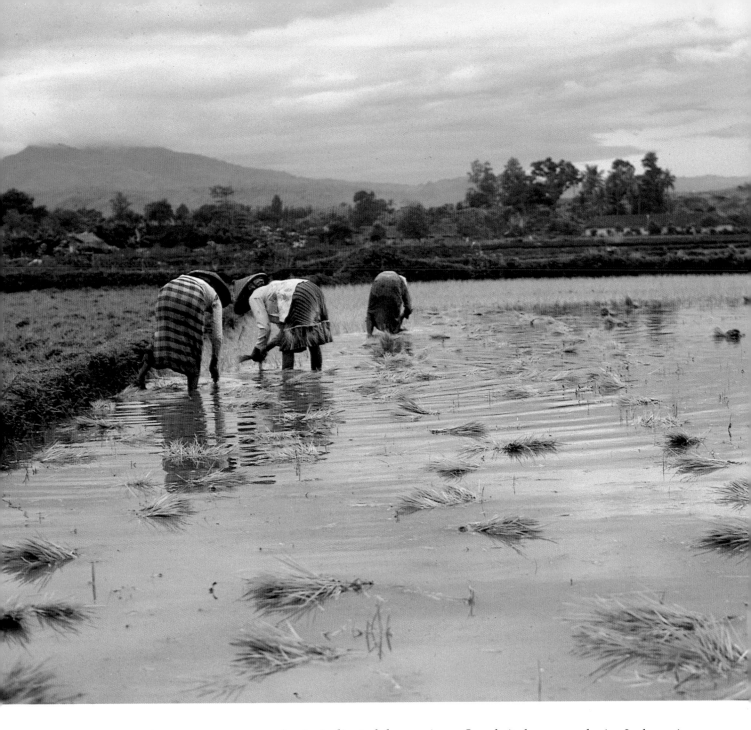

Bimanese women planting rice on the outskirts of Salama village during the 1980/1 wet season. They are protected from the sun with conical straw hats, head-cloths, long-sleeved blouses and locally woven sarongs.

As is indicated by various Sanskrit loan-words in Indonesian languages, the islanders acquired new textile skills as a result of contact with India. The Sanskrit term for 'apparatus', which can be applied to spinning-wheels, appears as *jantra* in Javanese and *jentera* in Indonesian. Although an indigenous word for silk, *bsar*, is found in Java, the Indonesians mainly use *sutra*, the Sanskritised name for this yarn. The Indonesians may also have adopted the Indian terms for cotton, *kapas*, and indigo, *nila*, when new plant strains were introduced from South Asia, since they probably already possessed their own varieties.

Forms of writing were also introduced from South Asia, though few Indonesian records survive from before the ninth century. Some of the most significant early documents are the 300 or so *sīma* charters

18

from Java, which were written between the early ninth and late fifteenth centuries. According to Jan Wisseman Christie (1990) these documents, preserved on stone or copper plate, record the transfer of tax and labour rights by rulers or high-ranking officials. Feasts and ceremonials, during which gifts were presented, were associated with the establishment of *sīma* grant settlements. Various kinds of textiles were given on these occasions, and fabrics feature prominently in the gift lists connected with these charters. During the early tenth and eleventh centuries the charters began to contain more information on taxable economic activities, providing another viewpoint on textiles, though the gift lists became briefer. By the middle of the eleventh century the emphasis had changed again, and the detailed tax lists began to be supplanted by increasingly complicated

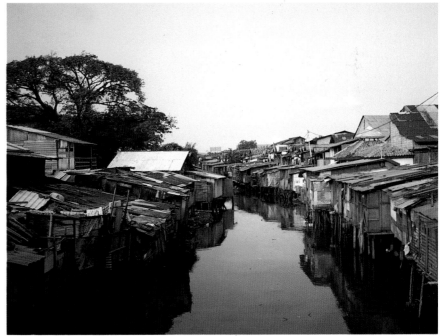

Dwellings built on raised piles, to prevent flooding, alongside a waterway near one of Jakarta's harbours. Seafaring peoples, such as the Malays, Buginese and Makasarese, live in coastal regions, especially around ports, throughout the archipelago. Sunda Kelapa, 1990.

regulations concerning the regalia of rank and restrictions on the use of certain kinds of textiles.

In early East Javanese communities taxable activities were divided into two major categories, one of which was further sub-divided. The first of these broad categories appears to have encompassed a variety of semi-professional activities including pottery, bamboo mat- and screen-making, and sugar-processing. These tasks were probably carried out on a part-time basis in many rural households. Five different kinds of dyers are mentioned in the early tenth-century charters, as well as the producers of mordants and other products associated with dyeing. Among the other occupations listed one finds the makers of spindles or other pieces of textile equipment and specialists involved in preparing patterned cloth by tie-dyeing,

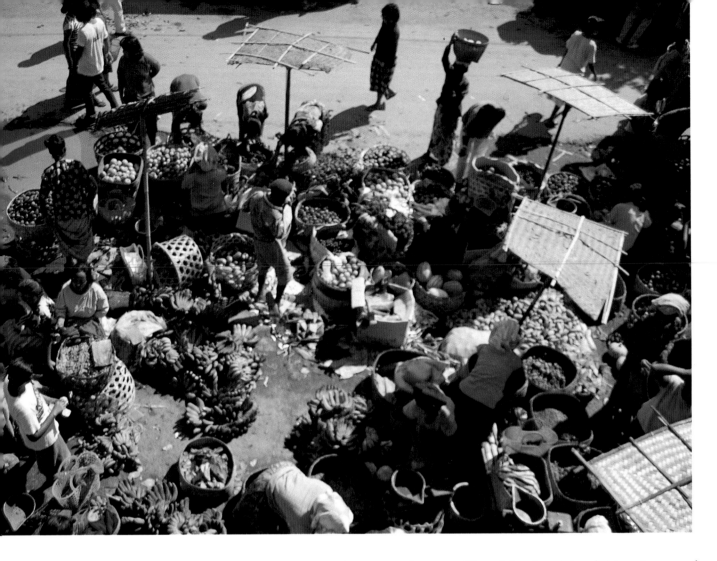

Fruit and vegetable market in Ubud, Bali, 1989. Traditional dyestuffs and yarns are still sold in some rural markets, though this is becoming less common.

perhaps a reference to the use of ikat. Membership of this category of semi-professional producers changed over time, and another kind of dyer is mentioned in the early eleventh century.

The second major category of taxable activities is connected with the markets that were held in Javanese markets on a five-day cycle. Full-time market traders and those who made their living as professional artisans were considered to be members of this second group. These professionals were divided into two categories: first, those who made the goods they sold or provided a service; and second, those who sold manufactured goods, raw materials or foodstuffs provided by others. The first group included *cadar* (sheet) cloth weavers who probably wove with professionally spun cotton and silk. Javanese market lists confirm Chinese Sung Dynasty records regarding Indonesian sericulture, and it is clear that by the eleventh century the Javanese were producing their own silk, as well as importing it from China. *Cadar* weavers are also known to have used a special loom which may have been adapted for weaving with silk. Fabrics woven by professionals were much finer than those made in ordinary households and were considered to be appropriate gifts for rulers. Both peddlars and market-based traders belonged to the second sub-category, many of whom were involved in selling textiles. The vendor of cloth, who sold fabrics and made-up garments,

held an especially esteemed position and is mentioned in charter lists from the early tenth to the late fourteenth centuries. Among the goods distributed by peddlars were silk, cotton yarn, morinda roots (for dyeing) and safflower dyes.

Gift lists associated with the transfer of tax and labour rights often record the presentation of hundreds of textiles. Men and women's fabrics, which were measured in different units, are referred to in the lists, often without much additional information. It would appear that many of these fabrics were not especially valuable, though the ones given to rulers and top officials were of high value. Patterned cloth, probably red in colour, was presented, though dark and blue cloths were not apparently used as ritual gifts, at least for recipients of high social status. Patterns relating to animal forms – deer, fish and the king crab – are mentioned, though the majority of cloths were probably decorated with floral or geometric designs. The gift lists also refer to textiles 'made in the north' or 'made in the east', as well as in India, whereas others are described as specific garments (for example, head-cloths and shoulder-blankets).

After the tenth century greater emphasis was placed on gold coins, reflecting perhaps increasing sophistication in the economy, and the importance of textiles as ceremonial gifts declined. But as Jan Wisseman Christie (1990) has argued, cloth, though no longer widely used during presentations, became more significant in other contexts. Increasingly the *sīma* documents began to list privileges which included the right to wear certain kinds of cloth. A textile kown as a *banaten*, which was used for decorative hangings, appears on privilege lists, as do the ceremonial waist-wrappers, the *dodot* and *tapih* (see pp. 146, 148). In connection with garments worn on ritual occasions the lists refer to certain patterns including the 'rock-bodied' design (immortality), the nine-planet design, the red lotus (Siwa's flower), and various other floral and botanical symbols.

Although Indonesian textiles during the Hindu-Buddhist era were made to satisfy local demand, they do appear to have been of sufficient quality to attract the attention of foreigners, especially the Chinese. Not only did envoys from Bali, Java and Sumatra take textiles as gifts to China, but there is some evidence that Indonesian cloth was used in trade. Chau Ju-kua, for example, a Chinese port official dealing with foreign trade, describes Java in 1225 as a source of various coloured brocades, gauzes and damasked cotton. He also mentions the raising of silkworms. Indonesian silk was of interest to other chroniclers, too, notably Ma Huan, a fifteenth-century Chinese Muslim. In his account of his travels, *Ying-yai Sheng-lan* (1433), Ma Huan refers to the patterned silk sarongs worn by the ruler of Java and the cultivation of mulberry trees (used in sericulture) in north Sumatra.

Ma Huan's writings are indicative of the growing strength of

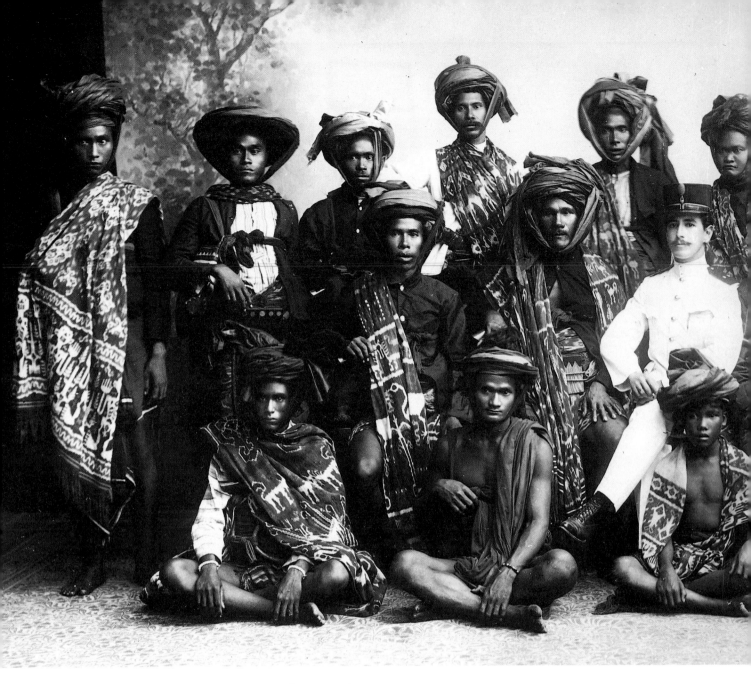

Early 20th-century studio photograph showing Sumbanese men and a seated Dutch colonial official. Fish, horses, roosters and ancestor figures are among the motifs that can be seen on the warp ikat shoulder-blankets worn by the high-born men.

Muslim merchant-princes in the Indonesian islands. Islam, which had been brought by southern Arabian and Muslim Indian traders, spread inland from the coast, and by the end of the fifteenth century Majapahit, the last great Hindu empire, was in decline. Encircled by nascent Muslim states, this Hindu-Javanese empire, which had claimed suzerainty over much of the archipelago, gradually collapsed. Rather than accept the new faith many officials, priests and artists from the old court of Majapahit sought sanctuary in neighbouring Bali. Surrounded by Muslim Indonesians, the Balinese still adhere to their Hindu-Buddhist traditions.

Shortly after the demise of Majapahit the Portuguese made their first appearance in the Indian Ocean after rounding the Cape of Good Hope. With a combination of religious and economic zeal, backed by superior nautical skills, they tried to wrest control of the spice trade from the Arabs and other Muslim traders. They attempted to keep

prices high in Europe by monopolising the shipment of spices but were eventually unable to prevent other Atlantic maritime powers from entering the East Indies. In 1521 Magellan's ship, the *Victoria*, arrived in the Philippines on her homeward voyage, followed by conquering Spanish forces in 1565. Although Portuguese supremacy elsewhere in the archipelago was eclipsed by the Dutch and the English in the seventeenth century, they remained a colonial power in the region longer than any other foreign power and withdrew from East Timor as late as 1974. Portuguese influences are readily detectable in Indonesian arts and music, especially in the eastern islands.

With Islam firmly established in the western islands, Christian proselytising from the sixteenth century onwards was largely confined to the north and east, and today Christian communities are found throughout eastern Nusa Tenggara, Maluku (the Moluccas) and the northern Philippines. Indigenous beliefs survived, however, until well into the twentieth century in the more remote highland and forest regions, which lay beyond the areas dominated by world religions. Although many Indonesian weavers and dyers still make use of ancient motifs, Hindu, Buddhist, Islamic and Christian design elements can be detected in the textiles produced on the islands that were influenced by these major belief systems.

Christian and Muslim traders alike were lured to the Indonesian Archipelago by the prospect of making vast profits in the spice trade; it is clear, however, that some of them also became involved in buying and selling textiles. Indian fabrics are mentioned in trade lists, and by the sixteenth century, if not earlier, Gujarati *patola* cloths were being shipped to South-East Asia (see p. 162). On visiting Ambon, Duarte Barbosa, the early Portuguese traveller, found that much-sought-after Indian textiles were accumulated in vast piles and were sometimes used to discharge ransom payments. The Dutch, in particular, recognised the financial value of Indian fabrics and attempted to monopolise the *patola* trade in the seventeenth century. There is some evidence that Indonesian products were also included in the textiles trade. A shipment of *kembangan* – thought to be Javanese *teritik* cloth – is referred to in 1580, and in 1641 the term 'batick' appears on a bill of lading in connection with cloths taken from Batavia (now Jakarta) to Sumatra (see p. 86). An account of the Indonesian *pelangi* technique (see p. 95), written by the Dutch botanist Rumphius, also survives from the seventeenth century.

Based in their headquarters in Batavia, the Dutch became the dominant commercial power in the Indonesian Archipelago. Initially Dutch goals were limited to trade, but by the extension of their business interests they gradually became involved in local politics. Dutch interests were regulated by the Vereenigde Oostindische Compagnie (Dutch East India Company), but fearing its collapse on the Amsterdam stock exchange towards the end of the eighteenth

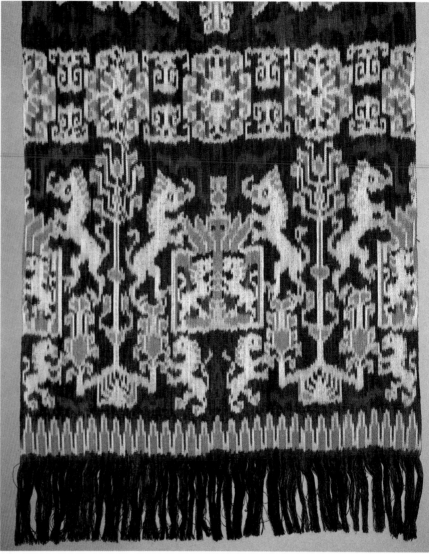

A coat of arms, probably copied from a Dutch colonial coin or an official seal, decorates this shoulder-cloth, *hinggi*, from Sumba. Woven in heavy cotton, this warp-ikat fabric was purchased by the author in Bali, 1982. 127 × 60 cm.

century, the Dutch government took control of its assets. This was followed by a period of unsettled government during the Napoleonic Wars, and Dutch Indonesian possessions temporarily came under British control (1811–16). The Governor-General of this time was Thomas Stamford Raffles (1781–1826), an energetic administrator who somehow found time to write his *History of Java*, which was published in 1817. His book contains a great deal of information on Javanese society and handicrafts, as well as an account of an unsuccessful attempt to introduce British fabrics to Java. His collection later acquired by the British Museum dates from this period.

Following the return of their territories, the Dutch remained the predominant power in the Indonesian Archipelago until the mid-twentieth century. Their rule, in common with other colonial regimes, was a mixture of exploitation on the one hand and the introduction of numerous technical and educational opportunities on

An illustration showing part of a tapestry-woven cotton sash (Bimanese *salampé*; Sumbawanese *pebasa*) from Sumbawa which was published in *De Weefkunst* (J. E. Jasper and Mas Pirngadie, 1912).

the other. The Dutch continued to take an interest in the textiles trade and made various attempts to stimulate the batik industry. At the height of the colonial era an immense series of publications on Indonesian arts and crafts was prepared. Co-authored by a Dutchman, J. E. Jaspar, and an Indonesian, Mas Pirngadie, the two volumes that deal with fabrics are *De Weefkunst* (1912) and *De Batikkunst* (1916). Extensive collections of Indonesian handicrafts were also assembled with both governmental and independent support. The museums established by the Dutch in both Indonesia and the Netherlands are still the starting-point for contemporary researchers. Important ethnographical research was also conducted by the British in their colonial possessions in north Borneo and the Malay peninsula, and by the Americans in the Philippines (ceded by Spain to the USA in 1898).

Dutch power collapsed in 1942 in the face of the Japanese advance. The invaders needed local support for their war effort, and some Indonesian nationalists were provided with military training, which later proved useful in the struggle against colonialism. The majority of islanders welcomed the demise of the harsh Japanese occupation in 1945, and the nationalists, fearing a return to foreign domination, declared independence. The Dutch, after unsuccessfully trying to regain control, eventually recognised the Republic of Indonesia in 1950. The only remaining Dutch possession, Irian Jaya, was ceded to the young republic in 1969, though it has much in common with neighbouring Papua New Guinea. Indonesia expanded its boundaries yet again when it annexed newly independent East Timor, ignoring protests from the Portuguese. Although American constitutional plans for the Philippines were disrupted by the Second World War, the United States President was able to proclaim Philippine independence in 1946. After their return the British followed a different course of action: they recognised local nationalist aspirations but retained control of their territories until 1963.

In the post-colonial era the indigenous textile industries played an important role in economic development. Many small factories continue to provide a major source of employment, especially in the urban areas of Java and Bali. Although their businesses are primarily reliant on locally developed skills, many make use of recycled equipment, salvaged from defunct textile factories in the industrialised West. Generally speaking Indonesian textile factories operate on low overheads and narrow profit margins, and for many unskilled employees the work may be both tedious and poorly paid. These factories often offer limited job security, and workers are laid off during lulls in the economic cycle. Despite the problems, however, these factories, with minimal investment, are flexible and can readily adapt to changes in demand, particularly in the unpredictable international fashion markets.

Not only does the international fashion trade provide for Indo-

Javanese cotton waist-cloth, *kain*, decorated with a revived north coast batik design showing a ship. This fabric was purchased by Dr Jan Wisseman Christie in Jakarta, 1977, though the original pattern dates from the early 20th century. 252 × 102 cm.

nesian weavers and dyers but so does the home market, which is sustained by an ongoing demand for distinctive regional fabrics. Increasingly new fabrics are being designed with both home and overseas markets in mind, and a new generation of local textile designers has attracted international attention. Many of these specialists have enriched their artistic repertoires through contact with fabric designers from Europe, the Antipodes, North America and Japan. Certain kinds of textiles may be specially commissioned from abroad, and traditional designs are often reinterpreted to suit a wider international audience. Tourism, though often seasonal in character, also provides an important source of income. A textile can be a colourful local memento as well as being a lightweight gift that can be carried easily in a suitcase.

26

INTRODUCTION

After cremation the ashes of the deceased in Bali are taken in noisy procession to the sea or a local river and tossed into the wind, signifying the purification and disposal of the material body. The women are wearing batik waist-cloths, Malay blouses and festive sashes. Kuta Beach, 1989.

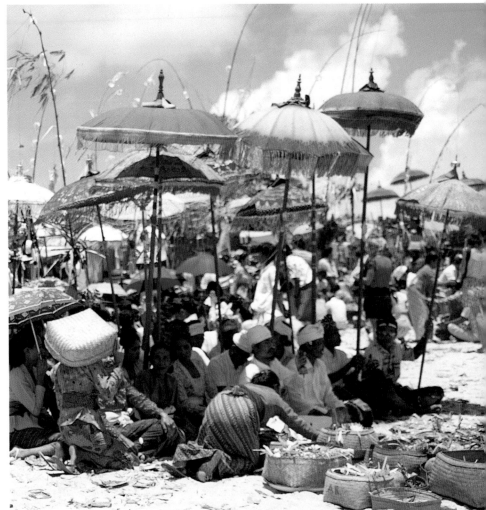

More recent years have seen the involvement of increasing numbers of local people in research and development. Although the modern Indonesian textile industry should be understood with reference to contemporary commercial realities, the cultural significance of indigenous fabrics should not be overlooked. Organisations devoted to nurturing ancient traditions and promoting an awareness of traditional crafts have been established. There is also a growing body of literature in Malay-Indonesian, examining both traditional and modern skills from a variety of academic, economic and cultural perspectives. New museums have been opened throughout the archipelago in response to both local demand and the needs of foreign visitors. As important regional and ethnic symbols textiles are prominently displayed in many of these new institutions.

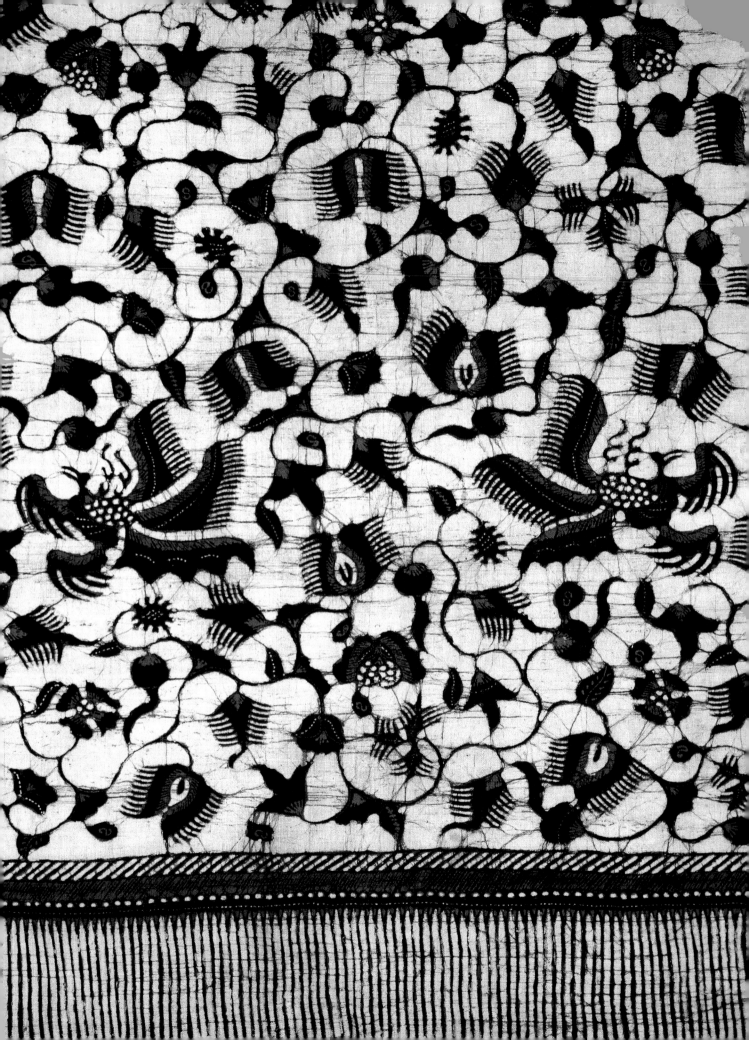

2

The Raw Materials

Hand-drawn *batik tulis* on homespun cotton from Kerek in north-east Java. This waist-cloth, *kain*, is decorated with flying birds and foliage on a marbled background created by cracking during the dyeing process. Purchased by Dr Jan Wisseman Christie in Jakarta, 1977.
250 × 74 cm.

The peoples of the Indonesian Archipelago make use of a wide variety of textile materials. While some yarns and dyes are imported, many are obtained from local tropical plants, often by processes unique to the archipelago. Sometimes these economically useful plants are grown on plantations, but frequently they are cultivated by peasant farmers as an additional crop after the rice has been harvested. Dyes and fibres are also extracted from wild plants. Not only are the rainforests and mangrove swamps of the humid western islands important but so are other ecological zones: the cooler highlands and the open woodlands and savannahs of the east all contain plants that can be used in making fabrics. Although the methods used to obtain indigenous textile materials are often labour-intensive and therefore not viable in terms of modern economics, they have the advantage of being renewable, an important consideration in the increasingly resource-depleted world.

Fibres
Cotton
Though possibly not native to South-East Asia, cotton has long been the predominant Indonesian textile yarn. While it is unclear precisely when the Indonesians began to cultivate cotton, Chinese records refer to its use in Sumatra as early as the sixth century AD. Sumatra lay along the sea route between China and India, and during the Srivijaya period Chinese merchants visited Palembang in order to purchase Indian cotton goods. In addition to merchandise new ideas and techniques spread along these trade routes, and it seems likely that some of the Indonesian textile methods originated in South Asia.

Upon their arrival in the Indian Ocean in the fifteenth century, the Portuguese found a well-established trade in cotton goods. Indonesian cotton production appears to have flourished until the late eighteenth century when both Sulawesi and Timor were known for their cotton goods. Until the early nineteenth century there was still an extensive hand-spinning industry in Java, but domestic production declined as cheap cotton articles became available from the plantations and factories of the north Atlantic seaboard. Dutch attempts to stem this demise through a scientific approach to cotton growing were not entirely successful.

During the Second World War the Japanese, urgently in need of cotton yarn, tried to stimulate the domestic industry by the introduction of new plant strains, but these schemes did not prosper. Small-scale cotton production, however, persisted in the Indonesian Archipelago, particularly in the highlands of the eastern islands and Borneo. Today the Republic of Indonesia, like most South-East Asian states, satisfies its industrial requirements by importing cotton yarn from India and the United States. However, in recent years the Indonesian authorities have tried to reduce their country's dependence upon outside sources, and government-sponsored cotton-growing schemes have been set up in north Sumatra, Flores, Sumbawa and Lombok.

Cotton yarn is made from the fibres that surround the seeds of plants belonging to the genus *Gossypium*. Several different species are cultivated in the Indonesian Archipelago, one of the most common being *Gossypium herbaceum*. The fibres from this hardy and disease-resistant plant take dye colours well and, when woven, the fuzzy yarns produce a thick and slightly rough cloth. (Its insulating properties are much appreciated in the cooler upland areas.) A range of other cottons have also been grown with varying degrees of success. *Gossypium obtusifolium* was cultivated as a field crop in southern Sumatra and elsewhere under Dutch colonial auspices. On the Malay peninsula the British experimented with *Gossypium brasiliense*, a shrub of South American origin, which did not lend itself to field cultivation despite being well suited to the tropical environment.

At the height of the domestic cotton industry in Java cotton was often planted as an additional crop in the paddy fields towards the end of the wet season. Cotton does well if it receives moisture as it grows, followed by a dry period upon reaching maturity. In eastern Indonesia cotton may be grown in the corner of a rice field or garden, or may be planted in rows between other crops such as maize or cassava. Cotton can also be seen growing wild in some highland areas on fallow swidden fields.

The methods of preparing cotton by hand, given a few regional varieties, are similar throughout Indonesia and much of South-East Asia. The fibre-processing tools often look different, not because

Detail of a traditional batik from Kerek, north-east Java. Handspun cotton woven in a plain tabby weave (see also illustration on p. 28).

Iban woman from Sarawak, north Borneo, demonstrating the use of a double-handled cotton gin. Photographed during the course of research for *The Pagan Tribes of Borneo* (C. Hose and W. McDougall, 1912). Royal Anthropological Institute.

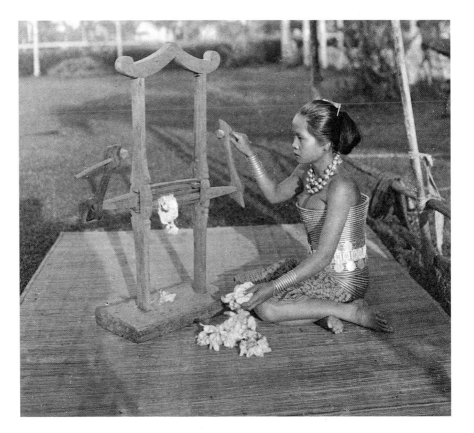

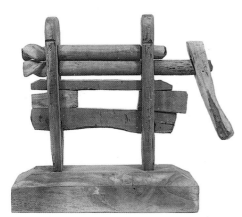

Bimanese cotton gin from Karumbu, Wawo, 1981. w. 40 cm. Pitt Rivers Museum, 1982.8.12.

their operating principles differ radically but because they are designed in accordance with many different local styles. Craftsmen belonging to the same cultural group may decorate tools to suit their own or their customer's personal taste, though the basic ways of using them remain unaltered.

When the cotton has been picked the remains of the outer layer, the pericarp, are removed. The cotton is then dried for four to five days before it is put through a gin to remove the seeds. The gin comprises two wooden rollers set into a strong wooden frame. The craftswoman sometimes sits on a plank projecting from the heavy base of the gin to provide greater stability. As the lower roller is turned with a handle the motion is transferred, by means of a screw, to the upper roller, which rotates in the opposite direction. Some of the gins used by the Iban of Borneo do not have screws, and instead each roller is turned by a separate handle. Wedges are used on both kinds of gin to alter the pressure between the rollers.

In preparation for spinning the cotton is pulled apart by hand and then the fibres are fluffed up by means of a bow. A taut rattan or twine bowstring is strummed across the fibres, making them light and airy and therefore easier to spin. In Java, Sumbawa and some parts of the northern Philippines the cotton may be pounded with rattan beaters to achieve the same effect. (Younger women of Bima, Sumbawa, prefer the more energetic second method, and rhythms produced by

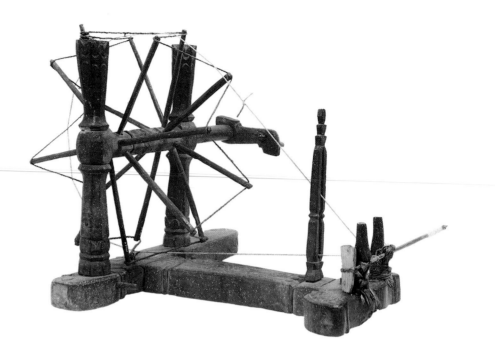

Spinning-wheel, *janta*, from Londu in the Wawo hills. Bima, Sumbawa, 1981. w. 43 cm. Pitt Rivers Museum, 1982.8.15.

the beating are sometimes accompanied by songs.) The fibres are then rolled, sometimes by rolling a spindle across the cotton on a flat stone, into hand-sized cylinders or tufts.

Spinning-wheels are widely used throughout South-East Asia and are found on all the major Indonesian islands as far east as Sulawesi and Sumbawa. The Indonesian spinning-wheel usually comprises a spoked wheel or drum, rotated by a handle, that turns a mounted spindle by means of a belt or cord. Sitting on the floor, usually with the apparatus to her right, the spinner attaches fresh fibres to the tuft of cotton on the spindle. As she rotates the wheel she draws the wad of cotton in her other hand away from the spindle, thereby twisting the fibres into yarn. Where the spinning-wheel is not found, the hand-held drop spindle is used. The spindle, which is weighted by a wooden or clay whorl, is spun by hand and then allowed to drop so that it twists the fibres as it falls. In both methods the freshly made yarn is wound on to the spindle after each draw.

The spun yarn is usually unwound from the spindle and looped around an H-shaped frame known as a hand reel (or niddy noddy) to form skeins. These skeins can be placed on a swift, an apparatus with revolving arms, from which the yarn can be drawn off as required. In small factories yarn is often stored on drums that serve the same purpose as the swift.

Silk

Though not as widely used as cotton, silk is prized as a luxury yarn. However, despite its popularity, neither the moths whose cocoons are used for silk filaments nor the mulberry trees on which they feed

Opposite Batik *selendang* made of Rembang silk and decorated with foliage and phoenix designs. Fabrics of this type were made near Lasem, Java, for export to Bali before the Second World War. Collected by Dr Jan Wisseman Christie in Bali, 1980. 186 × 49 cm.

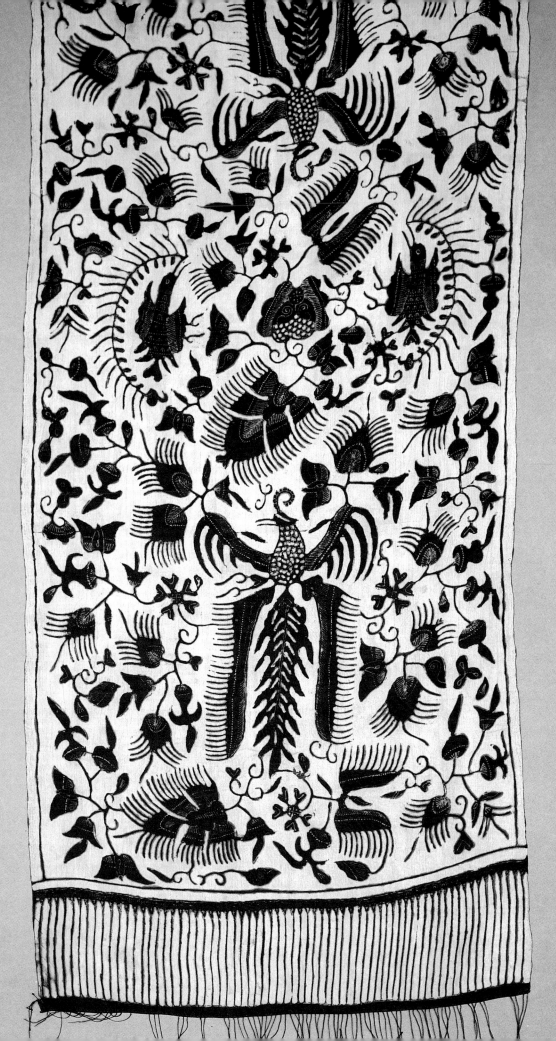

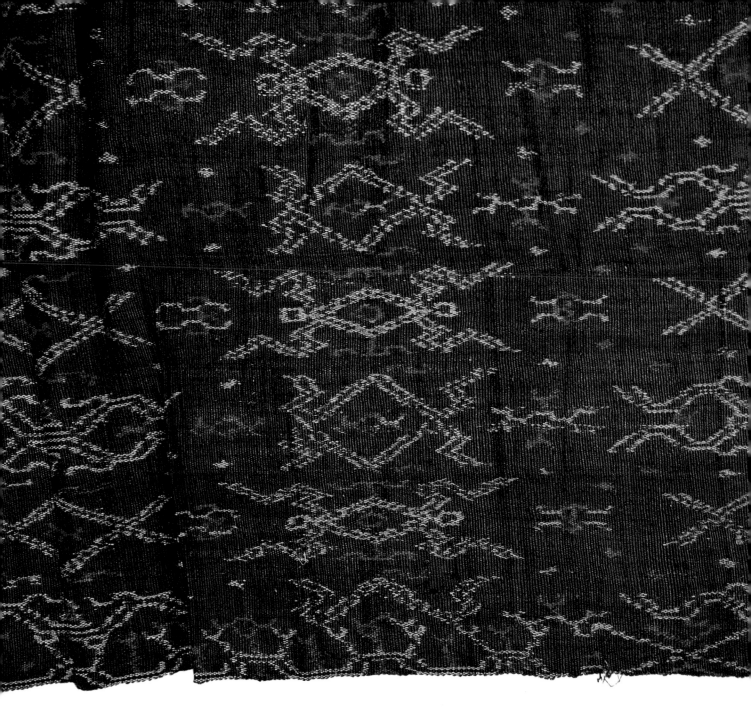

A long narrow cloth woven in plant fibres, possibly *Musa textilis*, and decorated with warp-ikat designs. T'boli people, Kota Batu, Mindanao, Philippines. 290 × 39 cm. Philla Davis Collection, Hull University, CSEAS, PDT24.

are native to South-East Asia. China is traditionally regarded as the home of silk, and legendary histories indicate that the Chinese may have developed the art of sericulture as early as 3000 BC. Although this knowledge eventually filtered southwards into South-East Asia, the Malay/Indonesian word for silk, *sutra*, is of Sanskritic origin, indicating that the peoples of the archipelago may have learned about silk through contact with Indians during the early part of the first millennium AD.

While the mulberry tree, *Morus indica*, can be grown in parts of Java, Maluku and elsewhere, the production of silk is not widely distributed in Indonesia. Since the Srivijaya period silk has been cultivated intermittently in Sumatra, though with the exception of an experimental project near Bukittinggi production has now virtually ceased. Today most Indonesian silk is produced in southern

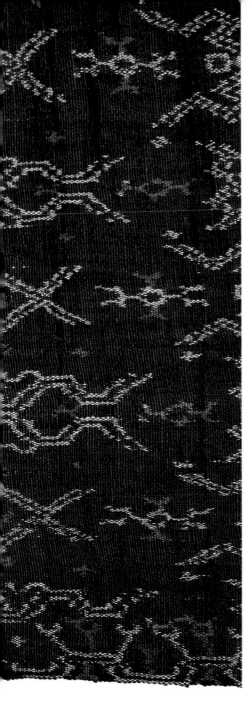

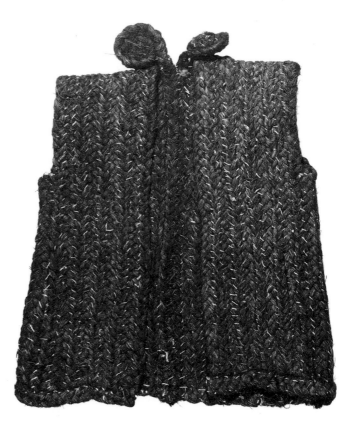

Sulawesi, around Tajuncu, which supplies the Buginese textile industry with much of its yarn.

Several species of moth can be used to make silk, but for commercial purposes the most popular is *Bombyx mori*. Silk is made from the protective filaments secreted by the caterpillar when it passes into the pupal stage of its development. The filaments have to be extracted before the metamorphosis because the emerging moth emits a fluid that weakens the cocoon fibres. The cocoons are immersed in water and heated to 60° C (140° F) which kills the pupae and loosens the gum, serecine, binding the filaments together. The filaments are then lifted from the water and wound on to a reel. Various plys of silk yarn are made by spinning together different amounts of filaments.

Pineapple (*Ananas comosus*)

In addition to weaving with well-known yarns such as cotton and silk, Indonesian peoples make use of a wide range of different fibres extracted from tropical plants. For example, a yarn made from pineapple leaves was used on the Malay peninsula for sewing thread until it was replaced by cotton. The Iban of Borneo used pineapple yarns for the same purposes. Extracted by retting the leaves in water and then scraping off the outer skin and pulp, pineapple fibres were woven into textiles by Filipinos on Panay Island and by the Kayan of Borneo. In the Philippines pineapple and silk threads are also woven

Plaited fibre (coir) waistcoat used as armour. British Museum, 1954. AS7.139.

together to make a cloth used for dresses and shirts. Rain-capes made from mixed cotton and pineapple yarns were worn by nobles on the island of Sulawesi.

Ramie (*Boehmeria nivea*)

Ramie is another plant that yields a useful textile fibre. It was grown in Sulawesi during the seventeenth century, and in the early nineteenth century the Dutch imported ramie from Sumatra. It grows on the Malay peninsula and in the central Philippines, and the Indonesian government has experimented with this plant in north Sumatra. Once the ramie shrub reaches maturity, the stems are cut and the outer layers removed in strips. Gum is extracted from the fibres by soaking them in caustic soda and rollers may be used to soften the yarn. Ramie has properties similar to linen, though it is not as elastic nor as resistant to rubbing.

Lontar palm (*Borassus flabillifer*)

The lontar palm is the source of numerous products, including a textile fibre. Yarns made from palm fibres are woven with cotton by the people of Tanimbar to make distinctive textiles.

Raffia (*Corypha elata*)

A kind of raffia can be made from *Corypha elata*, another palm. The leaves are shaved when they have reached about a metre in length, before they unfurl. The palm raffia is then dried in the sun. Filipinos use this fibre to make a wide range of items, including clothing. Work clothes made from palm leaves are worn by the Rotinese and by the Torajans of Sulawesi.

Turn-of-the-century body-tension loom with a continuous warp. It has a plant fibre, possibly raffia, warp and weft. There is also a sword-beater and a rolled-up piece of barkcloth which was used to transport the loom. British Museum.

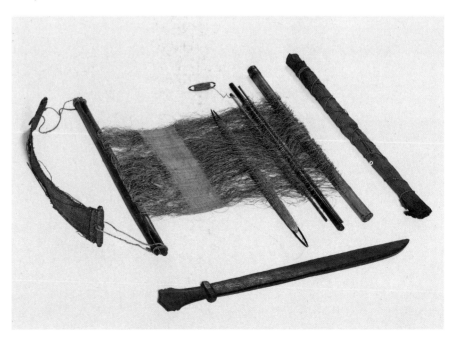

Curculigo latifolia

Fibre can also be extracted from the leaves of this tufted plant. The leaves are picked and then soaked in water to separate out the fibres. The yarn, which resembles a rough string, is variously used (including for fishing nets) by the Bahan, Dusun and Kayan of Borneo.

Fimbristylis globulosa

Fibres taken from this plant, a kind of sedge, are widely used for matting and are woven into fabrics by the Toraja of Sulawesi.

Musa textilis

A textile yarn can be made from fibres extracted from this member of the plantain family. *Musa textilis* grows wild in central and southern areas of the Philippines and on the islands of Sangir and Talaud to the north of Sulawesi. Recognising its potential, the British and Dutch colonial authorities in Singapore and Java respectively experimented with this plantain. To obtain the filaments the plant is cut down after reaching maturity (between one and a half and two years old) and the outer layers of the leaves are removed in strips. The ribbons of leaf are then passed through a toothed stripper to remove the pulp and waste and to release the fibres. These are then combed and hung on lines to bleach in the sun. Before weaving, the fibres are knotted end to end and are stretched on a bamboo frame. Although not as soft as cotton, and somewhat slippery to feel, the yarns hold dyes well.

Barkcloth

Though not strictly a textile, barkcloth is worth mentioning here. This material, which is felted rather than woven, is made from the fibrous

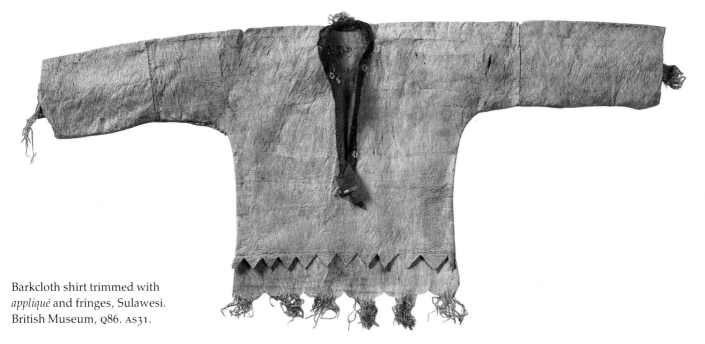

Barkcloth shirt trimmed with *appliqué* and fringes, Sulawesi. British Museum, Q86. AS31.

bark of several kinds of tree. Bark is stripped from saplings or the limbs of trees and the outer layer is scraped off. Strips of the inner bark are laid on a log and beaten so that the fibres spread out and felt together. Loose pieces of material are removed by washing. On the Malay peninsula forest hunter-gatherers wear fabrics made from a variety of breadfruit, *Artocarpus elasticus*, and in Borneo *Artocarpus tamaran* is used to make a good cloth. A fabric made from the bark of *Broussonetia papyrifera* is also known in Indonesia. In Java it is chiefly used to make a cloth for sleeping in.

Pages 38–9 Minangkabau woman's sash with a silk ground weave and gold supplementary weft. Collected by the Hull University Minangkabau filigree expedition to Sumatra, 1989. 154 × 33 cm. Hull University, CSEAS.

Metallic yarns

Gold and silver yarns, in particular, are prized throughout the Indonesian Archipelago. Although precious metals are mined, especially on the Malay peninsula, most of the metallic threads used by weavers are imported. French and Japanese metallic yarns, while expensive, are highly regarded by South-East Asian craftsmen; Indian thread is cheaper but less durable. In Palembang, Sumatra, weavers have been known to unravel gold yarns from old textiles in order to make newly commissioned fabrics.

Some metallic yarns used to be made by the Indonesian craftsmen themselves. Gold and silver were often obtained by melting down colonial, particularly Dutch, coins. Wire is made by drawing precious metals through successively smaller holes in a perforated plate (draw plate). The metal has to be heated and hammered (annealed) at regular intervals to realign its crystalline structure and prevent it from becoming brittle. The fine ribbon is eventually spun around a cotton or silk core. As metallic yarns age they slowly come apart, so that the core becomes visible beneath the wire. Sometimes silver ribbon is not spun around a core but is couched or embroidered directly on to the fabric. Various regions are known for the quality of their textiles embellished with metallic yarns – the Malay peninsula, Sumatra, Nias, southern Sulawesi, Sumbawa, Bali, the southern Philippines and coastal Borneo.

Synthetic yarns

Synthetic yarns such as rayon, acrylic, acetate and polyester are now widely available in the Indonesian Archipelago. Artificial fibres are imported from a variety of sources, including Hong Kong, though some synthetics are produced in Java. Many handloom weavers, even in the more remote parts of Nusa Tenggara, now use artificial yarns, sometimes combining them with other fibres like silk and cotton. Weavers like to work with synthetics because they are light, easy to handle and do not break as easily as locally spun cottons. Furthermore, the colours of factory-dyed synthetic yarns are often more varied and longer-lasting than those that can be produced by more traditional means. Fabrics made with artificial fibres are also

Opposite Unsewn sarong cloth made of synthetic yarns decorated with stencilled designs. Made in a small factory in Gianyar, Bali, 1989. 200 × 113 cm.

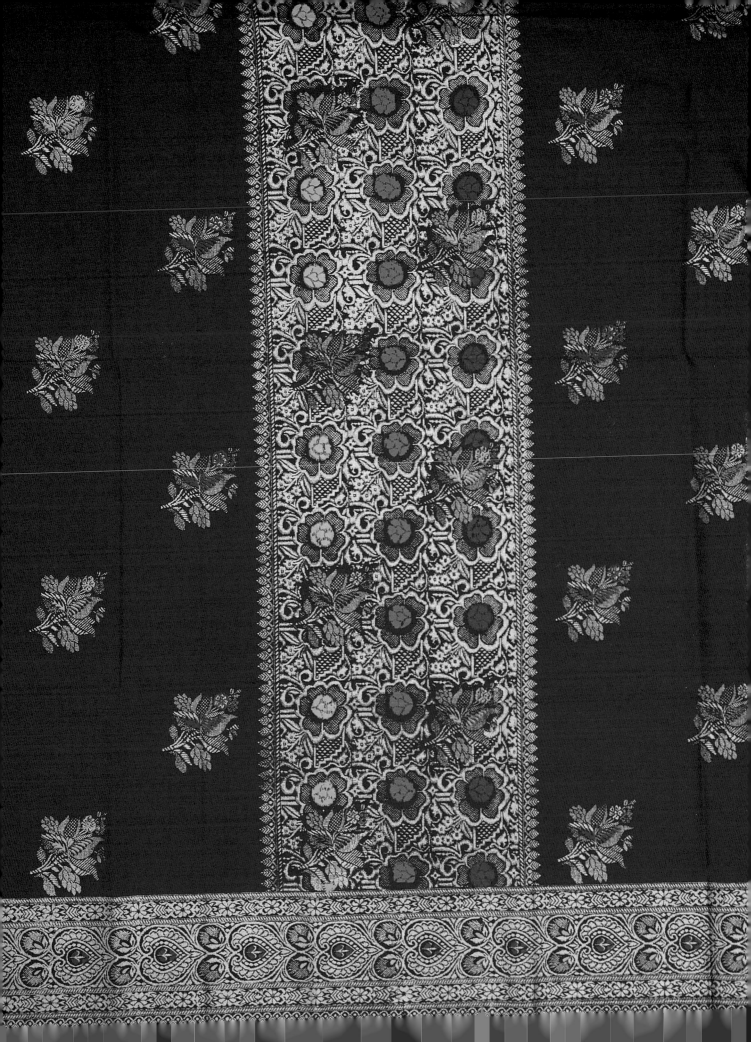

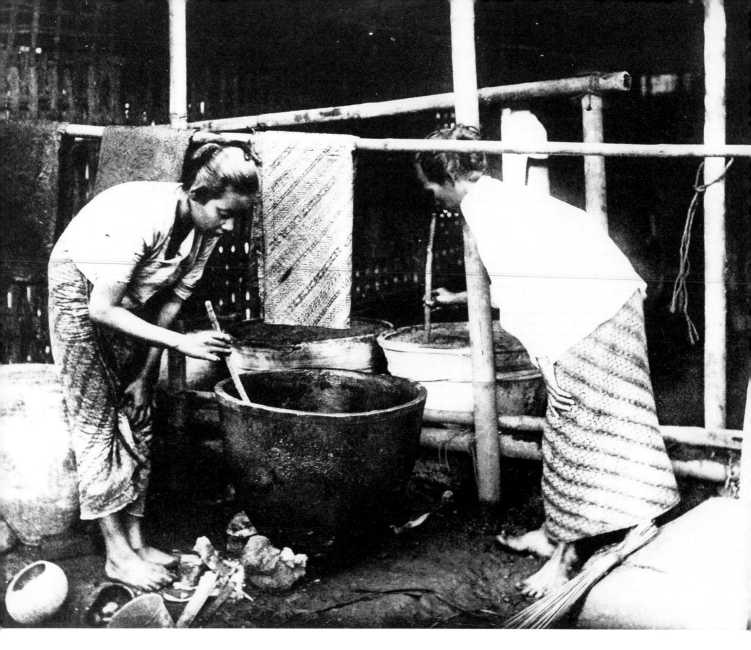

Turn-of-the-century photograph showing Javanese batik dyers at work. The brush in the foreground could have been used to strain off impurities.

usually more crease-resistant than those made solely with natural yarns. Synthetic threads take dyes well, and in Gianyar, Bali, numerous ikat-decorated textiles are made in small factories.

Dyes

In addition to weaving with different kinds of fibres Indonesian peoples make use of a wide variety of dyes, many of which are extracted from tropical plants. As indicated by Javanese records, some of these dyes have been used since the tenth century. Jan Wisseman Christie (1982), for example, has identified the following organic dyes in the *Alasantan* text, an inscription incised on copper plates shaped like palm leaves dating from AD 939: *mañambul* (a kind of dark or black dye), sappan wood, *Emblica officinalis* (a brownish red stain), *Eugenia* (a red dye), indigo and *Morinda*. Although industrially made dyes are employed today in Indonesian textile factories, especially in Java, some small producers still dye cloth with natural colours. In the 1980s, as has been discussed by Rens Heringa (1989),

the villagers of Kerek in north-east Java traditionally made four hues with organic dyes: blue-black (indigo), dark red (*Bruguiera*), bright red (*Morinda* and *Symplocos fasciculata*) and yellow (*Cudrania*).

The process of dyeing is often highly complex, since some dyes take better to certain fabrics than to others. Many dyes cannot be used directly, and an auxiliary agent or mordant may be required to improve their fastness and intensity. Mordants can be described as metallic salts that have an affinity with both dyestuffs and fibres, and in the archipelago these fixing agents can be obtained from a range of sources. In Bali, for example, the ashes of the coconut palm, *Cocos nucifera*, are strained through a bamboo sieve and mixed in cold water for use in Turkey-red dyeing. The Iban on the island of Borneo use lime (calcium oxide) and gypsum (calcium sulphate) as mordants, substances which they may obtain through trade. Lime, which can be extracted from both limestone and sea coral in kilns, is known in many parts of the archipelago; gypsum is less common, though it can be found in alluvial deposits on the Malay peninsula. Some Indonesian dyers use common salt as a mordant, as well as substances containing iron (ferrous sulphate) or alum (potassium aluminium sulphate) compounds. The latter is found in the tissues of plants belonging to the genus *Symplocos*. On the Malay peninsula fabrics are soaked in an infusion of bark and leaves from *Symplocos fasciculata* before entering the dyebath, and in Java *S. javanica* and *S. spicata* are used.

Oils are also occasionally added to mordants, especially in Turkey-red dyeing. The Balinese use coconut oil, the people of Nusa Tenggara candlenut oil (*Aleurites moluccana*), while the Batak of Sumatra favour buffalo lard. Essential oils taken from cloves, *Syzygium aromaticum*, and nutmeg, *Myristica fragrans*, may also be added to prevent a film developing on top of the dyebath.

Blue-black

INDIGO Along with spices and fragrant woods indigo has long been an important export item in insular South-East Asia. India has an ancient history of indigo production, and the Indonesians probably learned about South-East Asian varieties of this plant through contact with the sub-continent. (In the *Alasantan* inscription of AD 939 indigo is referred to in Javanese as *manula*, a term etymologically linked with the Sanskrit *túla*.) Indian indigo was also shipped to China via the Indonesian Archipelago from around AD 1200 onwards. The Indonesians, however, make dyes from native indigo plants, *Indigofera sumatrana* (= *I. tinctoria*?), and it is not clear whether the knowledge of these dyes was introduced from abroad or developed locally. The Portuguese were the first Europeans to become involved in this trade, and later both the Dutch and the British increased the production of indigo in their colonies. Indigo cultivation declined in the Dutch East

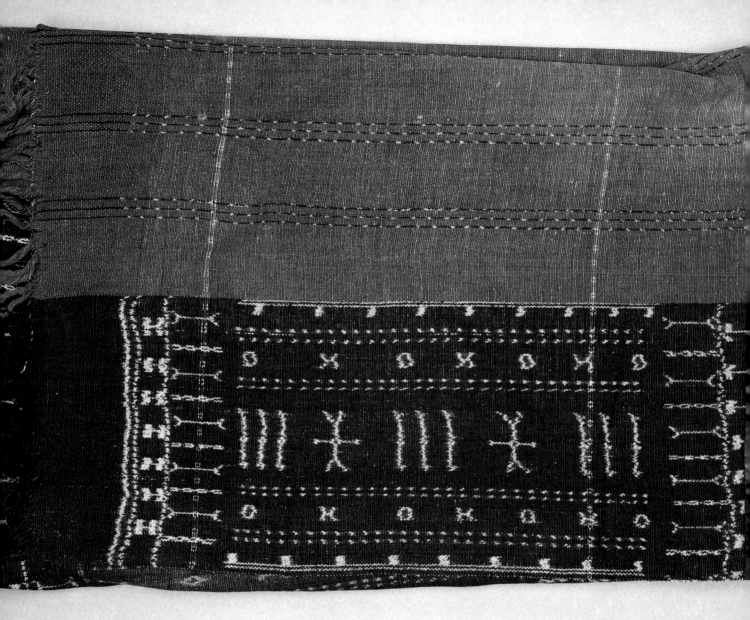

Shoulder-blanket of handspun cotton dyed with natural colours and decorated with warp ikat. Nagé Kéo people, Flores. 97 × 59 cm. Philla Davis Collection, Hull University, CSEAS PDT19.

Indies during the Napoleonic Wars when France invaded Holland. The British filled the gap left by the Dutch and retained a virtual monopoly over the trade until the true chemical composition of indigo dye was discovered in Germany in 1883. Cheap German dyes eventually began to replace plant sources, though with the outbreak of the First World War indigo production enjoyed a brief rise on Java. Despite the availability of industrially made dyes, the art of dyeing with indigo plants has not been completely abandoned, particularly on the islands of Nusa Tenggara.

Indigo is often grown on small plots, though the leaves are sometimes gathered from bushes growing in the wild. While the methods of preparing the dye vary regionally, the basic steps are similar. After collection the leaves are pounded in a mortar and then placed in a large earthenware pot to which water is added. The mixture is then left for three to ten days, and is stirred occasionally, emitting a distinctive smell. The impurities are skimmed off the surface of the liquid before the yarn is added. Slaked lime is often used as a mordant

44

and a wood-ash lye may be added. A wide range of different substances such as betel juice and tannic acid may be included to ensure a better dye. During the day the yarn is dried in sunlight in order to oxidise the colourless dye and convert it to indigo, and then it is returned to the dyebath at night. As many as thirty immersions may be required to produce the characteristic blue-black shade. One of the most widely cultivated kinds of indigo is *Indigofera tinctoria*, which originated in South Asia, though the American *I. suffruticosa* and the African *I. arrecta* are also known.

HOMALANTHUS POPULIFOLIUS The bark and leaves of this tree are used for dyeing black in Java, Sulawesi (among the Toraja) and various islands further to the east.

BORITI (*RHIZOPHORA MUCRONATA*) Coastal Malays obtain a deep brown or black dye from the leaves and bark of this variety of mangrove tree.

In addition to plant sources dyes may be obtained from other substances. Soot from lampblack mixed with resin is used to dye cotton fabrics a deep black in Kalimantan and Tanimbar. In Sulawasi and Timor soot may be painted on to pre-dyed indigo cloth to make black. Many traditional dyes have been supplanted by factory-made dyes, especially in small factories in Java and Bali. Yet even in these highly commercial contexts some plant-based dyes, such as indigo, continue to be used. This is particularly the case when designers are trying to replicate more traditional fabric designs.

Red, brown and purple

SAPPAN WOOD (*CAESALPINIA SAPPAN*) Many Indonesian artisans hold sappan wood in high esteem. Widely believed to be a 'lucky' timber, it is used to secure the joints of door and window frames and is thought to protect the home from misfortune. (Shipwrights, who also credit sappan with talismanic properties, use this wood to peg planks together.) The Malay and Indonesian terms for the wood, *sepang*, appear to be of Sanskritic origin, indicating that the knowledge of its use as a dye may have been introduced from India. Historically sappan was a much sought-after trade item, and around AD 1000 the Chinese were obtaining supplies of the timber from Java. By the fourteenth century Sumatra was also participating in this trade, and by the sixteenth century the Portuguese were purchasing sappan in Malacca. The Dutch in their mercantile capital in Batavia (now Jakarta) were also involved in the dye trade; during the early nineteenth century they obtained sappan from Sumbawa Island for use in the Javanese batik industry. Sappan wood from the Philippine island of Luzon was also highly regarded.

Dye is made by boiling shavings of the heartwood of sappan, a low

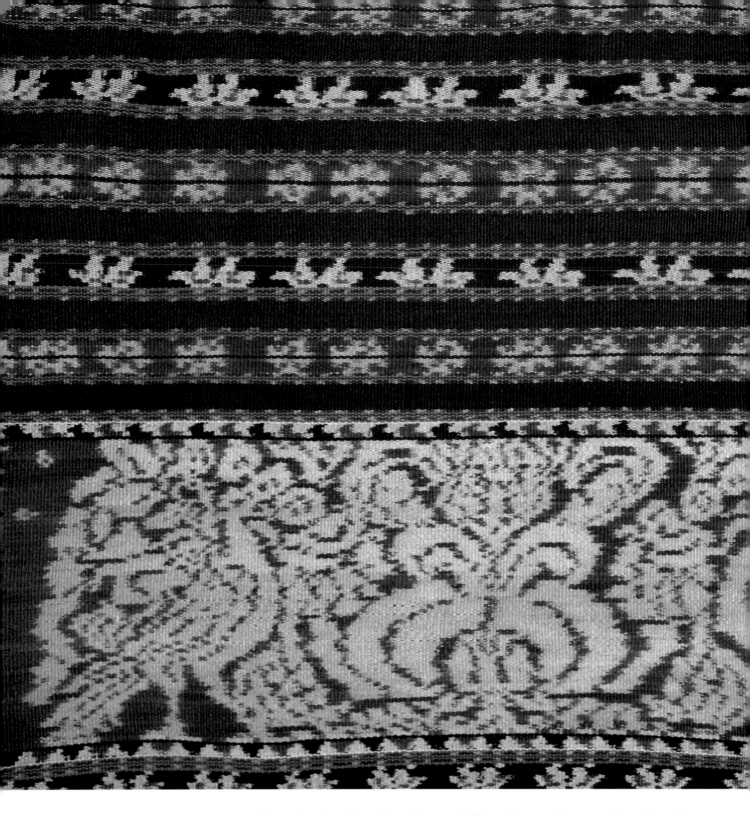

A handwoven cotton sarong from Savu decorated with European-inspired birds in warp ikat using natural dyes. Collected by Dr Jan Wisseman Christie in Bali, 1980. 157 × 119 cm.

thorny bush with yellow flowers. When first cut the wood is pale red, but it turns a darker shade as it is exposed to air. The dye is not long-lasting but can be used to impart a bright-red hue on a mordanted fabric. Alum may be used as a fixative, as well as *Baccaurea* bark or chopped *Melastoma* roots. Tannin extracted from *Ceriops* or guava leaves, *Psidium*, can also be combined with sappan to produce a reddish brown. The introduction of aniline dyes brought about the demise of the sappan trade in the archipelago.

MORINDA Red, purple and brown dyes can be extracted from the root bark of morinda trees. These dyes are known by various names, including 'Turkey red', and are thought to have been introduced to South-East Asia from the Middle East via India. The Javanese cultivate *Morinda citrifolia* (= *M. affine*?) for their batik industry. After collection the morinda root bark is crushed, mixed with water and then boiled. Mordants made from the powdered leaves of alumina-bearing plants are added, and the yarns are usually treated with oils mixed with ash lye prior to dyeing. The yarns are soaked overnight, then dried during the day. Approximately ten immersions are required to produce a basic red, although darker hues can be achieved with additional immersions; in Tenganan in Bali it can take up to six years to make one especially prized kind of red. Dyers in the more arid islands of Nusa Tenggara may experience difficulties in obtaining sufficient quantities of morinda. A yellow rather than red dye can be obtained from the roots of *M. umbellata*.

ANATTO (*BIXA ORELLANA*) This tree, a native of South America, was historically significant in South-East Asia. Its use is recorded in Penang in 1800, and anatto became popular with dyers along the west coast of the Malay peninsula. During the early nineteenth century anatto was planted along roadsides in Java to provide dyestuffs for the European market, but this trade declined as a result of competition from aniline dyes after 1884. The dye is obtained mainly from the coloured coats of anatto seeds. After drying in the sun, the seeds are mixed into a paste with water and then moulded into cakes. (Sometimes the seeds are crushed with rollers beforehand.) Although anatto is not especially long-lasting, it can be used to dye cotton directly. It may also be employed in conjunction with lime to produce a pale mauve, or with durian ashes or sappan wood. Anatto can be fixed with the aid of tamarind, *Tamarindus indicus*, and urine appears to have been used as a mordant during the seventeenth century.

BETEL PALM (*ARECA CATECHU*) A good example of a plant which is used as a source of dye but has other economic applications is the ubiquitous betel palm, *Areca catechu*. It yields a dull brown stain as well as tannin and various medical ingredients (it is chewed as a mild narcotic by weavers as they work). After the dye has been released from chips of betel wood by boiling in water, yarn is added to the hot liquid. Half an hour is required to produce a light brown tone, while overnight immersion yields a darker hue. Dye made from the betel palm is used in Kalimantan.

PELTOPHORUM The batik dyers of central Java use dyes extracted from trees belonging to this genus. Shavings of the bark are boiled in water and the fibres are dipped repeatedly into the warm dye. Before being dyed, the yarns are treated with oils, and after the dyeing they

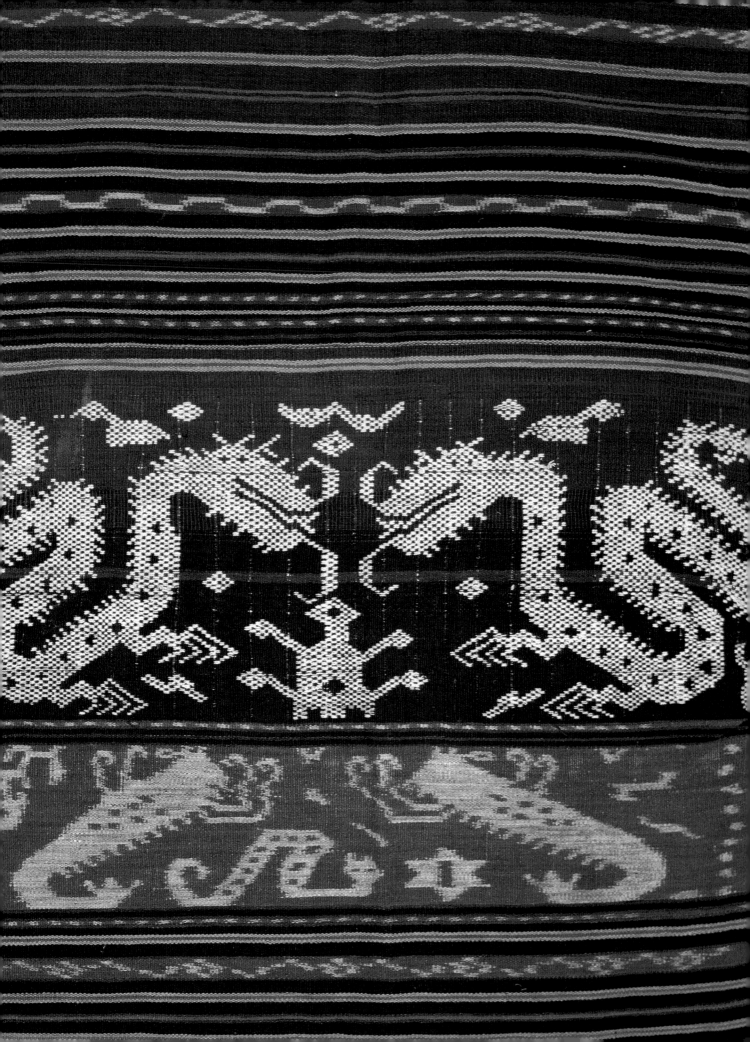

are mordanted. Hues ranging from yellow-brown to chocolate can be obtained, and sometimes the dyes are combined with others such as morinda.

SYMPLOCOS The bark of several members of this genus can be used in dyeing, particularly in preparing reds derived from morinda and sappan wood. A yellow dye, however, as well as a mordant, can be extracted from *S. spicata*.

CERIOPS TAGAL Brown or purple dyes can be extracted from the bark of this mangrove tree. On the Malay peninsula dyers combine the bark with indigo to produce black. *C. tagal* is also used in the Javanese batik industry, often in conjunction with indigo. (The Javanese use *C. candolleana* as a fixing agent, though this is thought to be synonymous with *C. tagal*.)

BRUGUIERA GYMNORRHIZA This mangrove tree, which is found in South-East Asia and other tropical regions, yields orange-red, brown and violet dyes. The Chinese used *Bruguiera* to dye cotton black.

TEAK (*TECTONA*) The skill of obtaining a brown or red stain from the leaves of this tree is known in both Sumbawa and Sulawesi.

MELASTOMA MALABATHRICUM The dyers of Selangor on the Malay peninsula and the Iban of Borneo make a black dye from the fruit of this plant. However, the leaves can be boiled with other substances to obtain a pink hue, while the chopped roots may be used in a preparation for dyeing light red.

Yellow

SAFFLOWER (*CARTHAMUS TINCTORIUS*) This plant, which has a long history as a source of dyes, was known in ancient Egypt and was probably introduced to insular South-East Asia from India. (The Indonesian term for safflower, *kesumba*, has Sanskritic roots.) The plant grows well in the drier climate of the eastern archipelago, and by the early nineteenth century safflower cultivation was already well established in Bali, Sumbawa and Sulawesi. Safflower petals yield two dyes – safflower yellow and carthamin. The crushed petals are kneaded and stirred in cold water and then allowed to settle so that the yellow liquid can be poured off. The process is repeated until all the yellow dye has been separated. A small quantity of the valuable red can be extracted from the base petals; however, this red dye is acidic and is used in alkaline solutions containing pearl ash, lime or tamarind juice. The hues obtained from safflower are not particularly stable and the economic significance of this plant has declined.

CUDRANIA JAVANENSIS A yellow dye can be extrated from the heartwood of this spiny shrub which is cultivated in Timor, Sumbawa and eastern Malaysia, and the Javanese import it for their batik industry.

Handwoven cotton sarong from Sumba decorated with ikat and supplementary warp. Chinese-inspired dragons can be seen on the central panel, while the lower section contains stars, snakes and prawns. 81 × 63 cm. Hull University, CSEAS PDT20.

Striped Yakan head-cloth, *pis*, collected by Gavin Patterson in Lamitan, Basilan Province, in the Philippines. The bright colours reflect the use of modern chemical dyes. 96 × 92 cm. Hull University, CSEAS, 1989. 1–1.

The dye is obtained by soaking chips of *Cudrania* in water overnight and then boiling them. After the water is strained off, alum is added. The fabric to be dyed is boiled in the mixture to produce yellow; if it is kneaded in indigo beforehand, a green colour can be created.

TURMERIC (*CURCUMA LONGA*) This is important as a dye as well as a food flavouring. In preparation for dyeing the rhizomes and roots are stripped and cleaned and then are either steamed in their own juices or boiled with a little water, after which they are dried. Before use the turmeric is boiled again and then crushed into a paste. It can be used directly to produce yellows, but browns and oranges can also be obtained by adding other substances. The Iban of Borneo use turmeric as a preparation for dyeing red, while the Bimanese of Sumbawa mix it with lime to achieve the same effect. Another species of this genus, *C. xanthorrhiza*, is used as a dye on the island of Madura.

ARTOCARPUS Dyes and a wide range of other economic products can be extracted from various members of this genus. A yellow dye which is used for the robes of Buddhist monks in Burma and Thailand is obtained by boiling wood from the jackfruit tree, *A. integer*, in water. This dye is also used by the Javanese and the Malays of Pattani and Kelantan. *A. champederi* and *A. lacucha* are favoured as a source of yellow dye by South-East Asian Buddhists.

SOPHORA JAPONICA The pods and unopened flower buds of this tree produce a yellow dye, though it may be used in conjunction with indigo to prepare green. The dye is used in the Javanese batik industry.

TERMINALIA CHEBULA The fruit of this tree is the source of a yellow dye that is usually combined with alum. (Another species, *T. cattapa*, is used to make brown dyes in the Philippines.)

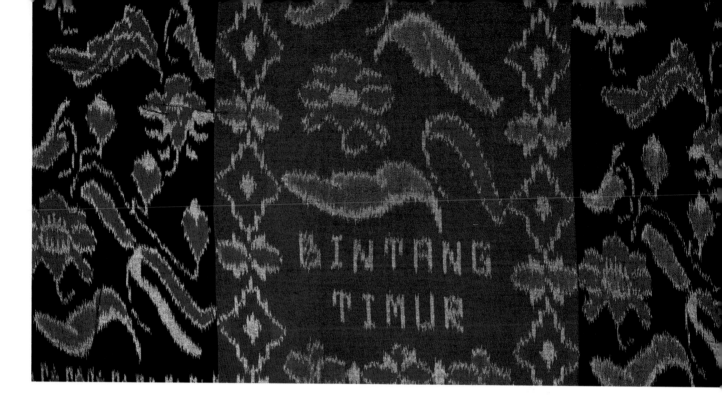

Balinese weft-ikat cotton sarong bearing the brand name Bintang Timur ('eastern star'). Collected by Lewis Hill in Yogyakarta, Java, 1975. 194 × 121 cm. Hull University, CSEAS, 75.25.

SESBANIA GRANDIFLORA The bark of this small, quick-growing tree yields a yellow dye that may be applied to nets and matting, and is sometimes used also to colour textiles.

Miscellaneous

DRAGON'S BLOOD RATTAN (*DAEMONOROPS*) The Iban and Dusun of Borneo use a dye made from the scales that cover the fruits. The Dusun shake the juice and resin from the fruits into baskets and then evaporate the liquid by boiling. Dry paste adheres to a stick placed in the pot, and the stick is later added to dyebaths as required.

RAMBUTAN (*NEPHELIUM LAPPACEUM*) In the Malay regions of Kelantan and Kedah silk dyed with turmeric may be converted to green with the aid of young rambutan shoots. The dyers of Pekan use the skins of the fruits to dye silk yarns, already pre-dyed red, black.

BUTTERFLY PEA (*CLITOREA TERNATEA*) The flowers yield a shortlived dye that can be used on white cloth. This dye is used to stain matting in the Riau Archipelago.

EBONY (*DIOSPYROS*) The fruits and leaves of the various members of this genus are used as a source of dyes and tannin.

GARCINIA Malay and Javanese dyers obtain dyes and mordants from the fruit and bark of various species of this genus.

RED PEPPER (*CAPSICUM ANNUUM*) In Sabah, northern Borneo, the Bajau people colour fabrics with this dye.

BUTEA MONOSPERMA The flowers yield a dye which does not take well to cotton but can be used on silk.

51

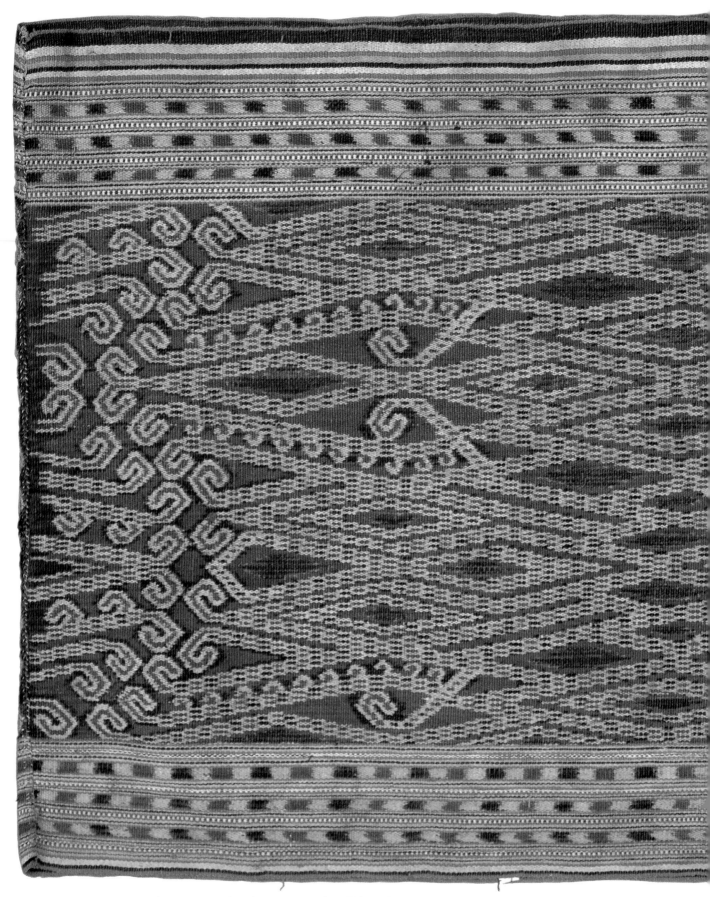

Iban woman's handspun cotton skirt, *bidang*, decorated with warp-ikat
designs. Collected by Prof. M. A. Jaspan in the upper Rejang region, Sarawak,
1971. 101.5 × 50.5 cm. Hull University, CSEAS 72.6.

3

Traditional Looms

A textile is technically a woven fabric, though in modern usage the term has wider applications. Woven textiles are made by interlacing one group of threads, the weft, with another set known as the warp. Weavers in the Indonesian Archipelago make use of a variety of looms which, while they may differ in appearance, usually have much in common with one another. Regional, cultural and personal preferences may influence their design, but their basic principles of operation are very similar.

Warping up

Before a loom can be used the warp yarns have to be prepared and then placed in position on the loom: this process is known as warping up. Yarns are prepared for weaving in a variety of ways. For example, weavers often find it easier to handle threads that have been stiffened slightly by being coated in a gum-like fluid called size. Yarn is therefore frequently soaked in a solution of glutinous rice or some other starchy mixture such as maize or cassava. When the skeins are dry they are placed on a swift, from the revolving arms of which the thread can be drawn off as required. For convenience the yarn may also be wound into balls or around hollow bamboo spools. In order to wind the thread on to a spool a spinning-wheel may be used in conjunction with the swift. The yarn is attached to a bobbin placed on the tip of a spindle so that as the wheel is rotated the spool is turned and yarn is drawn from the swift. Bobbins may be stored on a rack in readiness for weaving. In east Bali yarn is wound on to tapered wooden sticks that serve as bobbins. The narrow end of the bobbin is inserted into a wooden flywheel and then, after this has been set spinning, it is allowed to drop like a spindle.

Before beginning to weave the weaver works out how much yarn she will need. By increasing or reducing the number of warp threads she can alter the width of the completed textile, and she also has to take into account the fact that the weaving process will foreshorten the length of the warp. As the warp intermeshes with the weft it undulates, and therefore the length of yarn required is longer than the finished cloth.

A great deal of space may be needed for warping up because the process often involves stretching the yarn between two poles some four to six metres apart. These poles, which will later be replaced with parts of the loom, are attached to convenient house posts, fences or trees. The weaver walks back and forth between them, unwinding the warp from a spool or ball of thread in her hand. By passing the yarns on either side of a rod set halfway between the two poles the weaver forms a 'weaver's cross' and divides the odd from the even threads. Additional rods may be added to help keep the yarns taut and in parallel lines.

Sometimes an apparatus known as a warping-frame is used for greater convenience. The frame usually comprises two blocks with upright pegs, joined by a wooden bar. The distance between the two rows of pegs can be altered by sliding one of the blocks along the bar and then securing it with a wedge. The yarn is zigzagged between the pegs so that the warp is fully extended without taking up too much

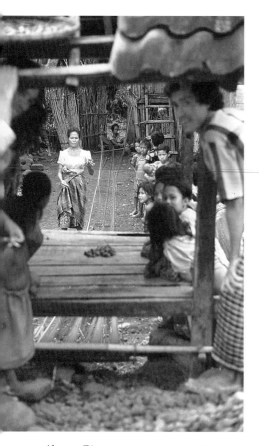

Above Bimanese weaver warping up with a discontinuous warp. Ntobo, Rasanaé, 1980.

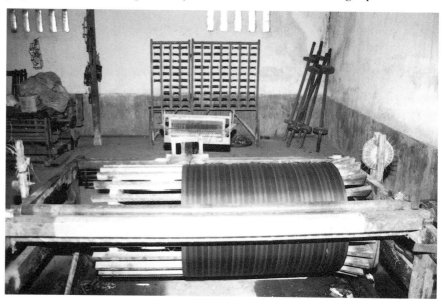

Right Spool rack and a large drum used in warping up in a small factory in Gianyar, Bali, 1989.

space. This apparatus is often used indoors. One or more pegs may be set between the two blocks in order to make weavers' crosses. Large versions of this apparatus, furnished with numerous pegs, are used in factories in Java and Bali, where the demand for textiles is high.

In addition to supplies of yarn, the weaver will have other items close to hand such as a pair of scissors or a sharp knife for cutting the

thread. Some craftswomen also use coconut-fibre brushes, bound with rattan, to remove tangles from the warp.

Body-tension looms

One of the most widely distributed looms in the Indonesian Archipelago is the body-tension loom. This loom makes its name from the manner in which it is used, namely the fact that the weaver employs her body to hold the warp yarns in tension. Body-tension looms are well suited to domestic modes of production and are often used by rural women during lulls in the agricultural cycle. These looms are made of relatively inexpensive materials, take up little space, and can be rolled up and stored when not in use. The overheads are low because body-tension looms in and around the home do not need to be kept in purpose-built weaving sheds. There are two main types of body-tension loom, which are usually distinguished from one another by the arrangement of the warp. The basic principles of the first category, which is commonly described as having a continuous warp, need to be considered before further discussion.

Continuous warp

The first stage of bringing the loom into operation is achieved by replacing the wooden poles that are used to stretch the yarn during

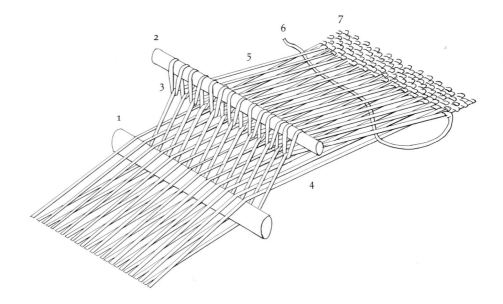

Basic principles of weaving:
1 shed-stick; 2 heddle; 3 leash;
4 shed; 5 warp; 6 weft; 7 web.

the warping-up process with two beams. These beams help to keep the warp threads in tension in parallel lines. The beam closest to the weaver is known as the breast-beam (or cloth-beam), while the one that lies opposite her is called the warp-beam. The latter is usually secured to strong upright posts or is slotted into a heavy wooden frame. A bar or strap, attached to the breast-beam with cords, is worn

around the weaver's lower back to maintain the tension in the warp yarns. The weaver sits on a mat on the ground with her feet outstretched and the warp inclined at a slight upward angle in front.

Alternate warp threads can be distinguished by describing them as odd and even yarns. The loom is arranged so that the odd threads pass under, and the even threads over, a rod inserted in the warp known as a shed-stick. The weight of the shed-stick carries the odd threads well below the even ones to form an opening or natural shed. A flat blade-like tool known as a sword-beater is entered into the shed and is turned on its side. This action enlarges the shed sufficiently so that the weft can be added by means of a shuttle to form a pick (or shot). The sword is then turned so that it lies flat between the odd and even warps, and is used to beat the weft into the already woven cloth, the web. (As the weaver leans forward to insert the sword the tension of the warp is slightly reduced but is fully restored as she leans back to beat in the weft.) After use the sword-beater is removed from the shed and is placed close at hand.

In the next stage the weaver changes the sheds by raising the odd threads with heddles (only the section of warp lying between the web and the shed-stick is lifted). The heddles consist of a long cord looped over a heddle rod and under every odd warp. By lifting the heddle rod the weaver can raise the odd warps above the even ones to create

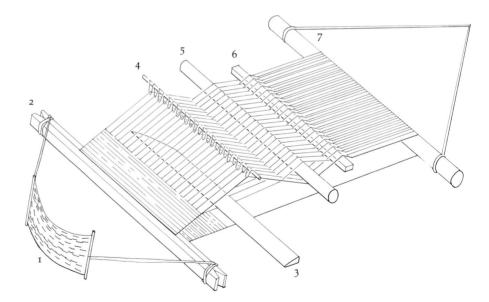

Body-tension loom (continuous warp): 1 backstrap; 2 breast-beam; 3 sword; 4 heddle; 5 shed-stick; 6 laze-rod; 7 warp-beam.

another shed through which the weft is entered as before. When the upward pull on the heddle rod is released, the weight of the shed-stick pushes the odd threads below the even ones again. This crossing action secures the weft by interlacing it between the odd and even threads of the warp.

In this kind of loom the warp threads pass under the breast-beam and join up with those at the warp-beam to form a complete circle and

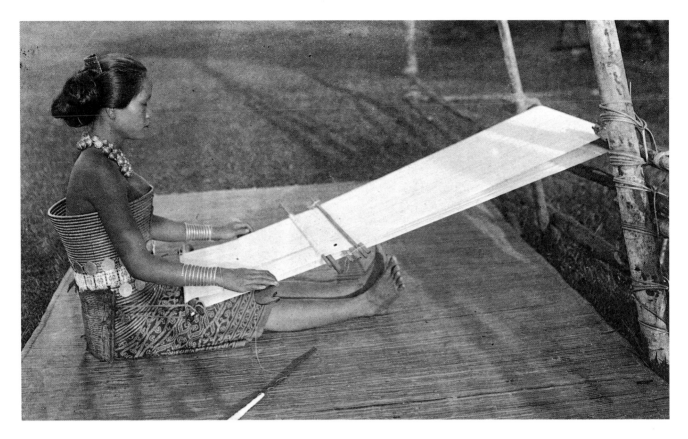

Iban woman demonstrating the use of a body-tension loom with a continuous warp. Photographed during the course of research for *The Pagan Tribes of Borneo* (C. Hose and W. McDougall, 1912). Royal Anthropological Institute.

are therefore said to be continuous. As the weaver works, she keeps the sheds at a comfortable distance by pulling the web towards her and under the breast-beam. The fabric is usually thought to be complete when most of the unwoven warp has been used up and when the cloth meets up with the freshly woven web. At this point the heddles and shed-stick may be removed and the remaining unused warp can be finished with a small shuttle going under and over odd and even yarns, and finally with the fingers. These methods are used to make tubular fabrics, and when a flat textile is desired the warp has to be cut.

A pair of laze-rods (or cross-sticks) may be inserted between the heddle and the warp-beam to prevent the warp threads from becoming entangled. A weaver's cross is made by passing the odd warps under the first laze-rod and over the second, and vice versa for the even threads. Some weavers use only one laze-rod, while others may tie additional sticks above and below the warp in order to keep a pair or more of laze-rods in place. Sometimes a circular cross is used instead of a weaver's cross, in which case both odd and even warps are wound around a single coil rod. A pair of heading rods are occasionally inserted in a weaver's cross between the breast-beam and the web. As more fabric is woven, these rods are pulled under the breast-beam.

In order to ensure an even width of cloth a flat, narrow stick, called

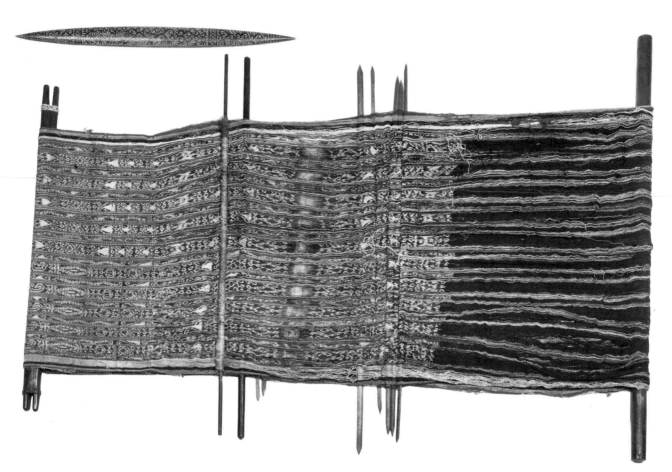

Early 20th-century body-tension loom set up to weave a cotton fabric decorated with warp ikat. The backstrap is missing; the shuttle can be seen above. Sarawak, north Borneo. British Museum.

a temple, can be inserted into the edges (selvages) of the web on the underside of the fabric. Many temples simply have sharpened ends that can be stuck into the textile, though some are fitted with metal teeth. The temple is placed between the breast-beam and the sheds and is moved periodically as fresh cloth is woven.

Although the body-tension loom with a continuous warp is widely distributed, it is usually found in the more isolated parts of the archipelago. In Borneo, for example, peoples such as the Iban and the Dusun, unlike many coastal dwellers, weave with this kind of loom. Many Iban and Dusun looms also have a breast-beam that is split down the centre so that the web can be secured between the two halves. These looms are furnished with thick straps, rather than bars, to go round the weaver's back; and the heavy warp-beam holder is uncommon in upriver areas. The Toraja of Sulawesi, the Donggo highlanders of Sumbawa and the weavers of many islands in eastern Nusa Tenggara also use looms that are not equipped with heavy frames to secure the warp-beams, though they do use wooden back bars rather than straps. In contrast, the weavers of Tenganan in Bali and of north Lombok use both warp-beam holders and carved back bars specially shaped to suit the weaver's personal requirements.

Because the archaeological evidence is limited, it remains uncertain how long body-tension looms have been used in the Indonesian

Archipelago. Ancient foot-braced looms of this type have been reported from elsewhere in South-East Asia, most notably the metal figures of women weaving that were found in Shizhaizan in southern China. These images were attached to the lid of a bronze container and have been identified with the kingdom of Dian which existed on the borders of the Han Empire (206 BC – AD 220). Although nothing of comparable age has yet been discovered in insular South-East Asia, some indication of the antiquity of the Indonesian body-tension loom can possibly be inferred from John Mack's studies of Malagasy weaving (1987). The island of Madagascar was settled by Indonesian peoples perhaps as long as 1,500 years ago. Today some Malagasy weavers use body-tension looms which resemble South-East Asian varieties, and presumably these textile skills were taken across the Indian Ocean during the migration period. One of the earliest datable representations of an Indonesian body-tension loom can be seen in a relief carving on a stone pillar base in the Madjokerto Museum in Java. The base comes from Trowulan, the capital of the Majapahit Empire, and therefore dates from either the fourteenth or fifteenth century. There is also a bronze figure of uncertain age showing a woman weaving which has been discussed by Marie J. Adams (1977). The sacred heirloom of a clan in the Lobe Tobi area south of Larantuka, it was sold to a dealer and its current whereabouts, according to Ruth Barnes (1989), are unknown.

Body-tension loom equipped with a reed and set up to weave a checked cloth with plant-fibre yarns. A selection of shuttles for different-coloured threads can be seen in the foreground. Luzon, Philippines. British Museum, +3495.

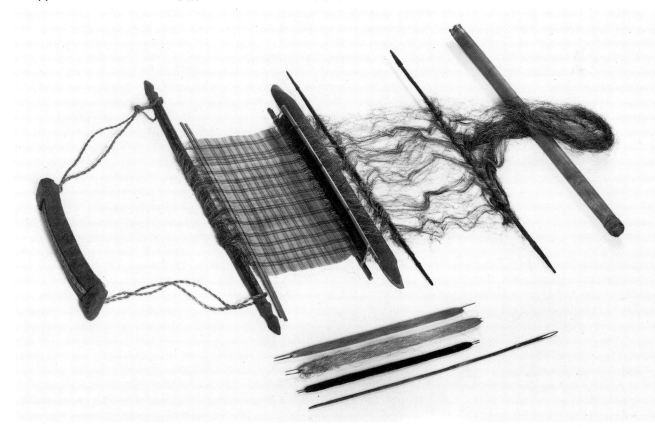

Bimanese weaver using a body-tension loom with a discontinuous warp. Ntobo, Rasanaé, 1980.

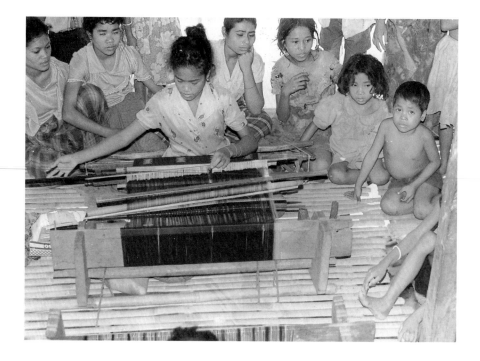

Bimanese weaver demonstrating the supplementary-weft technique on a body-tension loom with a discontinuous warp. The old palace, Bima, 1981.

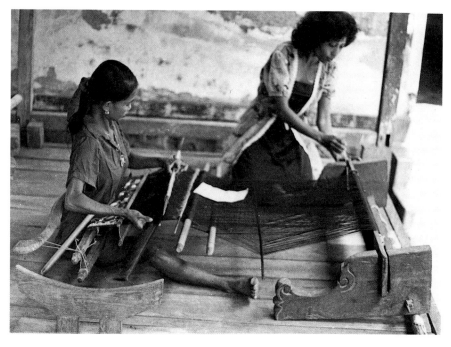

Discontinuous warp

The second main type of body-tension loom is also widely found throughout the Indonesian Archipelago. The arrangement of the warp on this kind of loom differs from the previous one in the way that the warp does not form a complete circle. Instead, the warp threads are attached to both the breast- and warp-beams. As the cloth is woven it is rolled around the breast-beam, while unwoven warp threads, which are stored on the warp-beam, can be let out as

required. The warp yarns are often secured on the loom by means of laths, tied to both ends of the threads, which are slotted into grooves in the warp- and breast-beams. Pegs or cords may be used to hold the laths in place.

These looms are usually furnished with a reed, a comb-like item of equipment that helps to keep the warp threads in order. The reed has teeth made from extremely though slivers of bamboo bound in a wooden frame. The bamboo is slightly flexible, and in the process of warping up the warp yarns are threaded between the teeth. During weaving the reed is used together with the sword in the following manner: first, the weaver widens the shed with the sword; second, the pick is entered by means of a shuttle; third, the weaver turns the sword and, gripping it with both hands, knocks it against the reed which in turn beats in the weft. The sword is withdrawn and after the shed has been changed the process can be repeated. Reeds are sometimes used in conjunction with a continuous warp, as is the case among the Igorot of the Philippines.

The weaver may place a sword-rest to the right of her loom so that she does not have to pick up the sword from the ground after changing sheds. This labour-saving device usually comprises a bar which is supported, at roughly the same height as the warp, by two posts set into a solid base. The sword-rest may be elaborately carved. Sometimes the bar of the rest is made from a tube of bamboo with a slit in it and this makes a 'whooshing' sound as the sword is pulled over it. Noise-making devices can also be found in other parts of the loom, as is the case in southern Sulawesi and eastern Sumbawa where warp-beams are often fitted with clappers. (In Sumbawa bamboo rattles and bells are also attached to the frame that holds the warp-beam.) These sound-producing items not only advertise the industriousness of the craftswoman but are said to scare off the evil spirits that can annoy solitary weavers.

The weaver usually keeps a range of items within easy reach, such as spools with fresh yarn, extra shuttles, records of patterns and, perhaps, a betel-chewing kit. (Betel, a mild narcotic made from the areca palm, *Areca catechu*, is sometimes chewed by weavers as they work.)

On the loom with a discontinuous warp a heavy wooden frame is used to hold the warp-beam in place. These frames, which are often decorated with carvings, vary from region to region. In Bali, Lombok, Java and the Wawo area of Sumbawa, for example, the holder usually comprises two short upright posts with vertical slots cut for the warp-beam. These posts are set into long horizontal planks, which lie on either side of the weaver. A similar kind of holder is used by weavers in coastal Borneo, Sumatra and southern Sulawesi, and the Malay peninsula. The Bimanese version does not have long horizontal bars and therefore the base has to be strapped to the floorboards.

Pages 62–3 Unsewn sarong cloth, *tembé*, woven on a body-tension loom with a discontinuous warp using imported yarns. Given to the author as a leaving present by A. D. Talu, 1982. Naé, Bima. 388 × 56 cm.

61

The Bimanese also make use of tall posts, which can be tied to the rafters, to hold the warp-beam in place.

This kind of body-tension loom is usually associated with the more densely populated lowland and coastal regions where the majority of inhabitants have long professed a world religion and recognised some form of central authority. Until the mid-twentieth century these looms were not only found in rural villages but were also used in palaces for weaving prestige fabrics. Generally speaking the continuous warp is used by peoples in the more remote eastern islands and the upriver and highland areas of the north and west, while the discontinuous warp is characteristic of court-based societies. There are, however, some exceptions. In Tenganan in Bali, for example, both the continuous- and discontinuous-warp looms are known, though the continuous warp is reserved for weaving the sacred double-ikat *geringsing* (also written *gringsing*) cloth where the warp is finally cut during a special ritual (see pp. 83, 134). Similar reasons seem to lie behind the retention of both types of loom in north Lombok. It would appear that both kinds are known in southern Sulawesi, since there is a model of a Buginese loom with a continuous warp in the Skeat Collection in Cambridge; but it is unclear whether or not this type of loom is used for weaving ritual fabrics.

Although a loom may be attributed with certain mystical qualities, it must satisfy practical criteria before it can be used, as is especially the case with the materials used in its manufacture. Because the different parts of a loom are subject to varying stresses, they are made from different materials. While there is scarce documentation in museums concerning this aspect of textile technology, there is a Bimanese body-tension loom in the Pitt Rivers Museum, Oxford, about which more is known. This loom was made on commission by Idrus Yahya between 1980 and 1982, and many of the materials used in its construction were recorded.

The back bar is made from an unidentified timber, known locally as *luhu*, which does not have a slippery surface and is easy to grip. Slivers of hard bamboo were used for the teeth of the reed, which are held in place with a coconut-wood frame. Although the Bimanese usually carve beaters from black ebony, this loom is furnished with a red ebony sword. The hard, heavy wood has a smoothly sanded surface that does not snag the warp yarns. The heddle rod is made from durable areca wood (tamarind is also sometimes used) and the laze-rods from bamboo. The rod that is used to fasten the warp to the loom is secured with smooth buffalo-horn pegs which will not become entangled in the threads. Because the warp-beam and its holders help to keep the warp in tension, they have to be fairly immovable and are, therefore, made from heavy teak.

The Pitt Rivers loom, as it is based on the Bimanese court style,

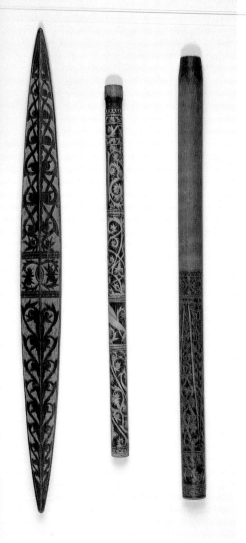

Three highly decorated Iban shuttles from Sarawak. On the boat-shaped shuttle the weft is wound lengthways along a groove, whereas in the two tubular shuttles the yarn is played out from a spool inside the case. British Museum, 6868, 1900–914, 1900–885.

is decorated with high-relief carvings. The bar worn behind the weaver's back is embellished with botanical patterns and cockatoo heads, while the ends of the sword-rest are shaped like foliage. Carved lontar palms can be seen on the warp-beam holders, as well as carved pineapples and leaf designs. The incised motifs on the shed-stick are darkened with soot, as is also the case with one of the laze-rods. Many carved details can be seen on other parts of the apparatus. Looms from other Indonesian regions may also be furnished with various decorative features, particularly those used in the old royal capitals.

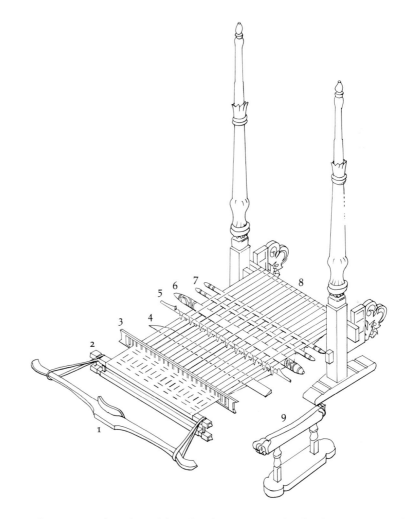

Body-tension loom (discontinuous warp): 1 backstrap; 2 breast-beam; 3 reed; 4 sword; 5 heddle; 6 shed-stick; 7 laze-rods; 8 warp-beam; 9 sword-rest. The drawing is based on a loom made especially for the Pitt Rivers Museum, Oxford, by Idrus Yahya, 1981.

Indonesian shuttles, like the looms in which they are used, are varied in appearance, though they belong to several distinct types. One of the most basic kinds is the stick shuttle, which comprises a plain straight stick around which the weft is wound. This shuttle can be found among the Iban, Buginese and Rotinese. A shuttle that closely resembles a 'carpet shuttle' is also known in Borneo and consists of a narrow wooden board with notched ends on to which the yarn is wound lengthwise. Another shuttle, which has much in

common with the 'carpet' type, is also used by the Iban: both ends of the shuttle are tapered so that it can be passed easily through the shed. The weft is wound lengthwise in a groove around the outer edge of the shuttle. Generally speaking the 'stick' and 'carpet' kinds of shuttle are used for weaving the ground weave on the body-tension loom with a continuous weft, though there are some exceptions.

A different kind of shuttle, made from a section of bamboo, is also known on many Indonesian islands. One end of the bamboo is plugged with wood and rounded off, while the other is left open. A bobbin, with yarn wound around it, is inserted in the tube so that thread is played out from the open end. The bobbin, if sufficiently heavy, does not fall out of the bamboo case during weaving, though sometimes it may be secured with a cotton wad. In Bali and Lombok, where a much narrower shuttle is used, the back end of the bamboo is slit in several places so that it splays out and grips the inserted bobbin.

Bajau woman's festival belt from Sabah, north Borneo, woven with a floated warp on a narrow-gauge loom. Collected by T. J. Cox in Kota Balud, 1974. 102 × 8.5 cm. Hull University, CSEAS 74–8.

Having a smooth surface, the bamboo shuttle can be knocked swiftly through the sheds. Used mainly in weaving with a discontinuous warp, it is sometimes used with a continuous warp, as in east Bali and north Lombok. The bamboo shuttle also tends to be reserved for making the basic ground weave, and additional decorative yarns (see Chapter 5) are sometimes woven in with the aid of smaller versions of the 'carpet' type of shuttle, which is well suited to weaving with heavier wefts, especially metallic ones. Shuttles are sometimes decorated with low-relief carvings, which will not snag the yarn, or incised patterns darkened with carbon.

In addition to the two main kinds of body-tension looms mentioned above there are smaller versions that are used to weave narrow bands. Some of these looms, such as those used by the Namasa of Sulawesi, do not have heddles and shed-sticks; they are, instead, equipped with square pieces of bone (tortoiseshell is used elsewhere in Sulawesi) known as tablets. The warp ends are threaded through holes in the four corners of each tablet, which may be rotated singly or

in pairs, to form sheds. The width of the cloth is limited by the number of tablets the weaver can operate conveniently, and fabrics made with this method tend to be narrow. The warp ends passing through the same tablet twist around each other during the weaving process to produce a distinctive warp-twined or tablet weave. A wide range of patterns can be made by altering the colour of the wefts carried by each tablet and by rotating the tablets in different ways. After each pick, the weft is beaten in with a sword.

Some tablet-loom weavers in central Sulawesi do not use a back bar to hold the yarns in tension. Instead they stretch the warp between two upright posts made from trimmed tree branches. The loom is held in place by rods, fixed to both ends of the discontinuous warp, and inserted behind elbows in the branches. The tablet-weaving loom is known in Java as well as Sulawesi, and may have been used in Bima, Sumbawa, until the mid-twentieth century.

Narrow bands, used to decorate sarongs, are woven by the Mara-

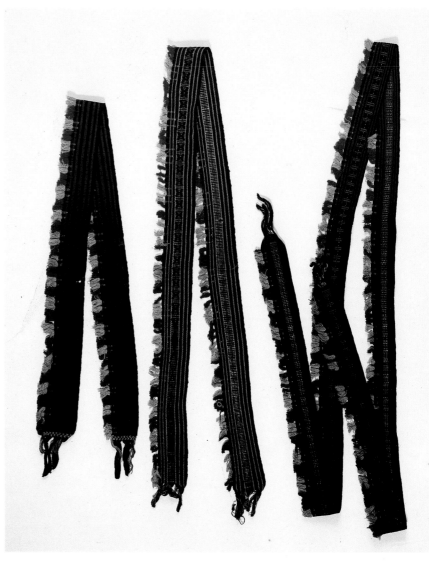

Ifugao girdles from the northern Philippines woven on a narrow-gauge loom and decorated with tassels. Early 20th century. British Museum, 1914–14, 90, 91, 92.

nao people of Mindanao. They use a small body-tension loom equipped with a rigid heddle. The odd warp threads are threaded through holes cut midway down a strip of card held in a frame, while the even yarns pass between the strips. By raising the rigid heddle the weaver makes a shed, into which she inserts a sword-beater and turns it on its side to widen the gap. After the weft has been entered with the fingers, it is beaten in and then the sword is removed. The next shed is made by pulling the fixed heddle below the even yarns. The process is repeated in order to interlace the weft between the odd and even warp threads.

Shaft loom

The other major Indonesian weaving device, the shaft loom, often has a heavy wooden frame and has to be housed in a workshop. Shaft looms tend to be used on a full-time, rather than seasonal, basis and are usually found in urban areas and around old royal centres.

The shaft loom is distinguished by the method of forming the sheds. On this kind of loom the warp ends pass through leashes hung from the two shafts from which the loom receives its name. These are suspended above and across the warp. Further sets of leashes hang

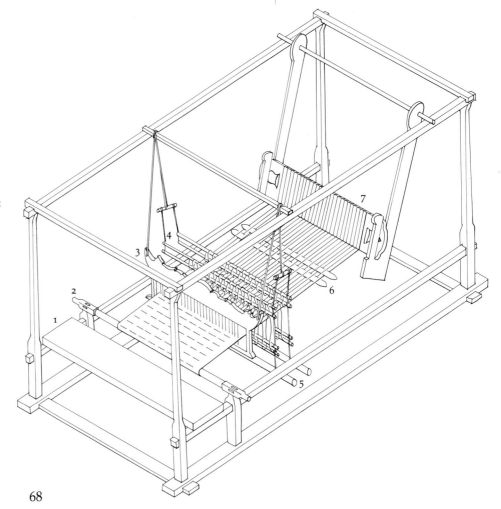

Malay shaft loom: 1 weaver's bench;
2 cloth- or breast-beam; 3 reed;
4 shafts; 5 treadles; 6 laze-rods;
7 warp-beam.

below the warp and are attached to a second pair of shafts suspended below the warp, thereby forming heddles which are used to change the sheds. Above the warp the two sets of shafts are connected by a cord which passes over a pivot or pulley; beneath the warp each pair is attached to a treadle. One of the treadles is used to raise the even threads, and the other to raise the odd ones.

One of the most basic varieties of the shaft loom is used by the Buginese to weave narrow bands. On this kind of loom the warp is held in tension by stretching it between two posts. The two sets of shafts, with string heddles, are hung in counterbalance and tied directly to treadles. The bar which serves as a pivot is hung from a more permanent fixture such as a roof beam or tree branch. The weaver sits beside the warp and changes the sheds by applying pressure to the treadles with her feet. This Buginese loom, unlike most other kinds of shaft loom, does not have a solid wooden frame and can be stored easily.

A more typical kind of shaft loom, often referred to as the 'Malay loom', is found in coastal Borneo, some parts of Java, central Sumatra, and in Kelantan and Pahang on the Malay peninsula. The appearance of this loom, with the exception of some minor regional

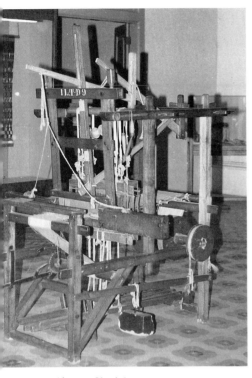

Above Shaft loom equipped with a sling-operated fly shuttle. Museum Tekstil, Jakarta.

Right Shaft loom used for weaving weft-ikat fabrics in a small factory in Gianyar, Bali, 1989.

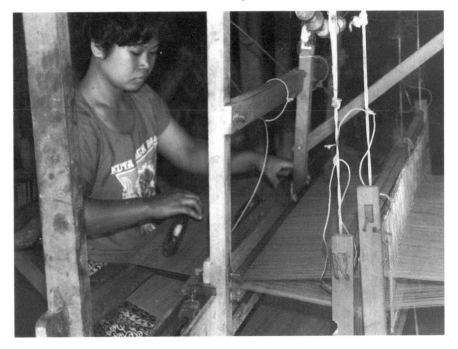

variations, is fairly uniform. It comprises a box-like wooden frame, some 1.25 metres high, with a built-in bench for the weaver. The flat warp-beam is slotted into a pair of wooden supports suspended from a crossbar lying across the top of the frame. The shafts, which have string heddles, are hung in counterbalance from two wooden rods hanging from a second crossbar on top of the frame. The treadles are made from two bars tied directly to the lower shafts. A heavy wooden

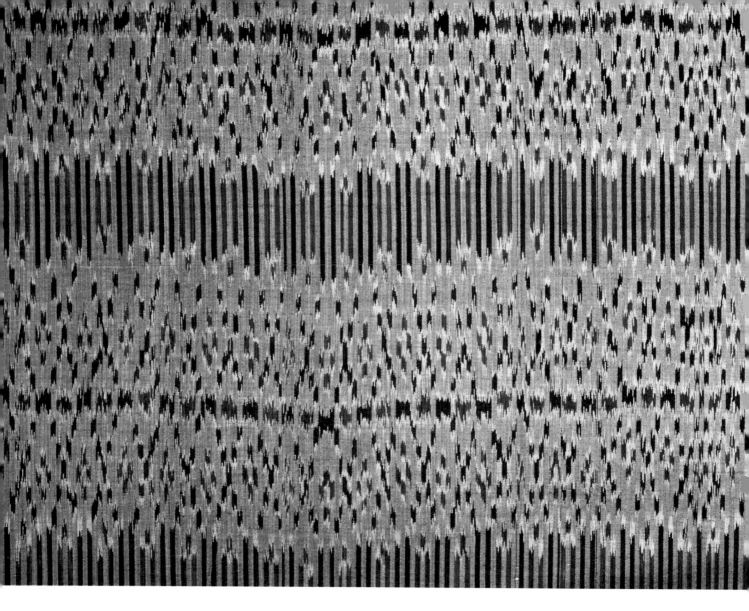

Balinese weft-ikat fabric woven on a shaft loom using synthetic yarns. Gianyar, 1989. 208 × 106 cm.

reed with wire teeth is hung from the same crossbar as the heddles and is used to beat in the weft. There are slots in both ends of the cloth-beam which are designed to fit over pegs on the top of the posts in front of the bench. The weaver periodically stops weaving and lets out unwoven warp from the warp-beam and winds the woven fabric around the cloth-beam. With the 'Malay loom' the weft is usually laid in the sheds with bamboo shuttles containing bobbins.

On some islands the fly shuttle is used in conjunction with another kind of shaft loom. The fly shuttle, which was introduced from Europe during the colonial period, is known in Sumatra, Java, Bali and the central Philippines; it was also used by Bimanese palace weavers until the mid-twentieth century. In this kind of loom a boat-shaped shuttle is sent 'flying' through the sheds by a mechanism operated by a sling. As the weaver pushes the reed away from the web, the motion is transferred by a series of levers to a rod which jerks up the sling. Before changing the sheds with the treadles, the weaver pulls back the reed and beats in the weft. On some looms the weaver pulls on a cord to activate the sling. Both the unwoven warp and the woven cloth are wound around rollers set into opposite ends of the

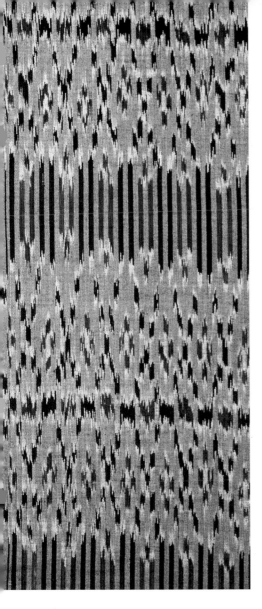

loom's frame. Fabrics woven with a fly shuttle are often wide because the width is not limited by the weaver's reach, as is the case with both the Malay and body-tension looms. Cloth can also be woven very rapidly by using a fly shuttle.

Although rulers and measuring tapes are used in small textile factories, rural weavers often make use of the following measurements based upon the body: the hand span (from thumb to little finger), the cubit (from elbow to middle finger), a portion of the cubit (from elbow to the knuckles), the arm span (the distance between the middle fingers of both hands with the arms outstretched), and the half-arm span (the distance from the nose to the middle finger). These measurements are often combined and the width of a fabric can be described as, for example, 'one cubit plus a hand span'.

While a textile can easily be measured, the time taken to weave it is less readily quantifiable, particularly in rural areas. This is because the rate of production is affected by several variables. First, a textile is often a one-off, especially when made for a specific individual, and may have a unique combination of materials, methods and designs. Second, naturally weavers vary considerably in their expertise and some work appreciably faster than others. Third, it may be impossible to estimate the amount of time actually spent weaving because the work is often carried out on an irregular basis.

Indonesian craftsmen often have a rough idea of how long it takes to weave specific fabrics, in spite of the problems of quantification, though estimates do vary. For example, the head of a Bimanese village, well known for its textiles, provided the following rule of thumb for weaving with a body-tension loom: two to three days for a shoulder-cloth, three days for a checked sarong, five days for a brocade sarong. In contrast, a weaver in a neighbouring village thought that even if a woman worked between five and ten hours a day it would take ten days to make a brocade sarong. Estimates of between four and six days for preparing a shoulder-cloth were provided by other weavers in the same village. Interestingly, these Bimanese estimates, which were recorded in 1981, can be compared with the rate of production noted by Raffles in Java in the early nineteenth century: using similar technology, it took four days to weave a sarong.

Although a weaver's output with a body-tension loom is not high, and may have altered little in more than a century, the introduction of the fly shuttle has clearly revolutionised production methods, as indeed has been the case elsewhere. According to Sylvia Fraser-Lu (1988), South-East Asian weavers can prepare three sarong lengths per day using the fly shuttle, though this improvement may not be due solely to the technology: urban weavers are much more likely to work on a full-time basis than their rural counterparts.

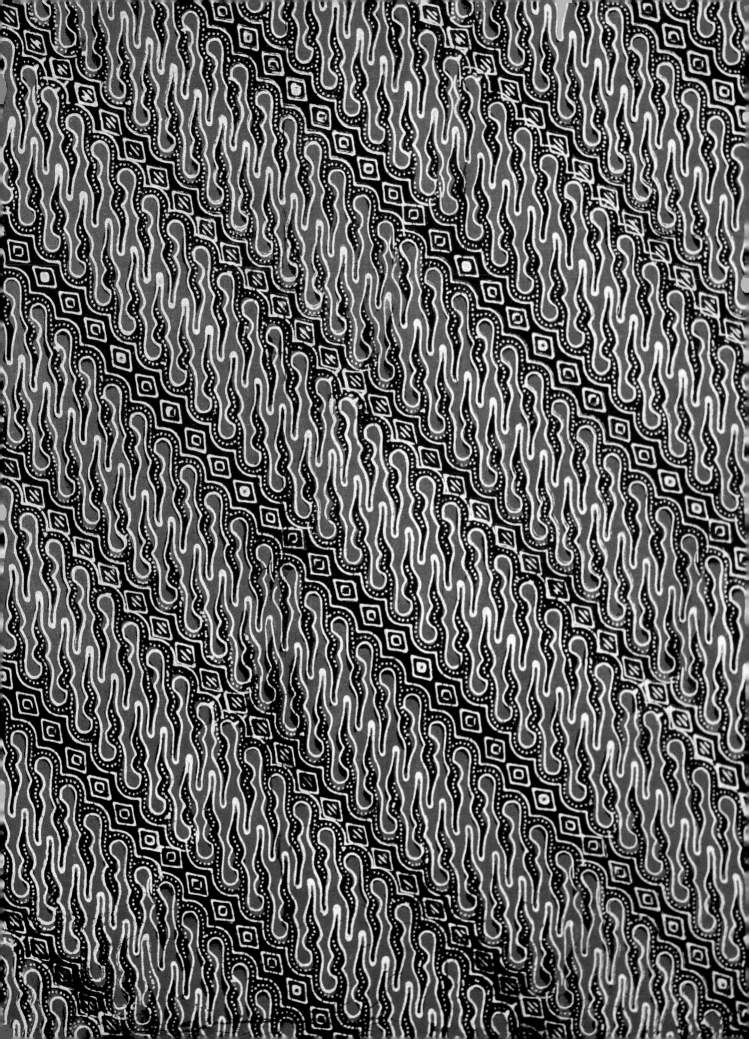

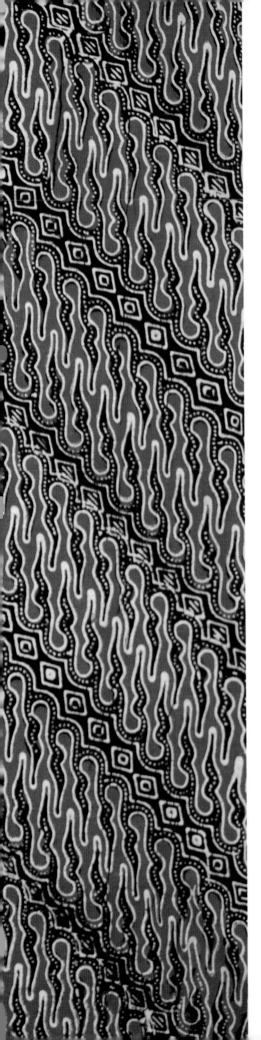

4

Batik, Ikat and other Resist-dye Methods

The Indonesian Archipelago is renowned for fabrics decorated using resist methods such as ikat and batik. These techniques are known as resist methods because materials are used during the process of dyeing that repel the dye. Resist materials may be attached to the yarns before weaving, as is the case with ikat, or applied to the surface of the woven cloth, as in batik. Although the Indonesian terms ikat and batik have entered the international textile vocabulary, two other important traditions, *teritik* and *pelangi*, which are less well known, will also be discussed.

Ikat

Of the various related resist methods the most widely distributed in insular South-East Asia is ikat. This method takes its name from the Indonesian word *mengikat*, and it involves binding the resist material at intervals around the yarn. The resist material may be tied to either the warp (warp ikat) or the weft (weft ikat), though there is also a rare technique, known as 'double ikat', in which both sets of yarn are decorated.

As is indicated by the *Alasantan* inscription (AD 939), the art of ikat was known in Java from at least the tenth century, though it is not clear which variety of this resist technique was used. Both the archaeological and the ethnographic evidence from elsewhere in the

Javanese batik waist-cloth, *kain*, decorated with diagonal rows of *parang* designs separated by lozenge-shaped *mlinjon* motifs. Renggaris, Yogyakarta. 213 × 102 cm. Philla Davis Collection, Hull University, CSEAS PDT13.

73

archipelago suggest that the warp-ikat method is the oldest; however, it remains uncertain whether the technique was developed locally or was introduced. Other early examples of ikat, which have been discussed by Sylvia Fraser-Lu and Jesus Peralta (1988), were excavated in Bonten in the Philippines alongside ceramics dating from the fourteenth and fifteenth centuries. Two pieces of cotton burial-cloth were found decorated with red stripes interspersed with stripes of black and white ikat.

Warp ikat

Warp-ikat fabrics are often woven on a continuous warp in the remoter parts of the archipelago where older forms of the traditional technology have survived. Peoples such as the Batak of Sumatra and the Toraja of Sulawesi use warp ikat, as do many of the inhabitants of the interior of Borneo such as the Iban. Warp ikat is very important in the eastern Indonesian islands of Flores, Sumba, Savu, Roti, Timor and Lembata, and in the Moluccas (Maluku). The main Filipino groups that make warp-ikat textiles are the T'boli, Mandaya and Ifugao. While different peoples may use slightly different materials and methods in preparing warp ikat, the basic principles remain the same.

Although the Javanese make warp-ikat textiles for the tourist market using factory-made cotton and synthetic yarns, this technique is traditionally applied to handspun cottons and other plant fibres such as raffia and bast. In parts of Mindanao in the Philippines banana-plant fibres are used, though the method of dyeing silk with warp ikat appears to be restricted to Aceh, Bangka Island and Danggala in central Sulawesi.

The resist material is applied during the warping-up process when the yarns are extended between two bars which are later replaced by warp- and breast-beams. In eastern Indonesia the warp may be stretched horizontally above the ground by tying the bars to upright wooden posts. A weaver's cross may be added by interlacing two cords in the warp, and the upper and lower halves of the continuous warp can be kept apart with a length of bast. The bars may be secured on a wooden frame to keep the warp in tension while tying takes place. In Sarawak and elsewhere in Borneo the cords which fasten the bars to the frame may be tightened by twisting with wooden pegs.

Dyers do not usually need plans when making patterns with which they are familiar, though outlines are sometimes drawn on the warp with charcoal. A variety of pattern guides are used, however, when new or especially complex designs have to be prepared. Today many designs are recorded on graph paper, though in the past palm-leaf lattice and bamboo were used in some areas. According to Marie J. Adams (1971), high-born women in Sumba jealously guarded access to the best pattern guides until well into the twentieth century. Some

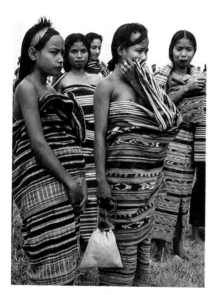

Young women on Sumba wearing handwoven cotton blankets and sarongs decorated with warp ikat. Photographed by Han Snel, the Dutch-born Indonesian artist who lives in Bali, in the 1950s.

Opposite Cotton warp-ikat fabric from Sumba decorated with birds and stylised tree designs. British Museum, 1949 AS9.3.

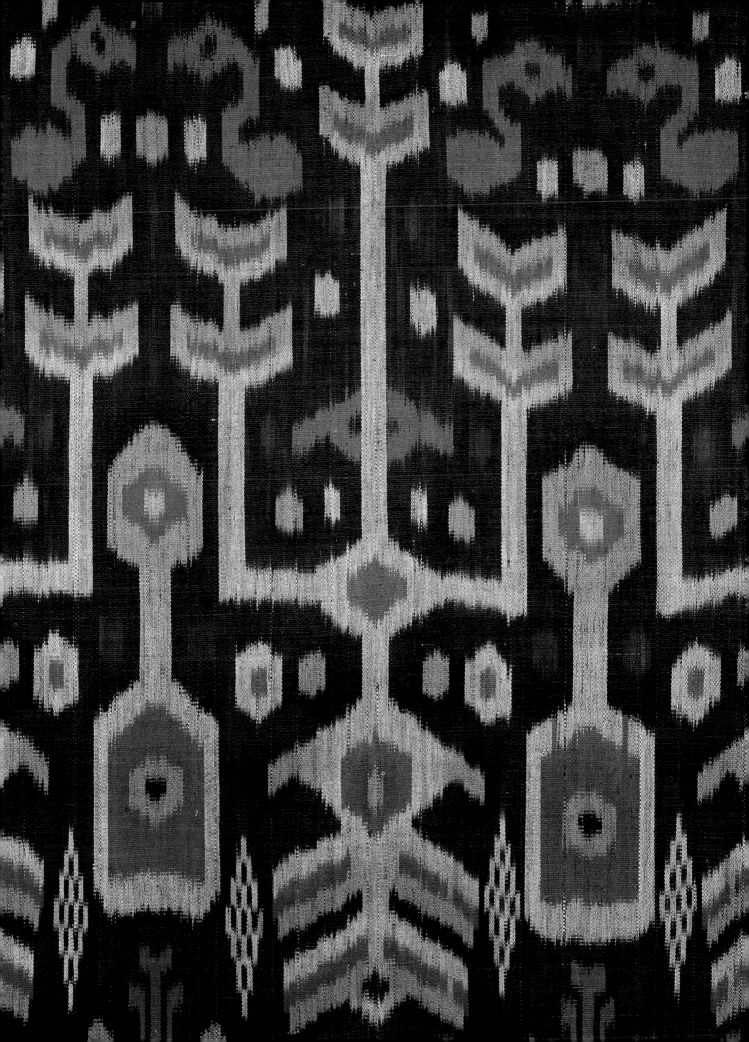

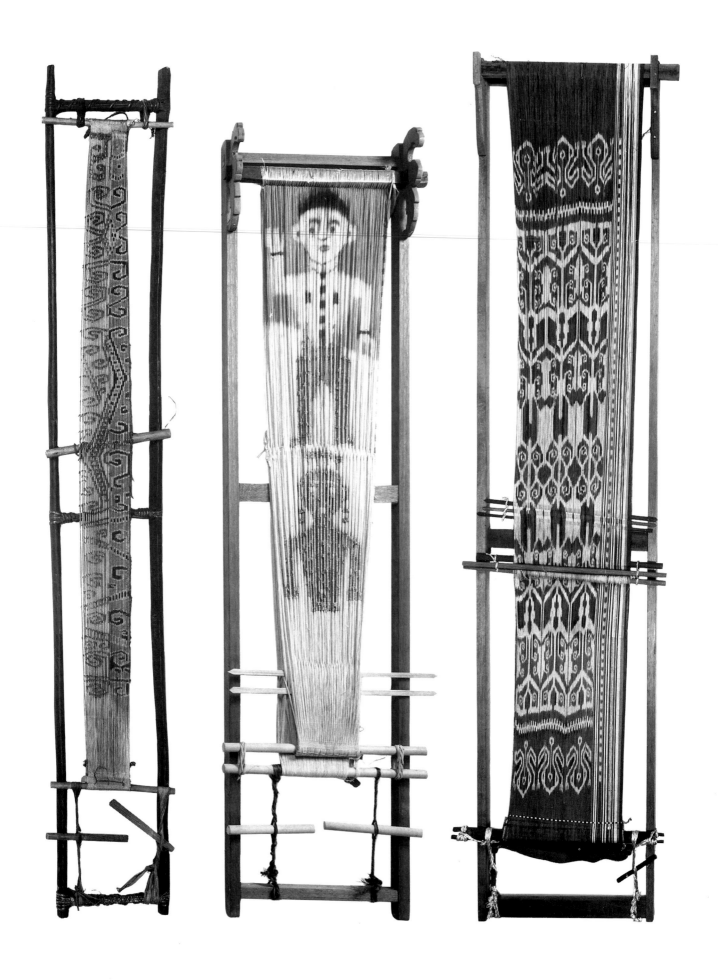

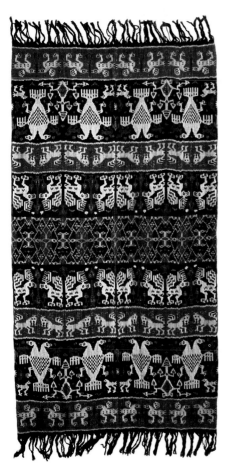

Above Fringed heavy cotton man's mantle from Sumba. The warp-ikat designs show double-headed eagles, birds and horses. British Museum.

Far left While resist material is tied for warp ikat, the yards are kept in tension. British Museum, 1986.3–17.2. *Centre* After dyeing, the resist material is untied from the warp to reveal the design, in this case a human figure. British Museum, 1971. AS4.18.
Left After dyeing the ties are removed to reveal the warp-ikat pattern. The weft is then woven and beaten in to produce a warp-faced weave. British Museum, 1971. AS4.17.

Right Karo Batak cotton textile, *kain uis*, decorated with warp ikat and metallic supplementary wefts. Collected by Prof. M. A. Jaspan in Sumatra. 168 × 77 cm. Hull University, CSEAS 73.74.

dyers also refer to old textiles, which are used as a kind of design library, and combine tried and tested patterns in new ways.

Before the resist material is applied, the warp yarns are grouped together in manageable bundles, since it is too laborious to tie each individual thread. Finer designs can be made by fixing the ties around the smallest possible number of yarns, and on some fabrics the warps are grouped together in threes. Bindings of grasses, coconut leaves, banana and palm fibre, rags or plastic string may be tied on to the areas that will not be coloured with dye. Each binding is wound several times around a group of yarns and is secured with a knot, the excess being trimmed off with a knife. In Borneo, the southern Philippines and some parts of eastern Indonesia the resist material is covered with beeswax to help it repel the dye. The Rotinese use special knots to indicate which ties have to be removed before dyeing with a particular colour. The protected areas retain the original colour of the yarn which can be seen when the ties are removed after dyeing. Because some of the dye usually seeps under the edges of the ties, the coloured sections often have a characteristic fuzzy outline.

Tying the resist material on to the warp is labour-intensive and dyers sometimes use time-saving methods. In Savu and parts of Flores and Timor patterns are replicated by binding several hanks and dyeing them together. On the finished textile these warp-decorated strips are separated by plain or striped sections. In Sumba dyers make mirror images of designs by tying the upper half of the continuous warp to the lower half, and similar methods are used in

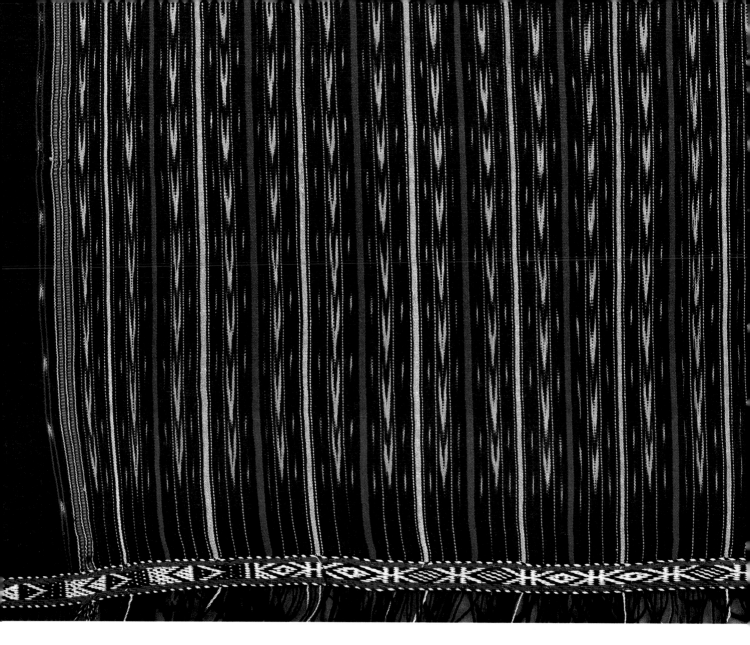

Toba Batak-style textile, *ulos padang rusak*, woven in heavy cotton and decorated with warp itak, twining and fringes. Collected in Bali, 1982. 188 × 74 cm.

preparing large fabrics. Because only narrow widths can be woven on body-tension looms, wide cloths are made by sewing together two textiles. The separate sections are usually tied together prior to dyeing so that they are decorated with the same warp-ikat designs, which are carefully matched when the textiles are joined to one another. These methods are used in Borneo by the Iban to make *pua* cloths (sacred ikat textiles formerly used by women to receive heads taken in raids) and in eastern Indonesia to make shoulder-blankets. The latter garments are sometimes worn in pleats so that the patterns flow down either side of the body, showing the hazy outlines of warp ikat to best effect.

Indigo is often dyed first, though many immersions in the dyebath may be required to produce deep blue. Then some of the ties are removed in readiness for dyeing with a second strong colour, usually either red or dark brown. The last ties to be taken off are those that protect the parts of the design which will be coloured with light hues such as green or yellow.

When all the ties have been cut away, the warp is prepared for weaving by immersion in size, after which it is stretched on a frame. Warp-ikat textiles are usually woven with a tabby weave, the basic binding system which is also known as plain weave. Many of the textiles do not have a balanced tabby weave and are woven so that they are warp-faced: the weft is beaten in so that it is hidden by the patterned warp. According to Sylvia Fraser-Lu (1988) warp-ikat fabrics in Sumba and Flores may have between 3,000 and 4,000 warp threads and can take up to six months to prepare, especially when traditional dyes are used.

The art of dyeing with traditional materials and methods can be unpredictable, and dyers sometimes observe special rituals in order to ensure the success of the undertaking. On Roti spirits are said to dip their hands and breasts in the dyebath, depriving the dye of its effectiveness, and talismans made of strips of lontar palm and three kinds of hen feathers are suspended above the liquid. Christian Rotinese use a plaited cross or mark a cross on the ground with lime powder before dipping the yarn in the dye. Pregnant and menstruating women are not allowed near the dyebath. The Toba Batak observe a similar custom and forbid pregnant women from participating in dyeing. Toba Batak dyers also have to refrain from talking about death, and nobody is allowed to come near the dyebath unless they are working. On Sumba dyers work in walled or fenced enclosures, away from prying eyes, and in Borneo the Iban traditionally venerate female deities who are credited with teaching humans the art of dyeing.

Weft ikat

Unlike warp ikat, which is rarely used to decorate silk, the weft-ikat method is associated with court-based societies rather than the small cultures of the more remote regions. Generally speaking weft ikat is found in the low-lying and coastal areas where world religions have long been influential. Historically these people had important links with the Asian mainland, and it is possible that the weft-ikat technique was introduced by Indian or Arab merchants, many of whom would have been involved in the textile trade.

In the archipelago the weft-ikat method is particularly popular among self-confessedly Muslim peoples such as the Buginese and Makasarese of Sulawesi and the Maranao and Magindanao of the Philippines. Many Malay dyers make weft-ikat fabrics, and this technique is known in the north-east of the Malay peninsula, Bangka Island and the province of Riau. Some of the finest weft-ikat cloths are produced in south Sumatra, especially in Palembang, where the method is often combined with other decorative techniques. Weft-ikat textiles are made in Gresik in east Java and on the island of Lombok. The Hindu Balinese are known for their high-quality weft-

Sarong cloth from Lombok bearing the brand name Tjap Tjandi and decorated with weft ikat and metallic supplementary wefts. 228 × 118 cm. Hull University, CSEAS.

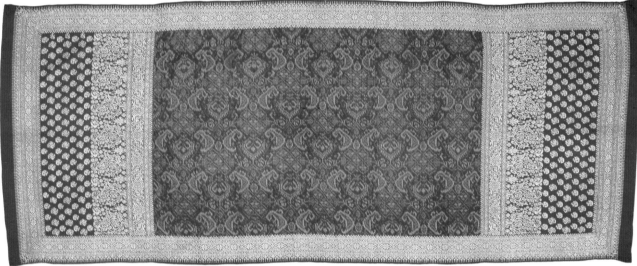

Silk textile decorated with weft ikat and gold supplementary wefts. Palembang, south Sumatra. British Museum, 1955. AS6.2.

ikat fabrics, as are the predominantly Christian inhabitants of Gorontolo in north Sulawesi.

The traditional means of preparing weft ikat resemble those used to make warp ikat. The weft yarns are stretched on a frame and are tied with dye-resistant bindings before immersion in a dyebath. The decorated weft thread is then woven on a body-tension loom. Today, however, the vast majority of weft-ikat fabrics are made in small factories, many of which are located in south Sumatra, east Java and Bali. Although the equipment in different workshops may vary slightly in appearance, the methods of production are similar.

First, the undyed weft is wound around a wooden frame which is approximately the same width as the finished cloth. Occasionally this is done by hand, but most factories use revolving frames which can draw yarn rapidly from a rack of bobbins. Second, the yarns are tied with plastic string and any surplus resist material is trimmed off with a sharp knife. As is the case with warp ikat, templates or pattern guides may be used with unfamiliar or complex designs. Third, after dyeing, the ties are removed and the decorated yarn is wound on to bobbins with the aid of a winding-wheel. The patterns are arranged so that each length of thread contains a complete design element, such as a botanical, figurative or geometrical motif. A bobbin will, therefore, have sufficient yarn to weave a section of the overall design, and each bobbin is numbered so that it can be used in the correct order.

In small factories weft-ikat fabrics are woven on shaft looms equipped with fly shuttles. A basic tabby weave is used, but because the pattern is in the weft the warp threads are monochromatic. Often the colour of the warp matches the predominant hue in the weft so that attention will not be distracted from the designs. Alternatively, a vivid warp may be selected which contrasts with the weft to produce a distinctive 'shot through' effect in the finished cloth. Because of the difficulty in matching design elements precisely, the weaver may realign weft yarns with the aid of a needle, and some textiles therefore have slightly uneven selvages. More weft than warp threads are often used, and the decorated yarns are beaten in tightly; the higher the density of weft ikat, the more visible the designs. Although silk is esteemed, many weft-ikat textiles are woven with cheaper factory-made cottons and synthetics; industrial rather than natural dyes are also used.

Not all the colours on factory-made weft-ikat fabrics are dyed with resist methods. Dyes are sometimes applied directly to the yarn with a spatula to produce highlights. To prevent the dye spreading the area around the design feature is masked with bindings, and after it has been dyed the newly coloured section is tied with plastic string to protect it from subsequent immersions in the dyebath. This process is known as *cetak*, from the Indonesian word meaning 'to print'.

As the means of production have changed, so has the customary division of labour based on gender. Some occupations such as tying and dyeing, which are traditionally the preserve of women, are now performed by men, though weaving is still predominantly a female occupation.

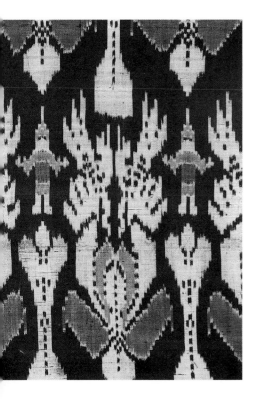

Detail of a Balinese weft-ikat fabric. Horniman Museum.

Double ikat

In insular South-East Asia the double-ikat method, in which both warp and weft are resist-dyed, appears to be restricted to the village of Tenganan in east Bali. This technique is also known in India and

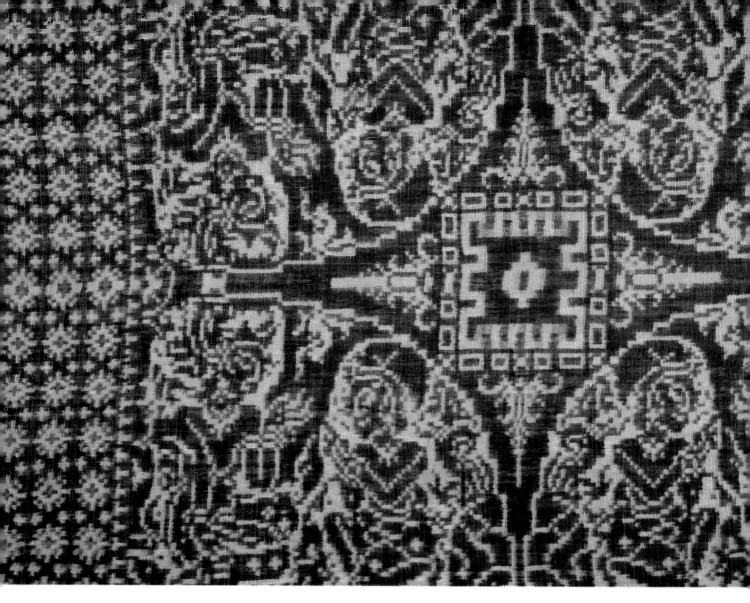

Balinese double-ikat fabric, *geringsing*, from Tenganan. A central star divides the design into four sections, each containing a seated figure of a man and a kneeling figure of a woman. Cotton and natural dyes. 230 × 48 cm. Philla Davis Collection, Hull University, CSEAS PDT2.

Japan, though it remains unclear whether or not it was introduced to the archipelago from either of these sources. Moreover, the people of Tenganan, who claim to be the descendants of the pre-Hindu inhabitants of Bali, are more isolationist than their fellow islanders, and it seems possible that the weft-ikat method was developed independently in Indonesia.

Double-ikat fabrics are not only complicated to dye but are difficult to weave, and the basic procedures are worth discussing here. The cotton yarns are prepared for dyeing by soaking them overnight in a solution of candlenut oil, wood ash and water, after which they are sun-dried for five to twelve days. Before tying, the warp and weft are stretched on different frames, and the one used for the weft can be adjusted to the desired width of the finished cloth. When tying on the bast-fibre resist, the dyers either follow charcoal guidelines on the yarn or use an old cloth as a template. The warp and the weft are constantly compared and measured to ensure the correct alignment of the designs in the finished cloth. The process is very labour-intensive, and sufficient yarn to make several textiles may be tied together to save time.

82

Because women in Tenganan do not use indigo, the hanks of tied cotton are taken to the neighbouring village of Bug-Bug to be dyed blue. On completion of the initial stage of dyeing the ties covering the sections which will be dyed red are removed and the yarns are placed in a dyebath containing morinda. Alum from a tree belonging to the genus *Symplocos* is used as a mordant. The yarns are left in the solution overnight and are dried in the sun during the day; it can take many months to achieve the distinctive rich hue of morinda. As a result of overdyeing the indigo-coloured areas become brownish-purple, though areas which are to remain blue are protected from the red dye with ties.

After sizing in starchy water the warp threads are laid on a body-tension loom with a continuous warp. The wefts are wound on to bobbins and are woven with a bamboo shuttle. Double-ikat textiles have a fairly loose tabby weave, with an even ratio of warp and weft yarns, although the spacing is often irregular. Before beating in the weft, the weaver may use a bone needle to make sure that the yarns are in the correct position, and consequently the selvages are often uneven.

These double-ikat textiles, known as *geringsing* (see p. 134), are believed to have protective powers, especially the ability to ward off sickness and evil. They are often used during rituals, particularly in rites of passage, and are valued throughout Bali and part of neighbouring Lombok. Because *geringsing* textiles are woven on a continuous warp they are tubular when removed from the loom. Uncut fabrics may be offered as clothing for deities and ancestors; but once the warp has been cut, *geringsing* textiles can be worn only by human beings.

Batik

Although the Indonesians, especially the Javanese, are widely regarded as the world's foremost exponents of batik, the early history of this resist-dye technique in the archipelago remains uncertain. Archaeologists have yet to discover Javanese batiks as old as some found in Egypt, which date from the fifth and sixth centuries AD. Well-established batik traditions are also found in West Africa, China, Japan and Turkestan, and historians have suggested that these resist methods were introduced to Java from India. Some scholars have also argued that the Javanese were unable to make intricate batik designs until the second half of the eighteenth century, when finely woven imported fabrics became available. Refined batik patterns, according to the latter theory, could not be executed on Indonesian textiles before that period because these were too coarse. Furthermore, it would appear from the linguistic evidence that Indonesian resist techniques are not very ancient because the term 'batik' is not mentioned in old Javanese.

Pages 84–5 A north coast Javanese cotton *kain* decorated with *batik tulis* showing Chinese-inspired *lokcan* (combined bird and foliage) and other mythological designs. Garuda wings can be seen inside the triangular *tumpal*-style motifs. Collected by Dr Jan Wisseman Christie in Jakarta, 1977. 252 × 104 cm.

83

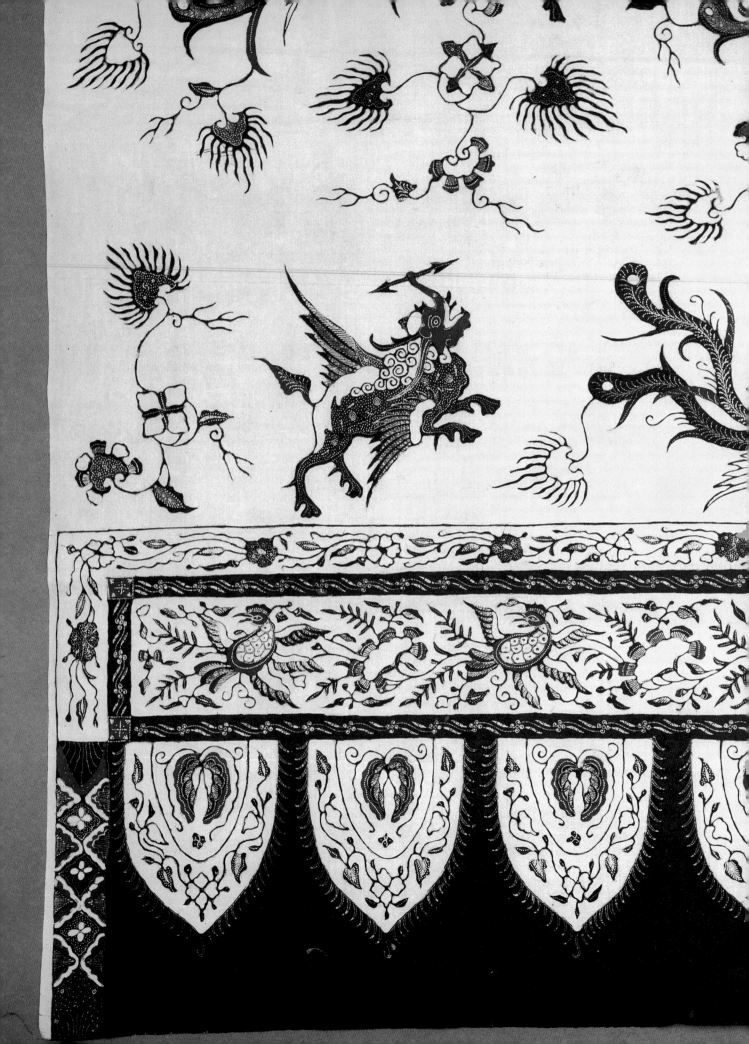

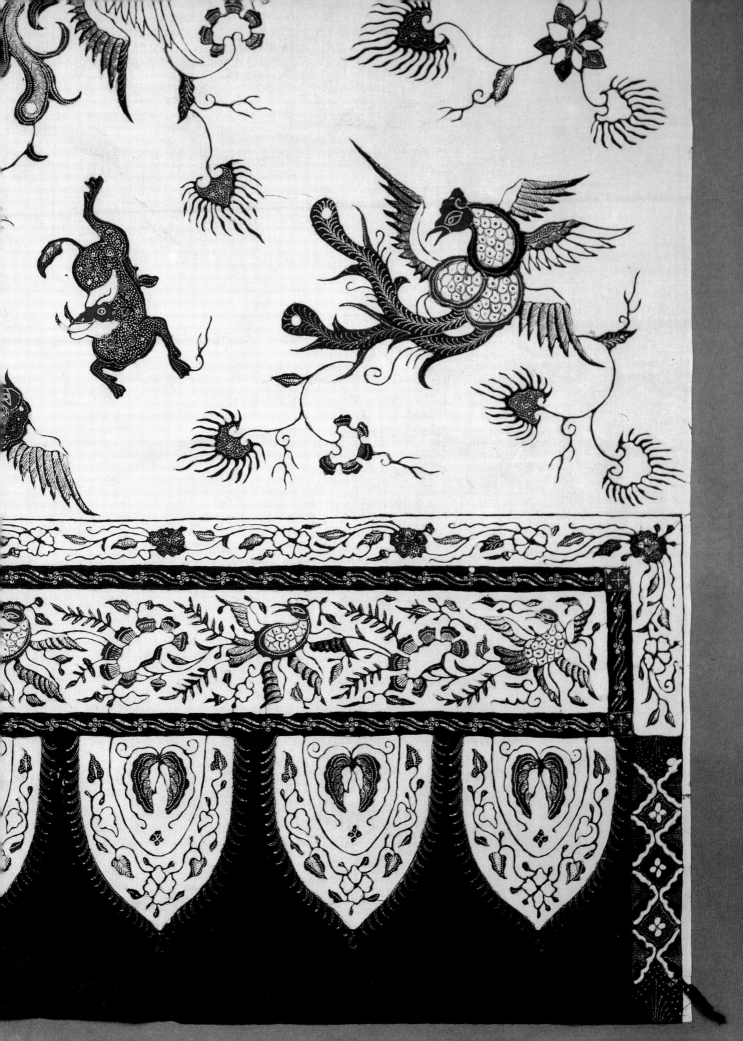

In spite of the above arguments there are good reasons for considering alternative points of view or at least keeping an open mind on the subject. First, the archaeological evidence is inconclusive, not least because textiles do not survive well in the hot and humid conditions which prevail in Java, and their history is difficult to trace. Second, this resist method may have been known in the archipelago well before the eighteenth century, since a shipment of cloths described in a bill of lading as batiks was mentioned in the preceding century (see p. 23). Third, the well-known sophisticated forms of batik could conceivably have developed from much older traditions, and dyers in the remote areas around Banten still decorate local rough cotton fabrics with this technique. The Javanese also had access to fine Indian cottons from as early as the tenth century, and a plain white textile, imported from the sub-continent, is mentioned in old Javanese documents. It is not, of course, known whether fabrics like these were decorated locally with batik. Fourth, the absence of 'batik' in old Javanese may be due to the fact that the term is possibly of Malay origin, from the work *tik*, meaning 'to drip' or 'to drop'. The word *tulis* designates fabrics in Javanese inscriptions dating from the twelfth century, and this word is later used to describe the process of applying batik with a pen.

Hence while little is known about the early history of batik in the archipelago, what is clear is that Indonesian, especially Javanese, tools and methods have been admired and copied by dyers throughout the world. During the nineteenth century European traders and scholars began to take increasing interest in batiks, and some of the finest Indonesian textiles in museum collections date from this period. The British Museum, for example, houses batiks which were acquired by Sir Thomas Stamford Raffles during his governor-generalship in Java between 1811 and 1815. (The full extent of his collecting endeavours will never be fully appreciated since fire broke out on the ship on which Raffles was returning to Britain and much was destroyed.) As a result of Raffles's work, the British began to investigate ways of producing imitation printed batiks that would be cheaper than the originals. They were, however, unable to match traditional Indonesian dyes and had to use large numbers of blocks and rollers to copy the handmade designs: the costs soon proved prohibitive.

Across the North Sea different approaches were tried. Indonesian batik makers were brought to the Netherlands to teach Dutch workers, and some of the people they trained were later transferred to Java where they helped to set up state-run textile combines. Batik factories were also established in Holland, the first being in Leiden in 1835. During the next decade the Swiss began to export imitation batiks, but following the adoption of wax-block-printing methods in Java in the 1870s, Swiss production declined. The Germans appear to

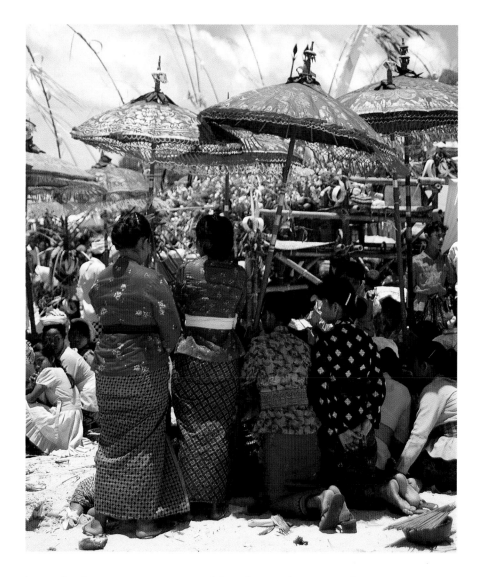

Balinese women wearing batik waist-cloths, Malay-style blouses and festive sashes. The parasols are covered with fabrics decorated with the *perada* (see Ch. 5) technique. Kuta, 1989.

have had more success, and by the early 1900s they were mass-producing batik fabrics with glass pens and electrically heated resists.

European artists, as well as industrialists, began to appreciate the advantages of batik, and the decorative styles of art nouveau owe much to Javanese influence, particularly in the Netherlands. One school of Dutch designers based in Haarlem became known for their use of batik inlays in furniture, and in 1916 a member of this group, Madame Pagnon, opened up a small factory in Paris. During the economic stagnation of the late 1920s demand for industrially made batiks declined, and the craft became once more the preserve of small-scale producers in both Europe and Indonesia.

The Javanese, sustained by local demand, continued to produce resist-dyed fabrics throughout the 1930s, though batiks were adopted as costume accessories by wealthy tourists visiting the archipelago. Clearly the fashion spread, and in his book *Big Money* (1936) J. Dos Passos was able to marvel at 'ladies in flowing batiks'. Batik produc-

Woman applying wax to the surface of a cloth using a *canting* in the *batik tulis* process. Yogyakarta, 1990.

tion stagnated during the Second World War, though it gradually revived in the post-war boom, and by 1958 British women were wearing summer dresses decorated with batik. In the 1960s and 70s batik sarongs became popular as beachwear, especially in California and Australia, and in the 1980s fashion designers continued to use traditional batik as a source of inspiration. Although batik is made throughout the world, by both large- and small-scale producers, Java remains the foremost centre.

For the finest Javanese batik the cloth has to have a high thread density and an even surface. Silk is occasionally used, though the most common material is cotton. High-quality fabrics were imported for the batik industry from India until they were supplanted by European goods in the nineteenth century; after the Second World War the Japanese also supplied the Indonesians with cotton cloth. In addition to foreign textiles the Javanese make use of locally woven cambrics which come in four grades – *primisima* (the finest), *prima*, *biru* and *merah* (the coarsest).

Cloth for batik is cut to the desired size from the main length of material and is hemmed to prevent fraying. To remove the size the fabric is washed, boiled and kneaded thoroughly, after which it is

Young men dyeing batik 'paintings' in the courtyard of a batik factory. The cloths, which are sold to both domestic and foreign tourists, are removed from the frames, dipped in dyebaths, and then washed and later dried on clothes lines. Yogyakarta, 1989.

dried outside. The cloth is prepared for dyeing with oil, usually either castor or groundnut, and a lye made from the ashes of rice straw or banana trunks. To prevent the wax from penetrating too deeply into the fibres the cloth is treated with a dilute rice paste or cassava size. Because batik makers need a smooth and malleable surface to work on, the cloth may be pounded with a wooden mallet before it is used.

Before the fabric is waxed it is hung over a frame and the main design elements are sketched in with either charcoal or pencil. Highly skilled batik makers may apply the wax patterns from memory, though sometimes a finished cloth, hung beside the worker, may be referred to. A stencil may also be used, as well as a pattern guide, known as a *pola*, which is placed underneath the cloth and traced.

With hand-drawn batik, known as *tulis* (meaning 'to write' or 'to draw'), the wax is applied with an instrument called a *canting*. This tool consists of a copper reservoir with one or more spouts and a handle of wood, reed or bamboo. The spouts vary in size and when drawing the fine outlines the smallest bores are used. Parallel lines or dots can be drawn with a *canting* which has multiple spouts, while broad tubes are used to block in spaces. Larger areas can be coated by a piece of cloth, tied to the mouth of the *canting*, to act as a brush.

Traditionally Javanese batik makers used beeswax imported from Sumatra, Sumbawa and Timor, but by the late nineteenth century they also began to work with ozokerite from Europe. Today mixtures of beeswax and locally made paraffin are common, to which resins (for adhesiveness) and animal fats (for liquidity) may be added. Recipes for batik wax are often closely guarded secrets.

The wax is heated in a metal or earthernware pan over a small brick stove. Once the wax has been warmed to the desired liquidity it is maintained at an even temperature. After dipping the copper head of the *canting* in the wax to fill the cup, the batik worker grips the tool with her thumb, index and middle finger. Care is taken not to touch the textile with the spout, and to prevent spillage the implement is held horizontally. Great skill is required when handling the *canting* because if the wax is too hot it will flow too swiftly and if too cold it will block the tube. Obstructions can be removed by blowing or by cleaning with coconut fibres. Wax which is accidentally spilled on the cloth can be removed with a sponge and a heated iron rod, though it is almost impossible to correct mistakes completely.

After one side has been completed, the cloth is turned over and the wax patterns are copied on the back. Good batik is reversible and the outlines have therefore to be followed precisely. The most experienced batik makers are normally responsible for the intricate patterns, while the less skilled workers are employed in blocking in large areas and copying. Acording to Noel Dyrenforth (1988) it may take a craftswoman, depending on the complexity of the design, between thirty and fifty days to prepare a two-metre length of cloth.

During the process of dyeing some of the colour may seep into fissures in the resist material, leaving the spidery patterns that are characteristic of batik. Dyers may deliberately create a marbled effect by cracking the wax carefully; alternatively, the amount of veining can be reduced by warming the cloth in the sun to keep the wax supple.

Traditionally, batik makers begin by waxing the areas that will resist the blue dye (Madurese dyers appear to be the exception). After immersion in the dyebath, the cloth is soaked in cold water to harden the wax, which is then scraped off with a knife. Additional resist material is then applied to the parts of the design, both blue and white, which will not be dyed with the next colour, usually brown. (In contrast to indigo, browns are dyed in lukewarm water, though the temperature is never high enough to melt the wax.) Today dyes may be applied with a brush to smaller areas of the design, which are then covered with wax to protect them from further immersions. On completion of the process of dyeing the cloth is soaked in lime before being transferred to a bath of fixing agent. Finally the fabric is washed, and any remaining wax is recycled by boiling it off in a cauldron.

Hand-drawn batik is time-consuming and expensive to make. The output of batik increased during the late nineteenth century following the adoption of the wax-block or *cap* process, which enabled each worker to wax many cloths per day. Although *batik tulis* is held in a high esteem, for economical reasons modern batiks are stamp-printed.

A *cap* typically comprises a single design element made from copper strips (approximately 1.5 cm wide) and small pieces of wire (for the dots) soldered to an open frame. The complete pattern on a cloth may be made from a number of interlocking blocks, and the corners of stamps often have pins for ease of alignment. Blocks may be made in mirror-image pairs which are used to stamp both sides of the cloth. These stamps are constructed by welding 3-cm-wide pieces of copper between the grid-like plates. The whole block is then cut carefully down the central axis to separate the two stamps. For clarity of outline the two *cap* have to be matched precisely on the upper and lower surfaces of the fabric.

The textile is printed on an angled table which is padded and tightly covered with a cloth. The surface may be coated with a dilute lye mixture so that the wax does not stick to it during the process of printing. As is the case with the *tulis* method, the wax is heated in a basin. A folded cloth, which soaks up the impurities and serves as a stamp-pad, is placed inside the pan. The batik maker presses the *cap* on to the pad to absorb the wax and then removes any excess material that may spoil the design. At precisely the right temperature, when the wax is neither too hard nor too soft, the printer applies the stamp. The edge of the *cap* is placed first on the fabric to ensure the correct

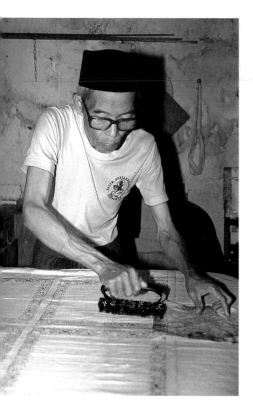

Man applying wax to the surface of a cloth with a metal stamp, *cap*. Yogyakarta, 1990.

A batik stamp, *cap*, used for making the *lar* (eagle wings and tail) designs. Yogyakarta, 1989.

position of the design. The block is then pressed firmly on to the cloth and is released to leave a wax imprint.

The production of *batik cap* is a predominantly male occupation, whereas *batik tulis* is traditionally made by women. Hand-drawn textiles, on account of their uniqueness and high quality, are often regarded as being superior to the block-printed ones; however, the *cap* method is undoubtedly more cost-effective. Furthermore, some batik makers may employ both techniques to decorate the same textile, using stamps for the larger areas and the *canting* for the fine details.

The preparation of batik is a highly skilled, and sometimes unpredictable, undertaking. Javanese batik makers traditionally perform certain rituals to ensure success in waxing and dyeing. For example, during the early twentieth century the women of Pekalongan used to stay up all night burning incense before commencing work on a new textile. Batik cloth itself is attributed with mystical qualities and may be worn as a talisman during rites of passage such as marriage. Some Javanese regularly placate the Goddess of the South Seas, who is regarded as vengeful, with offerings of batik cloth.

91

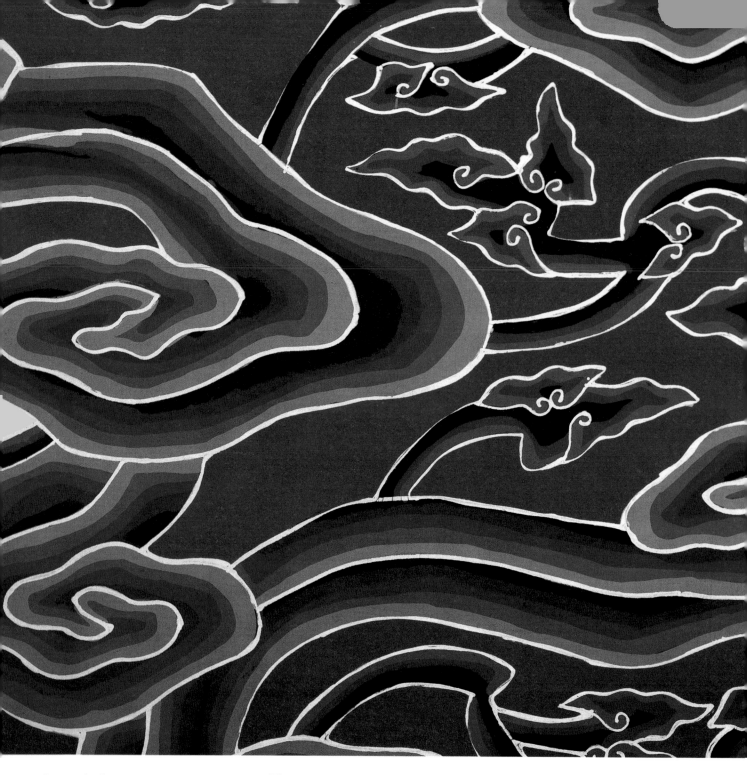

Cotton, *batik tulis* Ceribon-style *kain* decorated with Chinese-inspired cloud designs. Collected by Daina Griva in Yogyakarta, 1989. 240 × 135 cm.

There are three main batik regions in Java – central Java, south-west Java and the north coast. The first of these areas contains the old sultanate capitals of Yogyakarta and Surakarta, both of which are renowned for their cloth. The batiks of Yogyakarta can be distinguished by their strong designs executed in *soga* (chocolate brown) and dark blue against a white background. Traditional batiks are made mainly by specialists living within the old city walls, whereas the centre of modern batik production lies in the south of the capital. In contrast, the dyers of Surakarta are known for their use of *soga* on a pale yellow background, though like Yogyakarta they also make

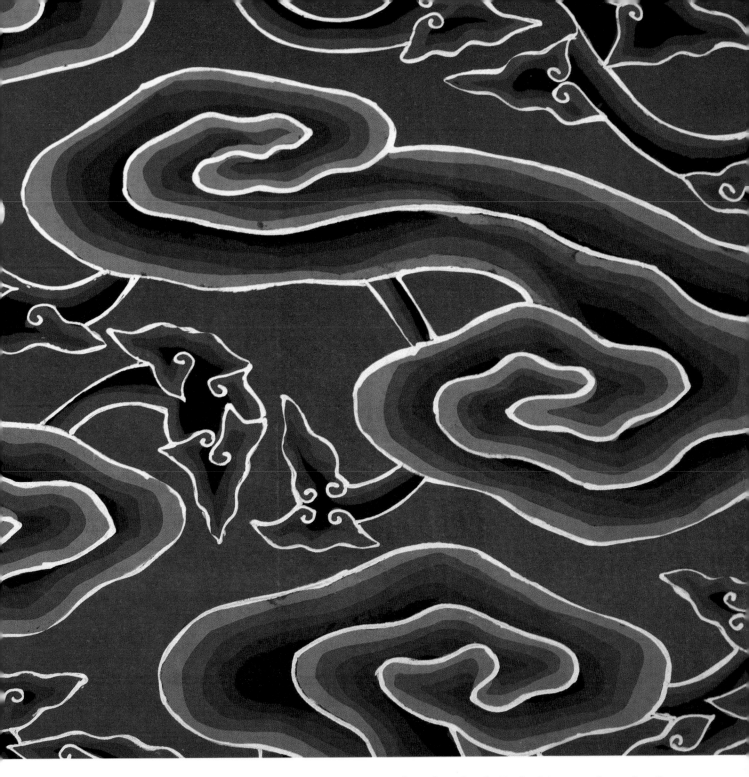

numerous varieties of modern batik. Both cities may have family-run businessess, some of whom employ piece-workers to perform basic tasks in outlying villages. Surakarta, however, is also the home of Batik Keris, a batik company that employs, according to Sylvia Fraser-Lu (1986), approximately 8,000 workers.

As is the case in much of central Java, the batik of the south-west is produced mainly by family-run concerns. Although the fabrics of this region have much in common with those of Surakarta and Yogyakarta, especially with regard to the use of blue and brown, there are significant differences. In Tasikmalaya, for example, batik makers

93

use various reds, greenish-blues and black, whereas in Banyumas russet and golden brown are favoured against a dark blue background. Batiks which resemble those of Tasikmalaya are also made in small factories in Garut and Ciamus.

In contrast with central Java, the batik makers of the north coast have long been exposed to foreign influences. This region, which stretches from Anyer on the Straits of Sunda to Banyuwangi on the eastern coast, has numerous fishing and trading ports. Historically, north coast batik was made not only to satisfy local demand but also for export to the outer Indonesian islands and elsewhere in South-East Asia. The population is more heterogenous than inland Java, and among the batik entrepreneurs are many people of non-Indonesian and mixed ethnic background. Some of the highest-quality north coast batik, dating from the late nineteenth and early twentieth centuries, was designed and made by women of Dutch and Eurasian origins. In addition to drawing on the rich heritage of the island of Java, the northern batik makers have incorporated a number of Chinese, Indian and Arab motifs in their fabrics.

Pekalongan is the foremost centre of north coast batik, and its textile traders are known for their commercial acumen. Traditional Pekalongan fabrics are characterised by floral motifs in pink, yellow and blue; modern designs, however, are often highly innovative and eclectic. Some Pekalongan-style patterns are also produced in Ceribon, another important batik-making city. Historically Ceribon court designs were made in accordance with Muslim prohibitions on idolatry, though heavily disguised depictions of animals appear on Kanoman cloths. Ceribon is famous for its Chinese-style designs, especially its red- and blue-cloud patterns, which have enduring popularity (see p. 162). Chinese-derived bird motifs, resembling those of Ceribon, are also made in the coastal town of Indramayu. Chinese, as well as Pekalongan, influences can be detected in the batiks of Lasem, where many of the small factories are run by people of Chinese descent. Contemporary Lasem cloths often have a multi-hued floral design set against both dark blue and light yellow backgrounds (the latter are frequently rich in decoration). Birds and foliage also feature predominantly in the batik designs of east Javanese centres such as Tuban and Sidoarjo, but in the neighbouring island of Madura these motifs are often highly stylised to comply with Islamic restrictions. Madurese batiks, which may be distinguished by their mushroom and brown hues, are produced mainly in the village of Tanjung Bumi.

Although Java is the pre-eminent centre of Indonesian batik, this craft is known elsewhere in the archipelago. Palembang and Jambi in southern Sumatra produce fine batiks which were originally based on local court styles. More basic varieties are found among the Toraja of Sulawesi, where the resist material is applied to locally woven fabrics

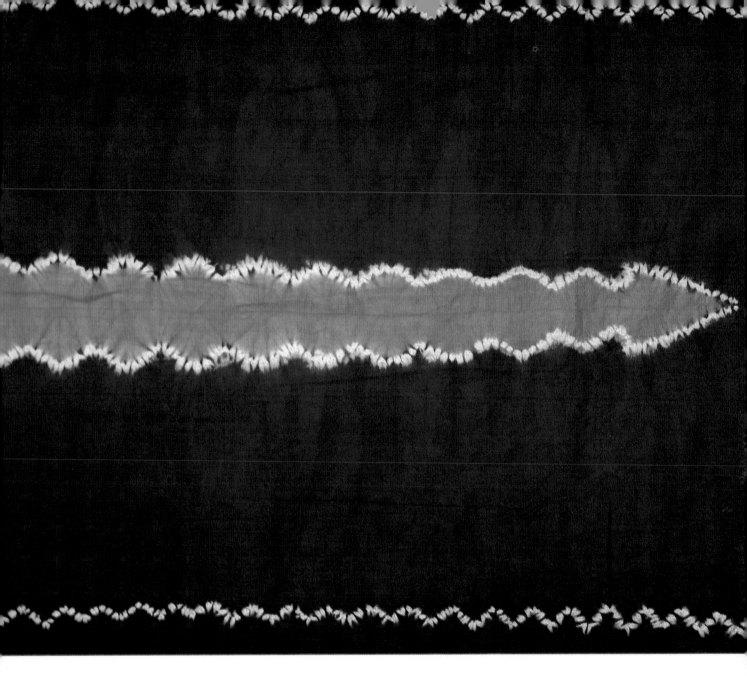

Javanese sash from Yogyakarta decorated with both the *pelangi* and *teritik* techniques. 180 × 33.5 cm. Hull University, CSEAS 1985.5–1.

via a hole in a piece of bamboo. Batik is also made on the island of Penang, both for local consumption and for sale to foreign tourists; and a batik industry based on tourism has been developed in Bali.

Pelangi and teritik

In addition to ikat and batik two other resist methods are found in the Indonesian Archipelago – *pelangi* and *teritik*. The former takes its name from the Indonesian word for 'rainbow', which vividly describes the way in which the bands and waves of colour produced with this technique merge into one another at the edges. *Pelangi* (also written *plangi*) designs are created by gathering up sections of cloth and by binding them tightly so that the ties and folds serve as resists. Bundles of cloth, pebbles or other small items may be bound in to pad out the areas that will be penetrated by the dye. After dyeing, the ties are removed to reveal the patterns and, as is the case with ikat and

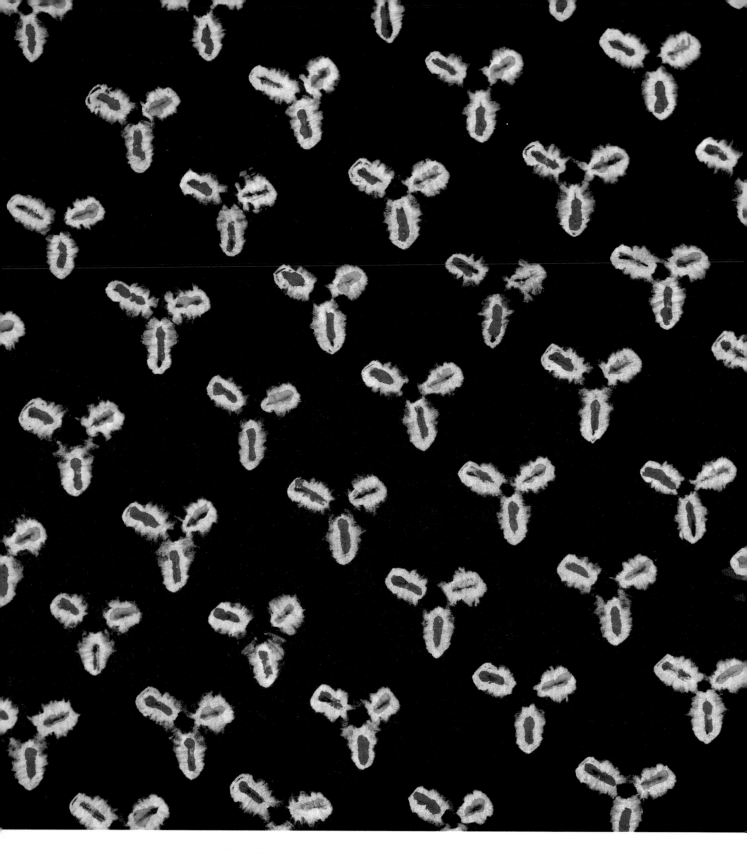

Javanese sash or breast-cloth decorated with the *teritik* method. 202 × 136 cm. Hull University, CSEAS.

batik, the position of the bindings can be altered in preparation for immersions in different dyes.

Pelangi is associated with central Sulawesi where the Toraja use this technique to enliven fabrics with brilliant splashes of colour. Sacred *pelangi* textiles, known as *poritutu coto*, are produced in the Rongkong region in Sulawesi. Decorated with circles and *tumpal* patterns, these

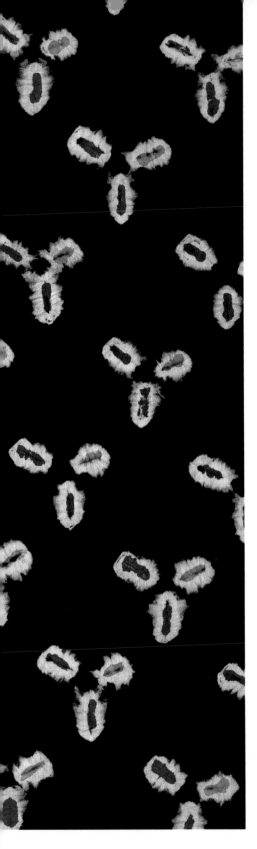

cloths are traditionally hung on poles before the house of a deceased person. Rows of circles created with *pelangi* can also be seen on sashes and shoulder-cloths from central Java, and on head-cloths from eastern Sumbawa. Although the latter are no longer made, old varieties are worn on ceremonial occasions. *Pelangi* cloths are also known in Madura and southern Sumatra.

With the *teritik* (also written *tritik*) method, stitched thread rather than wax or bindings is used to resist the dye. The designs are sewn on to the fabric, and after dyeing the stitches are cut away to reveal the patterns. In Indonesian the term *teritik* means 'to drip continually in small drops' and is therefore etymologically linked with the term batik. The work *teritik* accurately captures one of the applications of this resist method – namely, the use of stitches to make many small dots of colour. Fine lines can also be made with *teritik* and it is particularly useful for outlines.

The *teritik* method is found in central Java, where it is used to decorate the *kemben* (breast-cloth) and the *dodot* (long ceremonial cloth). The breast-cloth, and sometimes the *dodot*, has a lozenge-shaped centre field surrounded by dark-coloured borders. The latter may be covered in delicate *teritik* designs depicting eagle wings, sacred mountains, insects, birds, deer and foliage. More expensive varieties are often embellished with gold leaf. *Teritik* is esteemed in Palembang, Sumatra, where it may be combined with *pelangi* to make women's shoulder-cloths. These textiles, many woven in silk, are dyed with shimmering designs in crimson, pink, violet, green and yellow. The Chams, an isolated Austronesian minority on mainland South-East Asia, make traditional fabrics with *teritik* and *pelangi*. These people are also known for their wax and starch-resist batik cloths.

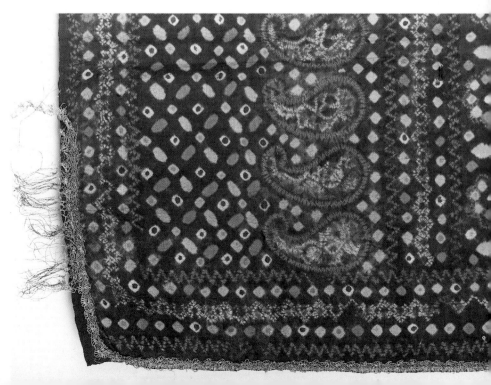

A Palembang *selendang* from south Sumatra decorated with the *pelangi* and *teritik* techniques and bordered with decorative couching. The Paisley-style designs reflect Indian influence. British Museum, AS.1980. A8(6).

5

Decorative Weaving, Embroidery and Related Techniques

Although the Indonesian region is esteemed for its elegant resist-dyed fabrics such as ikat and batik, it possesses many other fascinating fibre traditions. Some of these methods (for example, tapestry and twill) are used while the cloth is being woven, whereas others (for instance, embroidery and couching) are applied to finished textiles. Prestigious fabrics, especially those designed for public display, are often created by combining two or more of these decorative sewing and weaving methods. Precious metals and silk are among the most prized materials, and skilled embroiderers and weavers often work with these expensive materials, sometimes using them to embellish cloths that have already been dyed with resist techniques.

Stripes, bands and checks

Not all the woven and sewn decorative techniques are technically complex, and some of the most effective designs are achieved with relatively simple processes such as striping. In order to make stripes warp ends of different colours are laid out on the loom. The weft is usually one colour, unless bands are desired, and is woven in a plain tabby weave. The finished textile is often warp-faced so that the stripes are clearly visible. On some textiles the multi-hued warp may be the main feature, as is the case in central-east Lombok where cloths with broad, vivid stripes are woven. In other fabrics, however, the stripes are less prominent and may be partly covered with other

Striped cotton cloth, *lurik*, from central Java.
Collected by Prof. M. A. Jaspan, 1966. 356 × 71 cm.
Hull University, CSEAS.

design elements. The weavers of Lampung in Sumatra, for example, cover striped sarongs, known as *tapis*, in couching and embroidery, using mica chips, metallic thread and sequins. Stripes are also included as borders for ikat motifs in north Sumatra, Borneo and on many of the islands of east Nusa Tenggara. If the textile is used as a shoulder-cloth, the stripes will hang vertically, but in a sarong they may appear as horizontal bands. Striped fabrics can be made using a very limited selection of colours. On Sumbawa, for instance, the Donggo highlanders weave fabrics, which are closely associated with their cultural identity, using yarns dyed with only light and dark shades of indigo. Javanese striped textiles, *kain lurik*, were traditionally woven in a limited range of colours; now they may be multi-hued.

Banded fabrics can be made by weaving with a multi-coloured weft. Very often the weft bands are used in conjunction with stripes as borders for other design features, as is the case in north Sumatra, Sumba and Sumbawa. Bands and stripes can also be combined to make checked cloth, which is popular throughout the archipelago, particularly with coastal peoples like the Malays, Buginese, Makasarese and Bajau Laut. Subtle differences in colour and the arrangement of the checks are sometimes said to indicate the island of origin. Pink and mushroom hues are, for example, perceived as being characteristically Buginese by their southern neighbours, the Bimanese. Although a great deal of cheap checked cloth, often woven with synthetic yarns, is produced in Javanese factories, more traditional varieties are also available. Multi-coloured checks are woven by

A Javanese sash, *stagen*, woven in a heavy handspun yarn. Made in the village of Bantul and collected by Prof. M. A. Jaspan from inside the walls of the royal capital of Yogyakarta. 259 × 11.5 cm. Hull University, CSEAS 69.43.

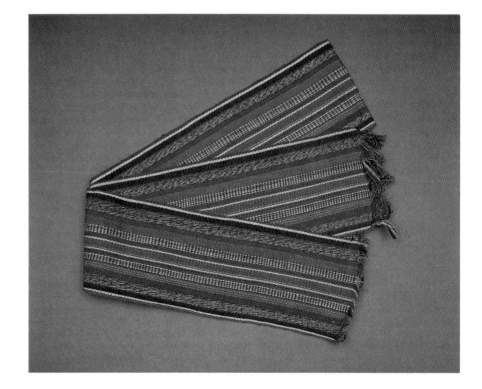

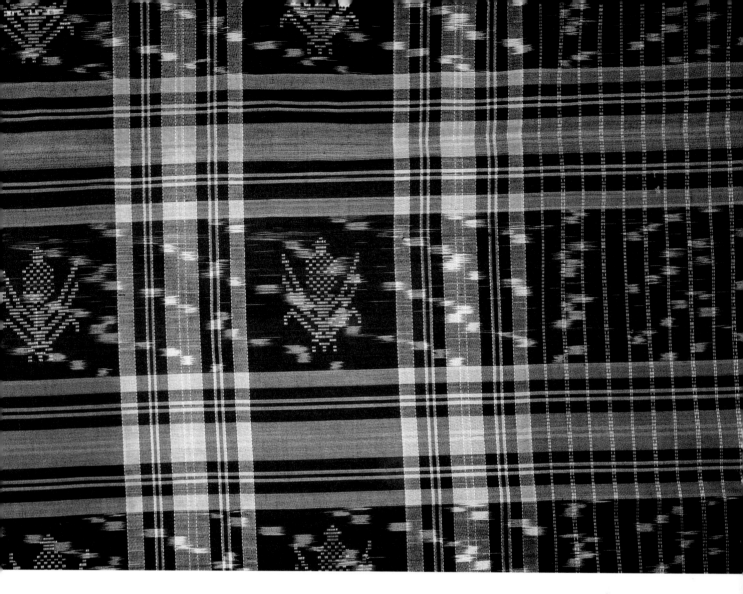

Checked sarong cloth decorated with weft ikat and supplementary weft. Made in Trengganu, Kuala Kenaman, and collected in Johor, now part of Malaysia, 1941. 190 × 105 cm. Hull University, CSEAS.

hand, in both cotton and synthetics, in west Nusa Tenggara, and the city of Ujung Pandang is known for its high-quality silk sarongs. In more remote areas, such as the Wawo hills in Sumbawa, simple checks are made using only undyed and indigo-dyed cotton yarns.

Checked patterns can be quite varied and names may be given to the different parts of the design. Among the Bimanese the bands and stripes are known as *bali*, while the small squares of colour that they enclose are called *lopa*. The finest checks are said to have *lopa* the size of small cubes of gambier (a plant extract used in tanning), blocks of which are pressed into a standard size for sale in local markets. The Bimanese also identify the narrow stripes along the selvage as the *penta* and *nganto*, and refer to the panel worn at the back as the *tinti*. The latter has fewer bands, and the square of colour may differ from those on the rest of the fabric (similar panels can be seen on Malay, Buginese and Javanese checks). The position and balance of the colours can be altered to suit the taste of the customer, and before commencing work the weaver may wind samples of yarn around a strip of lontar-palm leaf. Each section of the strip corresponds to a different part of the proposed check, and by adding and subtracting threads the weaver and the purchaser are able to modify the design.

101

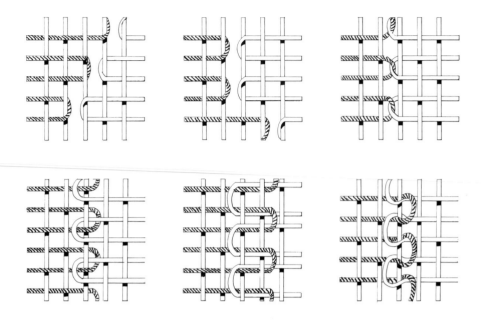

Interlocking and slit tapestry weaves.

Tapestry

Tapestry-woven fabrics, though not as common as checked textiles, are also found in a variety of different locations. With this technique the designs are created by weaving different-coloured weft threads into a plain warp. The weft yarns are said to be discontinuous because they do not traverse the fabric from selvage to selvage, and are usually lifted out between the warp yarns after each shot. On the more basic tapestry weaves the weft can be woven with an ordinary shuttle, but for more complex motifs smaller ones are used. The latter may be made from a range of materials including buffalo horn, palm leaf and cardboard from clove-cigarette packets. The methods fall into the two main categories of slit and interlocking, basic dovetails and diagonals being made with the former and a variety of weaves with the latter. Because the designs are made with the weft, tapestry cloths are frequently weft-faced.

The traditional Atoni warrior's costume in Timor included slit tapestry sashes, and in Sumba waist-cloths decorated with this technique were worn by men going into battle. The Batak of north Sumatra use bands of slit tapestry in some of their brocaded textiles, and among the Iban this kind of weaving is incorporated into the borders of men's jackets. In Seram (Ceram) and Mindanao interlocking weaves may be used to embellish sarongs, and on the latter island these techniques are also employed in making head-cloths. Low-landers on Sumbawa Island use interlocking weaves around the brightly coloured centre fields of fringed textiles which are worn around the waist or, less commonly, over the shoulder. Although the latter fabrics are not directly attributed with talismanic powers, unlike some ritually significant cloths from Sumbawa, they are worn

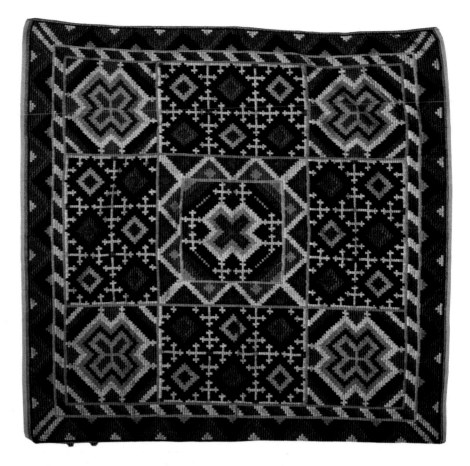

Tausug cotton head-cloth, *pis siyabit*, decorated with tapestry designs. Collected by Gavin Patterson in Zamboanga City, Philippines. 84 × 82 cm. Hull University, CSEAS 1989.1–2.

or displayed on occasions that have generally favourable connotations and are, therefore, associated with good fortune. Tapestry methods are also known in central Timor, Sulawesi, Lombok and among the Kadazan of Sabah.

Tablet weave

Another form of decorative weaving, known as tablet weaving (see Chapter 3), is found in Java and Sulawesi, and may have been used in eastern Sumbawa until the early twentieth century. With this method patterns are made by twining different-coloured warp ends with the aid of bone or tortoiseshell tablets. The warp yarns are fed through holes in each of the corners of the square tablets, which can be rotated to form sheds. Tablet-woven fabrics are characteristically warp-faced and, being narrow, are used for bands and sashes.

Float weave

In addition to the previously described techniques Indonesians make use of float weaves. A yarn is said to 'float' when it passes over two or more threads before it is interwoven. One of the most basic kinds of float weaving is a type of twill in which the weft passes over and under pairs of warp yarns. Each successive shot of weft is staggered leaving zigzag patterns in the ground weave. Different twills, includ-

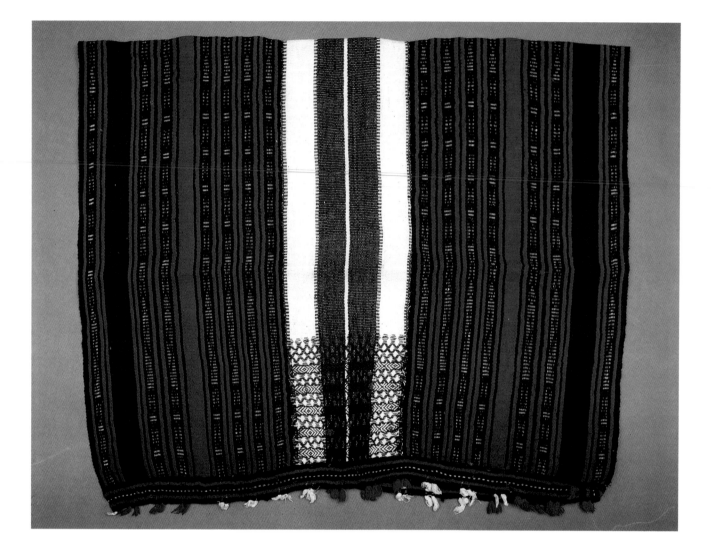

A modern Filipino textile woven in the style of a Bontok death blanket and decorated with supplementary wefts and fringes. Made from recycled yarns, mostly cotton, and woven in a double warp with a warp-faced weave. Known as a *pinagpagon*, this fabric was collected by Geoff Nettleton in Bagio City, 1977. 132 × 76 cm. Hull University, CSEAS 78.16.

ing diamond motifs, can be made by varying the ratio and direction of the floated yarns, and sometimes rods are inserted in the warp to pick out more complex patterns. When the warp and weft are different colours, the design appears as a kind of 'negative' on the reverse side of the cloth. Float weaves are known in Sumatra, the interior of Borneo, Sumbawa and Timor. During the nineteenth century women in Minahassa, in northern Sulawesi, wove striped sarongs decorated with elaborate geometric float designs.

Supplementary weft

Floated yarns are not only used to decorate the ground weave but can also be incorporated as additional threads to make a wide variety of brocaded textiles. Indonesian brocades, though not as internationally well known as the resist-dyed fabrics, are of comparable cultural significance and are held in high esteem in the archipelago. Brocades are produced on many Indonesian islands, one of the most widely distributed types being supplementary weft. In this kind of weaving,

pattern yarns, called supplementary wefts, are inserted into the same sheds as the basic ground weft. Designs can be created by allowing the decorative threads, which are often of a different colour or material from the ground weave, to float over selected warp ends. Supplementary wefts are described as continuous when they are woven across the full width of the cloth; but because the pattern yarns float under the warp between design elements brocaded textiles usually have a front and a back. If, however, the patterns are widely spaced, the floats may droop, and to prevent snagging the yarns may be worked backwards and forwards across each design. Supplementary wefts of the latter kind, which do not go from selvage to selvage, are said to be discontinuous.

Although the textured fabrics made with supplementary weft are technically similar, the means by which they are prepared can be quite varied. It can be virtually impossible to work out how a completed textile was produced, not least because it could have been woven with more than one brocade method. The classification of

Ragidup textile, made of separate panels sewn together, decorated with stripes, supplementary weft, supplementary warp and fringes. Woven in a mixture of heavy cotton and synthetic yarns. Toba Batak, Samosir Island, Sumatra. Collected by Prof. M. A. Jaspan. 248 × 111 cm. Hull University, CSEAS 69.58.

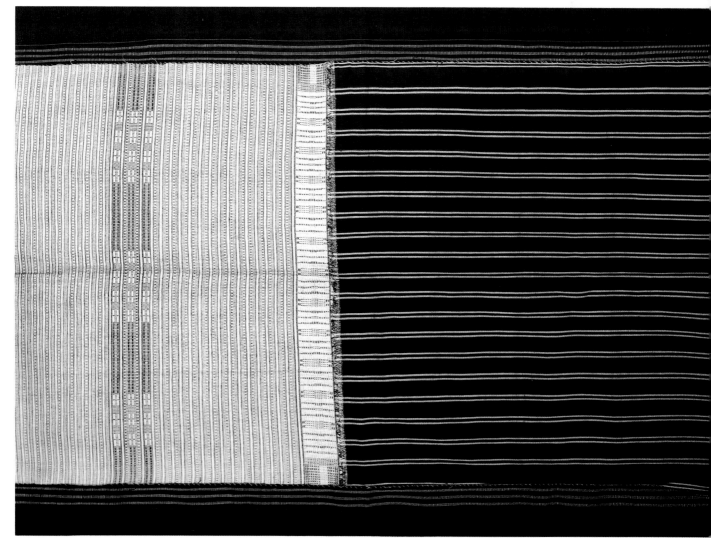

supplementary weft can, therefore, be problematic. One of the most helpful ways of appreciating the different kinds of weft brocade is to refer to the Indonesian language which distinguishes two basic types: *sungkit* and *songket*.

Sungkit

This method is known on a number of Indonesian islands, and though there are some regional differences, the basic principles remain unchanged. The following description of the use of *sungkit* in Bima, Sumbawa, can, therefore, be considered as being reasonably representative. Bimanese women use a body-tension loom with a discontinuous warp to make brocades in either silk and metallic yarns or synthetics. The weaver commences by raising the heddle and entering the sword into the shed. The sword is then turned on its side to enlarge the opening, and the supplementary weft is inserted with a series of small shuttles (Bimanese *sungkit* is usually discontinuous). The pattern wefts are beaten in with the sword which is turned on its side once again in readiness for the shot of the main weft which travels completely across the width of the fabric. After the weft has been beaten in the sword is removed and the sheds are changed, and the process is repeated. Skilled weavers are usually able to judge the extent of each design element by eye, though they also sometimes count along the warp yarns. Generally speaking *sungkit* is employed to make fairly simple motifs; sometimes, however, it is used to make more complex designs that are not repeated, such as the letters of a person's name.

Sungkit shuttles are often smaller than the shuttles used for the ground weave. The Malays, for example, may weave with a fine *sungkit* shuttle which has a spike that can be easily inserted between the warp threads. Among the Iban of Borneo decorative yarns are put in place with bone needles, while the Bimanese use simple shuttles, with a notch at either end, made from palm leaf and cardboard. The latter people also carve delicate *sungkit* shuttles from buffalo horn, which does not snag the warp.

Songket

Like *sungkit* the *songket* method is widely distributed, though there is some regional variation. In one of the commonest kinds of *songket* designs are woven with the aid of serried ranks of pattern heddle rods that are raised in a regular order. The heddle rods are used to lift selected warp yarns and therefore determine the way in which the supplementary yarns float. The following sequence, which is used in Bima, Sumbawa, is fairly typical of the kind of *songket* known in many parts of the archipelago. After lifting the main heddle rod the weaver widens the shed with a sword and lays in a continuous shot of the ground-weave weft. The main weft is beaten in and the sword is

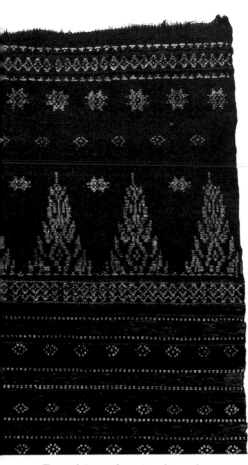

Tumpal (isosceles triangle) and eight-pointed star designs can be seen on this supplementary-weft and weft-ikat textile from the Upper R. Ogar, Sumatra. British Museum, +1918.

removed before the first pattern heddle is raised. The new shed is widened with the sword, as before (sometimes a special pattern sword is used) in readiness for a shot of the supplementary weft. Once the weft has been beaten in, the sword is removed and is reinserted in the shed created by the weight of the shed-stick. The second shot of the main weft is made, followed by the second supplementary weft, and the process is repeated using each of the pattern heddles in turn.

Highly complex designs can be made with rows of pattern heddles,

Songket: 1 ground weave;
2 supplementary weft; 3 heddle;
4 shed-stick; 5 pattern heddle.

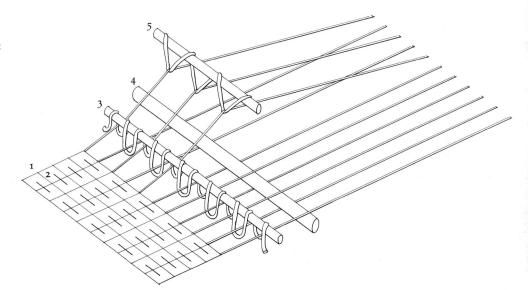

and the importance of using numerous rods is emphasised in an old Bimanese ditty formerly sung by young women to young men on their way to battle: 'Arrows in your shield can be used for heddles, so go forward into battle, I'll hear no excuses.' The process of setting up a loom to weave with many heddles requires both great expertise and patience. In 1982, for example, it took two women ten days to insert over sixty heddle rods in a Bimanese body-tension loom which is now in the Pitt Rivers Museum, Oxford. Either one of the weavers, or both of them, were employed on the task for between eight and ten hours a day. To work out the position of the heddles the women used a series of diagrams on graph paper which they placed beneath the warp.

When using rows of pattern heddles, the designs have to be finalised at the planning stage when the position of the leashes is ascertained. In contrast the *sungkit* method allows far more innovation during the process of weaving, and some craftswomen use this technique in conjunction with *songket*. A complex pattern is sometimes executed with the aid of heddles, while smaller details that are not repeated are added by the *sungkit* method.

In addition to making *songket* designs with rows of heddle rods weavers may use a related technique involving bundles of leashes, which is known in north-east Malaysia. Designs are made by count-

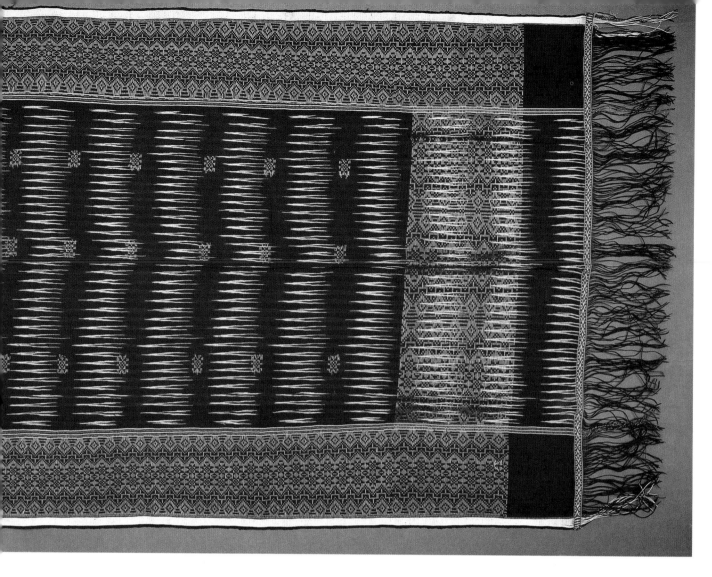

Batak shoulder-cloth, *ulos*, from north Sumatra. Decorated with metallic supplementary wefts, warp ikat, twining and fringes. Collected by David Eunice. 170 × 68 cm. Hull University, CSEAS 1986.1–3.

ing along the warp thread and by picking out the elements with a thin bamboo stick. Each section is lifted with a weaver's sword and fine cord is passed under selected warp yarns. The leashes are drawn together and are tied in bundles, known as *ikat butang*, which are either joined together with a cord or are left to rest on the warp. Before the supplementary weft is inserted, the appropriate row of bundles is raised and a sword is entered to widen the shed. An especially complex design, according to Sylvia Fraser-Lu (1988), may have between 100 and 150 rows of *ikat butang*.

Kain songket is widely regarded as the traditional fabric of the Malays, and the sarongs woven by this widely distributed people share many distinct features. There is usually a centre field, *kepala*, decorated with stars or botanical designs, which is flanked by two rows of bamboo seedling, *tumpal*, motifs. The decorated strips bordering the centre field are known as *papan*, while the remainder of the sarong is referred to as the *badan*. Today weavers of *songket* on the Malay peninsula are largely confined to the east coast states of Trengganu, Kelantan and Pahang. Malay *songket* is also woven in Mukah and Kuching in Sarawak and in Brunei Darussalam.

Songket textiles are woven in the Riau Archipelago, and in neighbouring Sumatra several groups weave with this technique, includ-

ing the Acehnese and Minangkabau. Some of the finest exponents of this craft are the weavers of Palembang in the south of the island. The coastal Malays of Kalimantan are known for their *songket* textiles, as are non-Malay peoples such as the Buginese and Makasarese of Sulawesi and the Sasaks of Lombok. The Balinese also use this method, which is associated with the old royal town of Klungkung. *Kain songket* may be woven on a shaft loom, as is the case on the Malay peninsula and north Borneo, or on a body-tension loom with a discontinuous warp, as in Sumbawa. The Bajau of Sabah use an especially broad body-tension loom to weave their supplementary-weft textiles.

Kain songket is often woven in expensive silk and precious metal yarns and was traditionally worn by the highest-ranking members of society. *Songket* fabrics are also associated with court-based societies, particularly those of maritime South-East Asia. Today cheaper versions of these textiles are made in many regions in a wide range of colourful synthetic threads.

Several other related varieties of supplementary weft are known in insular South-East Asia. The Yakan of the southern Philippines, for example, decorate fabrics with the aid of numerous bamboo rods which are inserted between the shed-stick and the warp-beam. According to Sylvia Fraser-Lu (1988), up to 200 rods may be utilised in a single design. The weaver raises each pattern stick in the correct order during the process of weaving, using her sword to widen the sheds. Every shot of supplementary weft is secured with a pick of the ground weave, and after use each pattern is pushed away from the weaver towards the warp-beam. On completion of half the design the bamboo rods are reused in reverse order to form a mirror image of the design. In the second stage each pattern rod is pulled towards the weaver after use.

By using the mirror-image principle weavers can make repeat patterns with limited numbers of rods. There is, for example, a loom from Borneo in Liverpool Museum which is set up to weave a repeated diamond pattern with only five rods. Iban looms from Borneo, equipped with even fewer pattern rods, can be seen in the collections of the Horniman Museum, London, and the Royal Museum of Scotland, Edinburgh. Sometimes two pattern rods are combined with a pair of heddles to brocade patterns, as is the case in eastern Sumbawa. In the latter arrangement the pattern heddle is situated between the main heddles and the shed-stick, while the pattern rods are inserted between the warp-beam and shed-stick. There is also an Ilanun loom from Borneo in the Cambridge University Museum of Archaeology and Anthropology which is furnished with a single pattern heddle, though unlike the Sumbawa looms it is not equipped with pattern rods.

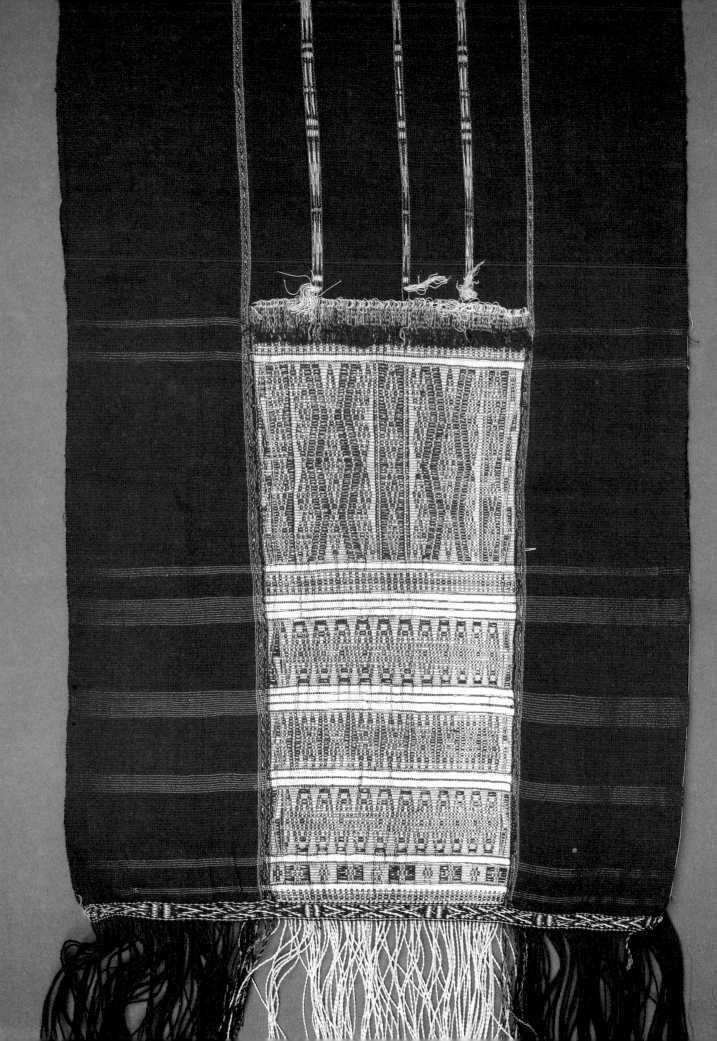

Batak textile, *ragidup*, woven with a cotton supplementary warp and a metallic supplementary weft. Made from separate panels sewn together, the fabric also has twined borders and fringes. A modern version of one of the most sacred Batak textiles whose name can be translated as 'pattern of life'. Collected by David Eunice in Sumatra. 216 × 33.5 cm. Hull University, CSEAS 1986.1–2.

The supplementary-weft method is widely distributed in insular South-East Asia. Aside from the *songket* textiles previously described, Sumatra is renowned for its ship cloths that were traditionally made in the Lampung region. These textiles were decorated with 'ship of the dead' motifs and two basic varieties were woven – the *pelapai* and the *tampan*. The former, which were made in the Kroë area, were the preserve of artistocrats and were displayed during rites of passage, whereas the latter were more common and were used in a variety of ceremonial gift exchanges. The Batak, another Sumatran group, use supplementary weft to make detailed designs on fabrics known as *ragidup*. Supplementary weft is also found in various locations in eastern Indonesia including central Timor, Seram, Sangir and Talaud, and Ternate and Tidor. The Toraja of Sulawesi weave blankets decorated with supplementary-weft designs showing horses, butterflies, humans, traditional houses and zigzags. These fabrics are particularly popular with tourists. Filipino peoples such as the Kankanay, Kalinga and Yakan use supplementary weft, as do the Tinguian (Isneg) who embellish blankets with rows of equine and anthropomorphic motifs.

Supplementary warp

The supplementary-warp method is another form of float weaving that is known in insular South-East Asia. Some of the finest examples of fabrics decorated with this technique are found in eastern Indonesia, particularly on the island of Sumba. Special textiles, known as *lau pahudu*, that were traditionally prepared by the noblewomen of east Sumba, are woven on body-tension looms using a continuous warp. The thick cotton supplementary warps are placed on top of the ground-weave warps made from finer yarns. The weaver places a

Handwoven cotton textile from Sumba decorated with supplementary-warp patterns showing rows of stars, ancestor figures and skull trees (in the past the heads of vanquished enemies were displayed in trees). British Museum, AS.1980. A8(7).

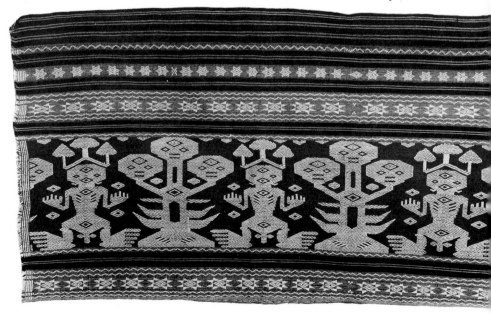

template under the yarns and inserts numerous rods into the warp to mark out the design. The pattern sticks are used in succession to select warp yarns which are raised with a weaver's sword to facilitate the passage of the shuttle. The weft conceals sections of the supplementary warp which float between the design elements on the reverse side of the fabric. Using light-coloured supplementary yarns on a darker background, the women of east Sumba make elaborate textiles emblazoned with animal, geometric and anthropomorphic patterns. The weavers of northern Luzon in the Philippines also use rows of rods to pick out supplementary-warp designs, which are executed in white on black. Supplementary warp is also known in Timor, Ternate and Tidor, and among the Maranao of the southern Philippines.

The supplementary-warp method is also associated with Bali where it was traditionally used to decorate long banners. Known as *lamak*, these banners are suspended from long poles or are hung from shrines during festivals such as the Balinese New Year, *Galungan*. The majority of banners are made from plaited strips of palm leaf and are, therefore, perishable; more permanent examples woven in cotton are seen more rarely. Cotton banners are commonly made with thick white supplementary warps set against a dark blue background woven in finer yarns. These fabrics often have wide vertical borders, filled with triangular and lozenge shapes, which flank a centre field decorated with diamond patterns. The bottom edge of the textile usually has a row of bamboo seedling, *tumpal*, designs. At the top there may be an hourglass motif, below which appears the stylised figure of a woman represented by the triangular shape of her skirt. The figure is thought to depict Dewi Sri, the rice goddess.

Twining and drawn threadwork

Twining is another widely distributed textile technique and is known in Timor, Sumba and Sumatra (among the Batak). In this process a set of weft yarns, which are often multi-hued, are twisted around one another in the same plain. This method is commonly used to bind loose warp ends after weaving to prevent fraying.

Decorative methods such as supplementary warp and weft and twining involve the addition of yarn. There are, however, Indonesian textiles, thought to come from Bali, that appear to have been made according to entirely different principles – namely the removal of threads from a completed textile. These cloths have gaps and gauze-like areas which were probably created by cutting and drawing selected warp and weft yarns from the woven fabric. Great care would, presumably, have been taken so as not to weaken the fabric by the removal of too much material.

Textiles can also be lengthened by interlacing extra warp yarns into the ends of the main warp. This method is used by the Batak of

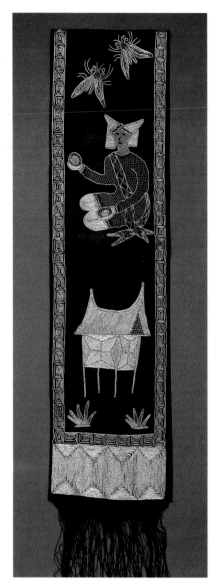

Sumatra to make some of their distinctive *ulos* fabrics (textiles decorated with ikat and supplementary weft used in traditional gift exchanges).

Couching

In addition to the previously described techniques there are a variety of patterning methods which are applied to cloth after weaving and dyeing. These forms of decoration are often combined with the methods discussed earlier to make especially elaborate textiles. Couching is one of the most important of these finishing techniques. It has the advantage of facilitating the use of elements that are either too heavy or stiff to be woven into the fabric.

Some of the best-known couched fabrics come from Lampung in southern Sumatra, where a range of finishing methods are used to embellish women's sarongs known as *tapis*. Metallic yarns are laid on to the surface of the textile and are sewn at intervals with a plain thread using a couching stitch. Shiny materials such as sequins and pieces of mica may also be tacked on to these fabrics resulting in a dazzling appearance. Couched yarns are used to make a variety of curved and geometric forms, as well as 'ship of the dead' motifs. However, several types of *tapis* exit, not all of which are decorated with couching methods. Textiles decorated with couched yarns are also esteemed on the Malay peninsula, particularly in Perak where gold thread is used.

Couching methods are known elsewhere in the Indonesian

Above Minangkabau woman's *selendang* of silk backed with cotton and decorated with couching and embroidery. Collected by Prof. M. A. Jaspan in Sumatra. 148 × 19 cm with a 22-cm tassel. Hull University, CSEAS 73.49.

Right Jacket made of striped handwoven fabric lined with plain cotton. The front panels are decorated with couching, embroidery containing mica flecks and shell beadwork. 19th century, Useora Duea, Sumatra. British Museum, +1917.

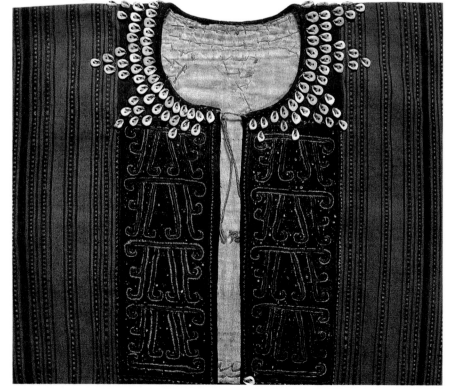

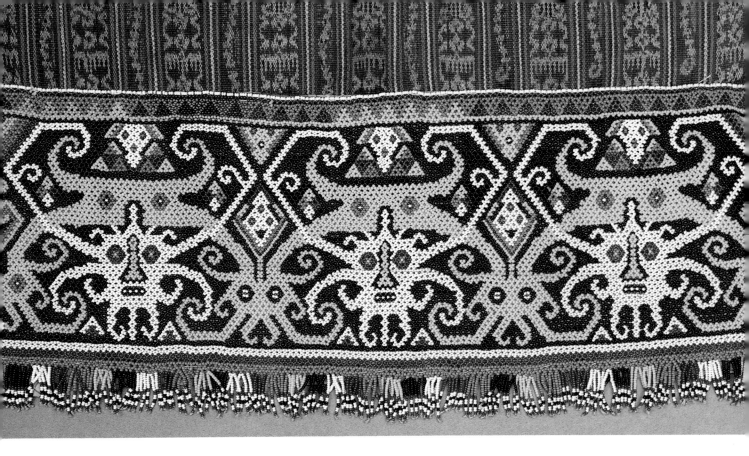

Beaded panel showing stylised human faces on the base of a warp-ikat cotton jacket. The beadwork may be Kayan or Kenyah, though the garment is probably Iban. Collected by Prof. M. A. Jaspan in the upper Rejang region of northern Borneo, 1966. 154 × 70.5 cm. Hull University, CSEAS.

Archipelago, particularly in Nias, coastal Borneo and Sumbawa. In these regions prized metallic yarns and ribbon may be tacked on to cloth in parallel rows to make high-status garments. Various items, including metal discs and feathers, are also sewn on to cloth by peoples living in the interior of Borneo.

Beadwork

Beadwork is often used to decorate textiles. Imported multi-coloured glass beads have long been popular, and these are sometimes combined with pierced cowrie shells. The Kauer of Sumatra decorate jackets with rows of shells, while in Lampung this material was used with beads to make a rare fabric known as a *tampan maju*. According to tradition the latter textile was placed near the bride's seat during the wedding ceremony and is thought to have been used in the gift exchanges that preceded marriage. The Angkola Batak are another Sumatran group who incorporate beads in their fabrics.

In eastern Indonesia beadwork features in textile decoration on the island of Flores and among the Toraja of Sulawesi. On Sumba human and animal-like figures are made by stitching beads and shells on to cloth.

Among the Maloh of west Kalimantan beadwork human figures, which are thought to represent slaves, were traditionally the preserve of aristocrats. These designs are made by stringing beads on open net bindings before sewing them on to a cloth foundation. Jackets stitched with shells showing stylised dragons and curvilinear tendrils and hooks are also worn by the Maloh. Other peoples in Borneo who are known for their beadwork include the Kayan, Kenyah and Iban.

Various Filipino groups sew beadwork and other decorative elements on to cloth. The Mandaya use glass beads, as do the Bagobo who combine them with pieces of shell. Shell ornaments are also suspended from Kalinga garments, while Igorot jackets may be embellished with numerous brass hangings. The Bila'an, who are known for their embroidery, attach coins and small brass bells to their textiles. The loincloths of Gaddang men are traditionally decorated with a beaded flap.

Appliqué

Many of the peoples who are familiar with couching also make use of *appliqué*. The latter method involves the addition of an accessory fabric, which is secured by sewing, on to the main textile. Strips of trade cloth, for example, are often used in *appliqué* along with beadwork by Bornean groups like the Maloh, Kayan and Iban. On Sumba the more attractive sections of old textiles may be recycled by sewing them on to new cloths, whereas in Sumbawa an assortment of

Cotton batik table-runner decorated with a synthetic *appliqué* centre panel and couched sequins. Collected by Prof. M. A. Jaspan in Yogyakarta. 133 × 34.5 cm. Hull University, CSEAS 74.89.

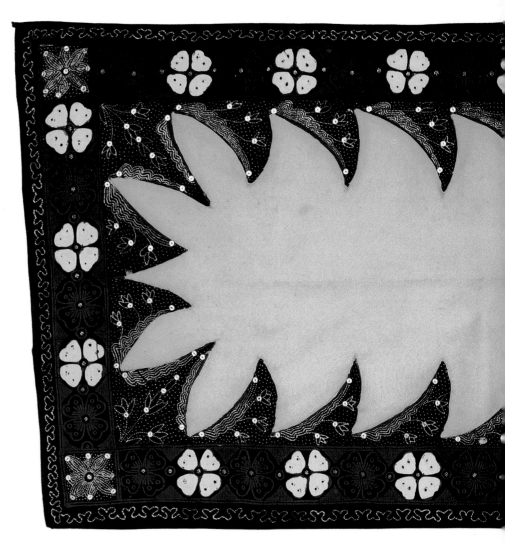

materials are employed in *appliqué*, velvet in particular being favoured.

Some of the batik designs currently produced in Java are thought to emulate the patchwork garments that were worn by priests until the early twentieth century. Mattiebelle Gittinger (1979) has suggested that although the patchwork may have been an outward expression of vows of poverty it is possible that the small pieces of cloth were endowed with magical connotations. This is certainly the case with a

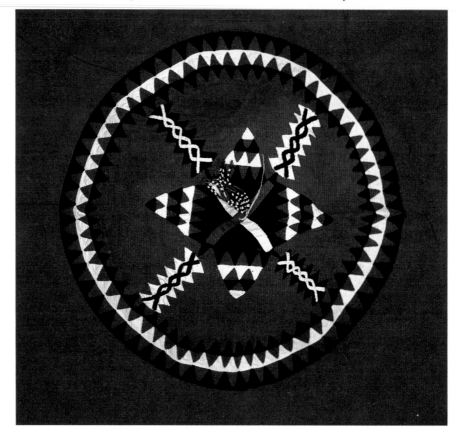

Cloth decorated with *appliqué* and a beaded tassel, and designed to be worn over a woman's conical straw hat. Philippines. 67 × 66 cm. Philla Davis Collection, Hull University, CSEAS PDT25.

patchwork jacket, said to have descended from heaven, which is venerated by the Sultan of Yogyakarta. Sacred fabrics decorated with *appliqué* are found elsewhere in the archipelago, especially note-worthy being the shoulder-cloths that were traditionally worn by royalty on the island of Nias.

Appliqué is also known in the Sulu Islands, where it is used in wedding banners, and among the Bukidnon of the Philippines who decorate garments, especially head-cloths, with this technique. Brightly coloured strips of cloth are sewn on to fabrics, along with small clusters of shells, on the island of Tanimbar in eastern Indonesia. Among the Kauer of Sumatra *appliqué* is combined with couching and embroidery.

Another technique, which resembles embroidery though is not strictly a textile method, is traditionally associated with the Toraja of

Sulawesi. It involves applying rectangles of painted barkcloth on to black blouses that are reserved for ceremonial occasions. Beadwork and *appliqué* designs are now often used in place of painted barkcloth.

Embroidery

Embroidery, one of the most versatile methods, is often used along with *appliqué* and couching, as well as a wide range of other textile techniques. Decorative needlework is esteemed in Sumatra, especially in Lampung, where a variety of richly embroidered textiles are produced. Along the west coast the Kauer, in particular, are known for their use of cross-stitch and their scrolled and geometric designs, studded with small mirrors. Embroidery is also found in the north of Sumatra, where cross-stitch, star eyelets and chain-stitch are used.

Decorative embroidery is popular in Borneo where it is known among the Iban, Kayan and Sakarang. In Sarawak Malay head-cloths are made from fine muslin and silk embroidered with gold ribbons

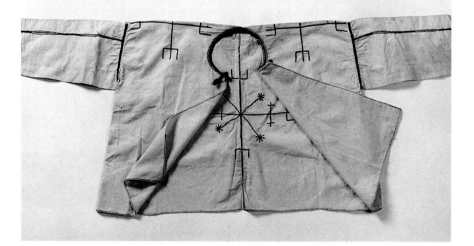

Jacket made of white cotton cloth decorated with red and blue embroidery. Yagaw Ksannóo, Kindoro culture, Philippines. British Museum, 1958. AS6.17.

using flat needles. Similar methods are employed in Sumbawa to apply fine metallic yarns to head garments and the fabrics which are wrapped around kris hilts during festivals. Long, straight stitches running parallel to the weft, known as pattern darning, can also be seen on textiles from Sumbawa. On a finished cloth the latter technique can be difficult to distinguish from supplementary weft. The Buginese and Makasarese make use of embroidery, as do other groups in Sulawesi, such as the Toraja. Bali adds to its wide repertoire of textile methods the knowledge of decorative needlework. A distinctive variety of embroidery, in which the ends of yarns are allowed to hang in tufts, is also found on the island of Sumba.

In the Philippines, where the traditional man's shirt is often embroidered, many groups use ornamental needlework. The Manobo, Bukidnon and Mandaya, for example, embroider textiles,

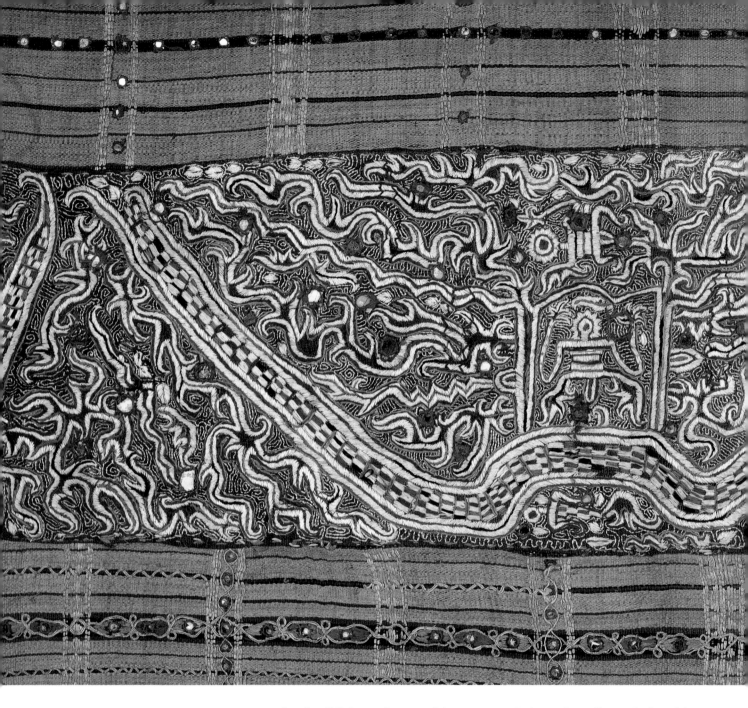

Warp-striped woman's *tapis*, decorated with couching, embroidery and flecks of mica. The ship bearing a human figure not only symbolises the journey to the afterlife but may also serve as a general symbol of transition. Fabrics decorated with ships are used during various rites of passage in Sumatra. Lampung, south Sumatra. British Museum, +1914.

as do the Bila'an who combine cross-stitch and outline-stitch with other applied methods. The Bagobo decorate the cuffs of trousers with embroidery and use stitching in conjunction with beadwork and couching. Textiles edged with chain-stitch and striped designs overlaid with embroidery are also made by the Kalinga.

Polishing

A textile decorated with metallic yarns, using techniques such as supplementary weft and embroidery, may also be given a glossy surface by rubbing it with a shell. Until the mid-twentieth century Bimanese noblewomen would treat a high-quality fabric with tamarind before ironing it with a cowrie. The cloth was laid on a table and pressure was applied with a bamboo pole inserted into the back of the shell and wedged beneath the ceiling. Not only did the use of

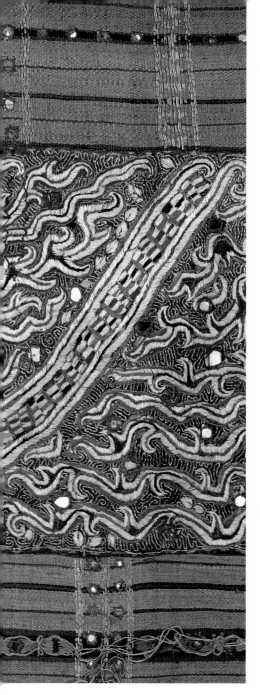

tamarind make the textile more lustrous but it was thought to help ward off moths. Similar methods have been noted among the Makasarese by Mattiebelle Gittinger (1979).

Gilding and painting

Gold is attributed with health-giving properties by many South-East Asian peoples, as well as being esteemed on account of its financial value. This prized material is added to fabrics in a variety of ways, in addition to being used as yarn. Glue in the form of the pattern may be placed on a cloth, then gold leaf, gold dust or gold paint is applied to the surface. The Balinese decorate coloured fabrics, known as *perada* (also written *prada*), with gold botanical patterns and borders containing geometric designs and swastikas. These textiles cannot be cleaned and, if handled without care, may deteriorate rapidly. Gold is also sometimes used to highlight Javanese batiks. On the Malay peninsula dark-coloured textiles are stamped with wooden blocks covered with gum; gold-leaf patterns cut from the same blocks are then added.

In addition to applying gold to textiles the Balinese are skilled exponents of the art of painting cloth. This is an old tradition and

Balinese festival garment decorated with gold *perada* patterns.
201 × 172 cm.
Hull University, CSEAS.

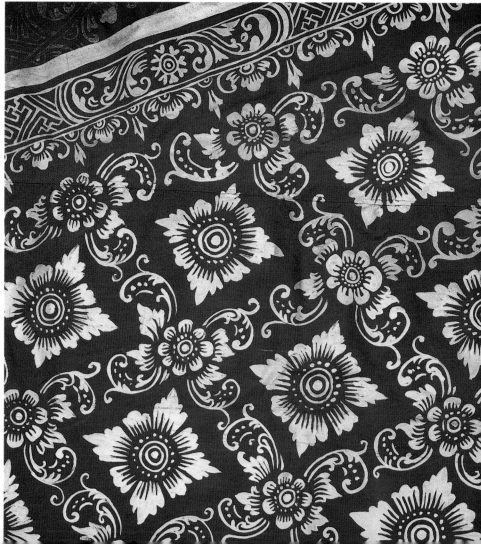

Painted cloths are traditionally used to illustrate Hindu Javanese/Balinese epics. Borders separate the different scenes, which are unwound as the narrative progresses. These fabrics were originally woven on body-tension looms, thereby limiting the width of the cloth. Bali. British Museum, 1950. AS+2.

much of the subject-matter derives from old Javanese literature, which drew its inspiration from Hindu India. The majority of surviving cloths date from the nineteenth and twentieth centuries, earlier examples having deteriorated in Bali's tropical climate. Although this art declined after the Dutch defeated the last Balinese princes in 1908, it was revived during the 1930s. In Bali painting is man's work, whereas weaving is woman's, and these paintings relate closely to the performing arts, especially the shadow theatre.

According to Geoffrey Marrison (1990) the Balinese traditionally painted on cloth imported from the neighbouring island of Nusa Penida, though they sometimes worked with barkcloth from Sulawesi. Before use the cotton cloth was sized with rice starch, flattened with a spatula, and polished with a cowrie shell. The image was sketched with charcoal and then defined with a pen made from either the rib of the sugar-palm or a sharpened bamboo. Colours were applied as flat infill by apprentices using bamboo brushes that were crushed at one end. The final details were added in black by the master, and the finished design was rubbed again with a cowrie.

The colours used by the Balinese were black, made from soot or Chinese ink blocks; white, from pig bone and mixed with chalk, glue and water; yellow and ochre, from crushed sea rocks obtained to the south of Denpasar; red, the best being Chinese vermilion powder;

green, a mixture of yellow and blue; and brown, a mixture of red and black. The best paint medium was fish glue from China; however, cheaper carpenter's glue could also be used, though it resulted in dark and cloudy hues. Gold leaf was reserved for the most expensive painting.

Several standard shapes of painted cloth are known, some of the most important being the *langse*, which were used as curtains at the sides of beds in noble houses. What is interesting about the latter textiles, as has been noted by Dr Marrison, is that they have similar dimensions (67 × 200 cm) to the relief panels on the temple of Borobudur in Java. This size corresponds roughly with many modern textiles woven on body-tension looms with a continuous warp. It is possible that the cloth painters of ninth-century Java were also responsible for temple designs, and it is not uncommon for craftsmen to work in more than one medium. Did they also use textiles as templates?

Although not especially common, painted fabrics are found elsewhere in the Indonesian Archipelago. The Toraja, for example, include paintings of the water buffalo, an esteemed domestic animal, on their textiles. In Borneo the Kayan paint tendril designs on barkcloth jackets, while in the south-east of the island twined bast-fibre garments may be decorated with paintwork.

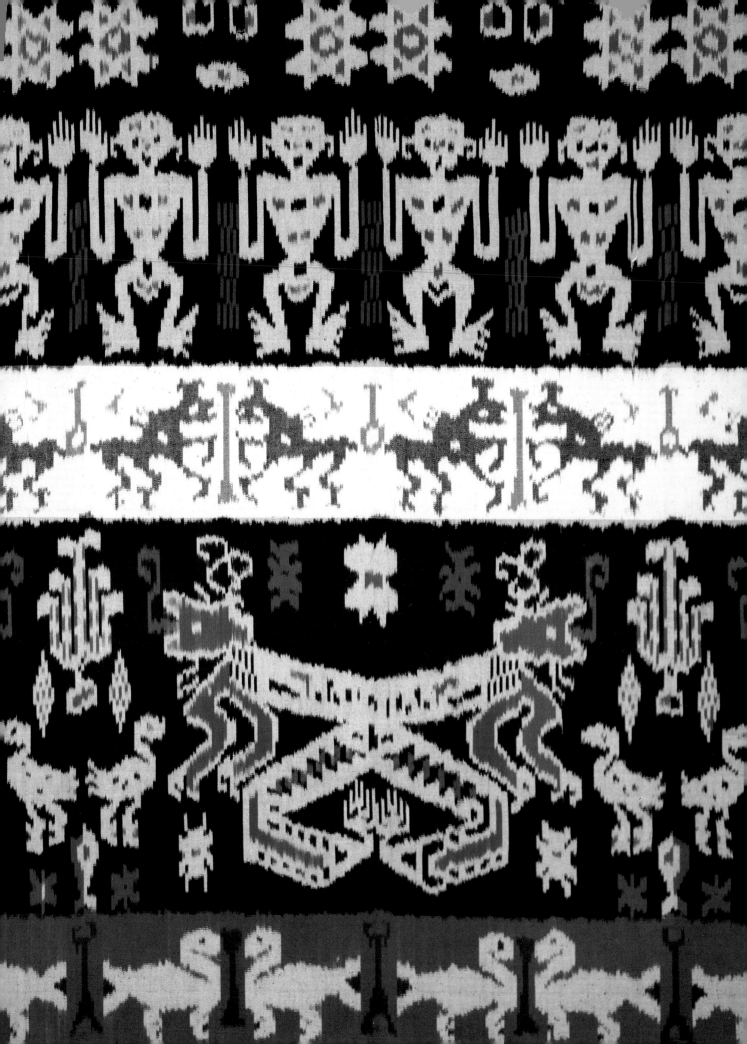

6

Textiles in Society

High-status man's mantle, *hinggi,* from Sumba, decorated with warp ikat and woven in heavy cotton. The designs include roosters, stars, frontally displayed human figures and Chinese-inspired dragons. 244 × 120 cm. Hull University, CSEAS.

The peoples of the Indonesian Archipelago are divided into numerous ethnic groups, each with its own distinctive language, customs and habits. In spite of this diversity, however, underlying themes can be identified, particularly with regard to the social significance of cloth. Textiles are usually identified with women, and weaving and dyeing are predominantly female tasks. In many Indonesian societies textiles, as symbols of womanhood, are exchanged in the festivals that precede marriage. Cloth is also widely attributed protective qualities, and sacred fabrics may be displayed during rituals which mark moments of transition when the individual is thought to be especially vulnerable to misfortune. Peoples who do not traditionally produce textiles often obtain them through trade for use in life-cycle festivities. Although a great deal of cloth is manufactured for purely commercial reasons, certain textiles are still valued on account of their symbolic and ritual associations.

Anthropological research in the archipelago reveals a fairly consistent division of labour with regard to handicrafts, commonly with no hierarchical implications: men and women's crafts are complementary rather than competitive. Although there are regional variations in the way tasks are divided, some crafts, such as the manufacture of cloth, are nearly always the preserve of one gender. The most usual division is that between metalworking by men and the manufacture of textiles by women. Men also tend to undertake such tasks as boat- and house-building, while women practise basketry and pottery. Many of the tasks connected with preparing fabrics (like harvesting cotton and dyeing) are also controlled by women, and the income derived usually belongs to them.

123

Some Indonesians explain this division of labour by recourse to folk models. In west Lombok, as has been noted by Andrew Duff-Cooper (1985), it is said that women's tasks are those most closely associated with the home. Similar notions are encountered in eastern Sumbawa, where it is held that women stay close to the household, making textiles and preparing food, whereas men go out of the village to work in the fields. According to another Bimanese aphorism, men perform heavier tasks (for example, blacksmithing and carpentry) and women lighter ones (for example, weaving and basketry). In one analogue

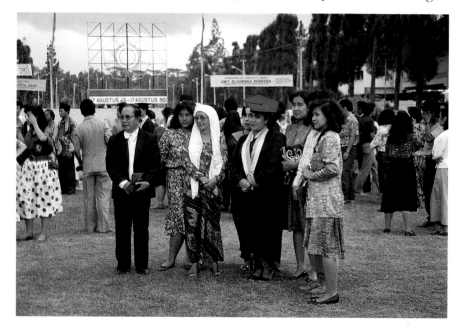

The traditional batik *kain* is worn by graduates along with academic dress at Gajah Mada University. Yogyakarta, 1990.

the sexual division of labour is likened to male and female methods of portage: a man traditionally uses a pole over his shoulder and can transport more than a woman, who usually carries goods on her head. Occasionally the division of labour is represented in the textiles themselves, and Ruth Barnes (1989) has recorded designs in Lamalera depicting the preparation of ikat as a female occupation and the harpooning of rays as a male occupation.

Generally speaking Indonesian folk models regarding the sexual division of labour reflect social realities, though the occasions on which customary practices are not adhered to are worth mentioning. In eastern Sumbawa such is the demand for labour during peak periods in the agricultural cycle, especially at planting and harvest time, that women leave the household and work in the ricefields; in certain circumstances economic considerations may override cultural preferences. Furthermore, some folk models, despite their wide applicability, do not apply to all Indonesian societies. Women do not invariably perform lighter tasks, and among some peoples, particularly non-Muslim ones, they may be involved in heavy work. This is especially true of Hindu Bali, where women dig ditches and carry

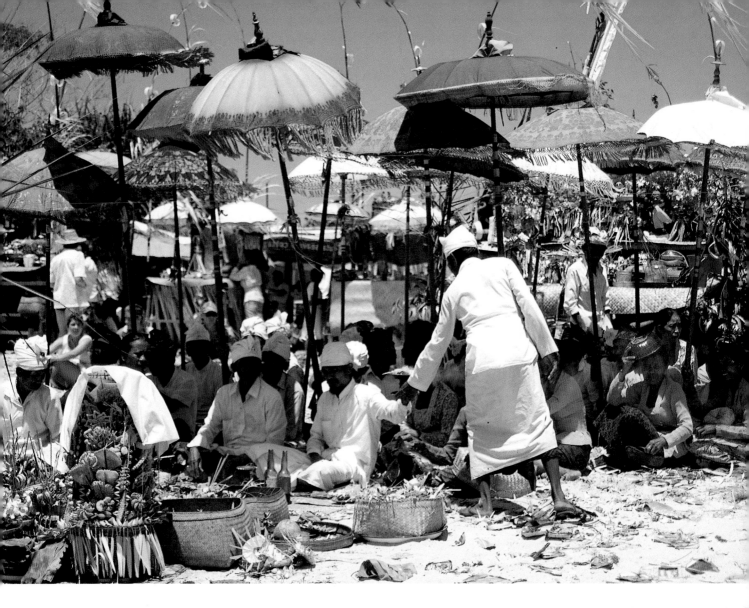

Above Wearing white clothes to symbolise their purity, these Balinese men recite prayers and make offerings. The ashes of the deceased are thrown to the wind, signifying the purification of the material body. Kuta Beach, 1989.

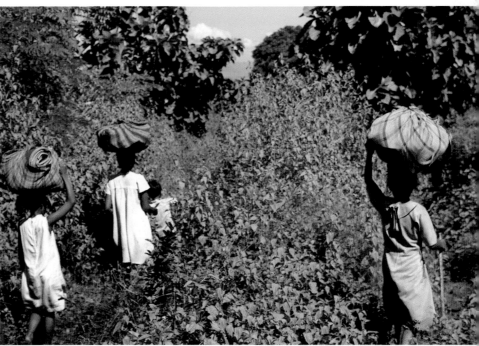

Right Highland women going to market in lowland Bima use sarongs to carry the produce they intend to sell. Sumbawa, 1980.

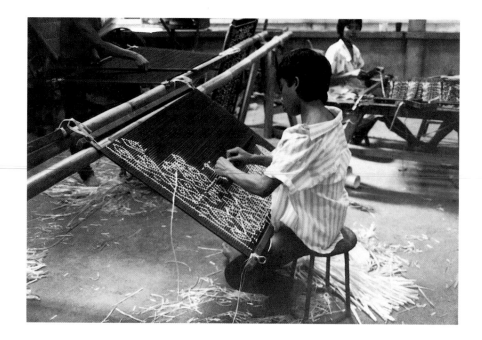

Boy preparing weft-ikat designs by binding the yarns with resist material. Gianyar, Bali, 1989.

bricks on building sites. It is significant, however, that even the Balinese associate women with textiles.

As well as being a feature of many folk models, the sexual division of labour is a common theme in Indonesian mythology. As has been recorded by Sandra Niessen (1985), for example, the Toba Batak possess a legend known as the myth of Tunggal Panaluan, in which male-female opposition is perceived in terms of weaving (women's work) and writing/magic (men's work). In this myth male and female twins are born already equipped with the tools of their respective professions – the boy with sacred texts and the girl with weaving implements. Later in life when their parents try to set them tasks that girls and boys do together the twins steadfastly refuse: the boy wishes to devote himself solely to the magical arts, while the girl wants only to weave. The link between women and the preparation of textiles is referred to in other Batak legends, like the tale of the girl who was turned into an ape for refusing to spin yarn. Yet in another Batak legend, which describes how a young woman was exiled to the moon because she was more interested in spinning than marrying, the converse occurs: this myth emphasises moderation when dealing with potent female symbols such as textiles.

Although weaving is a female occupation, the involvement of males in the production of cloth is also worth considering. Javanese men participate in the batik industry and are responsible for dyeing fabrics and preparing *batik cap* (see Chapter 4). In south Bali men are employed in small factories where boys tie ikat resists, alongside young women, and men are responsible for immersing the yarn in vats of dye. Male Indonesians have been known to make cotton thread, as was the case during the Japanese occupation of 1942–5,

when Bimanese men took up spinning in order to satisfy the invader's wartime needs. These examples, however, do not negate the proposition that Indonesian textiles are culturally associated with women, since they represent instances where traditional practices have been affected by external forces, including industrialisation.

In addition men make a major contribution to the production of cloth within a traditional context. Since they are responsible for wood-working, they produce much of the equipment used by the women, such as gins, spindles, spinning-wheels, swifts and looms. A craftswoman, therefore, may be dependent upon her father, husband or even son for part of her livelihood. Among some Indonesian peoples the process of weaving is seen as an expression of the interdependence of men and women, sometimes with sexual connotations. Thus the Batak liken the bamboo shuttle to the penis, as do the Makasarese and Buginese who traditionally believed that if a man held this weaving implement he would be rendered impotent. There is also a Javanese myth which tells of a weaver who drops her shuttle and promises to marry whoever retrieves it. When the shuttle is brought back by a dog, she is honour-bound to marry the animal. While the shuttle may be associated with the male, both the cloth and the yarn from which it is made are usually considered as female. Among the Toraja, for example, the words for weaving and vulva are etymologically linked, and textiles are traditionally likened to the female sexual organs.

Not only do men make weaving implements, they may also be involved in aspects of textile design, a practice which has a long history. As indicated by the *Waŋbaŋ Wideya*, a sixteenth-century Javanese-Balinese manuscript translated by Stuart Robson (1971), it was not unknown for men to draw the outlines of embroidery patterns in the old Indonesian courts. Bali has a long tradition of painting cloth, and it seems that some of the embroidered religious and mythological scenes produced on that island were originally sketched by men. Men also design the modern batiks in Yogyakarta that are primarily regarded as paintings: the completed drawings are then usually waxed by women before they are dyed.

As well as the occasions on which the preparation of cloth involves male skills, there are circumstances in which men make cloth by adopting female roles. Among the Bimanese, men who weave high-quality textiles are known to wear sarongs tied in the traditional female manner. Bimanese men who live as women may also be called upon to organise life-cycle festivals, and they often provide entertainment during wedding receptions, both occasions at which textiles are prominently displayed. Similar customs are found among the Buginese of southern Sulawesi who, historically, had longstanding links with the peoples of Sumbawa Island.

Male and female tasks are complementary, and therefore the

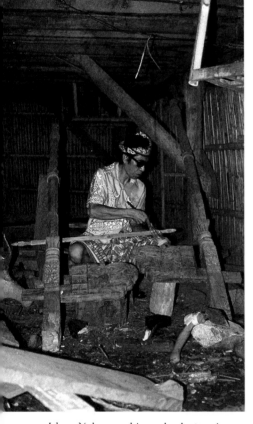

Idrus Yahya making a body-tension loom for the Pitt Rivers Museum, Oxford, using the space below the raised floor of his house as a workshop. Paruga, Bima, 1981.

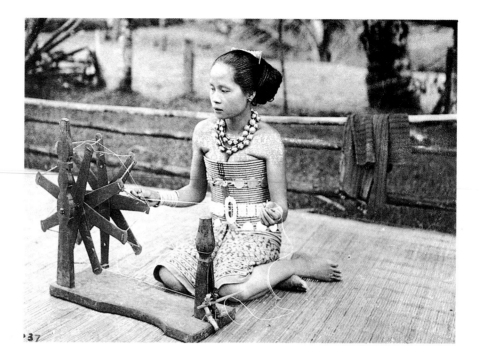

Iban woman with a spinning-wheel, photographed in Sarawak during the course of research for *The Pagan Tribes of Borneo* (C. Hose and W. McDougall, 1912). Royal Anthropological Institute.

possession of textile skills enhances a woman's eligibility as a wife. Upon mastering the art of weaving a woman is traditionally judged to be ready for marriage, and looms and spinning-wheels are widely associated with the rituals of courtship. Traditionally women in many Indonesian societies were expected to demonstrate their skills to potential husbands, as was the case in Java where women worked in front of their homes. In especially staunch Muslim communities, however, it was deemed unseemly for a girl to work alone in full public view, and she would have been expected to advertise her weaving prowess by attaching noise-makers to her loom. Amongst the Bimanese there are tales of suitors reciting poems beneath the windows where young women worked, the level of rattling emitting from the loom serving as a barometer of affection. Rattling looms that may have romantic associations are also known in the Philippines, and in the Cambridge University Museum of Archaeology and Anthropology there is a model of a Buginese loom with a clapper built into the warp-beam. The sound made by clappers and rattles not only indicated that the weaver was hard at work but was thought to help ward off evil spirits.

Model of a Buginese loom collected by W. W. Skeat. H. Ling Roth (1918) linked the sounding warp-beam on this loom to similar devices from elsewhere in Sulawesi and Java. The frame may have been constructed for display purposes since it is essentially a body-tension loom, though it is incomplete. Cambridge University Museum of Archaeology and Anthropology.

Because the crafts are traditionally practised at all social levels the sexual division of labour cuts right through the Indonesian class system. Highly skilled craftswomen were sought after as wives and sometimes married men belonging to higher social ranks – good weavers were often upwardly mobile. Some of the finest craftswomen were of noble lineage, and high-quality fabrics were widely

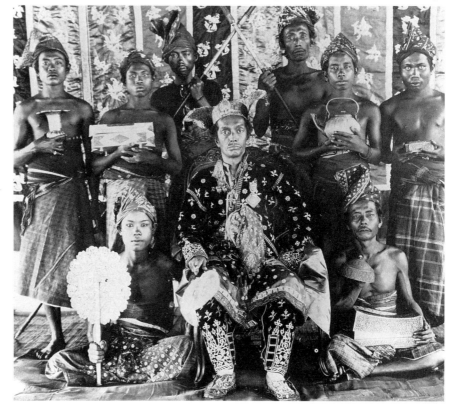

Prestige symbols dominate this photograph of the Sultan of Semawa (western Sumbawa) taken by Johannes Elbert, the German naturalist, in the early 20th century. The Sultan sits in front of a large textile surrounded by retainers bearing his ritual betel-chewing set. His silk clothes are decorated with couching, supplementary weft and embroidery, and the kris in his belt is concealed with a richly patterned fabric. The retainers wear tapestry-woven sashes and shiny polished sarongs. Museum für Völkerkunde, Frankfurt am Main.

produced under the auspices of royal women until well into the twentieth century. Skilled craftswork boosted the prestige of sultans and princes, and the finest artisans were encouraged, under royal patronage, to settle around palaces. Although the old ruling families, with some noteworthy exceptions, are no longer politically predominant, many people of royal descent continue to take an interest in these arts. Prestige crafts are still made in the ancient capitals of Yogyakarta and Surakarta in Java, where traditional batiks are made for the various court dancers, musicians and retainers.

While textile schools have been established in order to promote regional traditions, many weavers and dyers still learn through practical experience. A five- or six-year-old girl may begin by learning the basic tasks by imitating her mother or grandmother, gradually extending her repertoire of textile skills. In Lembata girls may commence spinning cotton as early as four years of age. The Bimanese expect a girl to be competent in the basic patterning skills by her early teens. While some of the best weavers are in their twenties and

129

thirties, women with young families may lack the opportunity to develop their skills, and the greatest experts are usually older women.

During the twentieth century many craft industries declined not only because of competition from imported wares but also as a result of industrialisation within South-East Asia. Skilled people, attracted by higher wages, have been lost to the new concerns, and in some cases locally produced factory wares have replaced handmade products. This is especially the case with checked cloth manufactured in Java, which has replaced handwoven plaids in many areas. However, some domestic industries have survived – even flourished – by exploiting regional markets that are not so easily penetrated by factory-based competition. Textiles remain important symbols of ethnic affiliation, and there is often strong local demand for distinctive regional fabrics woven by small-scale producers. Furthermore, the flexible domestic weaver, with comparatively low overheads, is well adapted to custom-made markets where contact between the maker and consumer is required. Personalised textiles are still popular, particularly on the islands of Nusa Tenggara. These fabrics often bear the name of either the purchaser or the person to whom the textile will be later given as a gift. Ritual cloths, which may bear specific esoteric designs, are frequently prepared with close collaboration between the craftswoman and the customer.

Government administrators and businessmen who spend their working lives dressed in lightweight suits are also keen buyers of handmade fabrics. In addition to wearing comfortable sarongs when relaxing at home they usually don traditional garments in order to celebrate important festivals. Professional men and women are sometimes experienced collectors and may acquire textiles for aesthetic reasons. For some of these people, particularly those who have left their homelands for life in one of the big cities, handwoven textiles may represent a link with the past.

Tourists have also long been important purchasers of traditional cloth. Regional textiles were snapped up as souvenirs by early twentieth-century travellers in the Dutch East Indies, and by the 1930s batiks were being worn as fashion accessories by the Hollywood stars and other celebrities who made Balinese resorts famous. During the post-colonial era tourists emerged as significant purchasers of traditional fabrics both for use as beachwear and as

Batik 'painting' (*batik tulis*) on cotton cloth showing scenes from rural life, designed to appeal to both domestic and foreign tourists. Yogyakarta, 1990.
91 × 73.5 cm.

Farmers from the Wawo highlands wearing homespun and factory-made sarongs with modern shirts and trousers. Teta, Bima, 1981.

mementoes to take home. Many makers of prestige cloths around the world royal centres, which have become important tourist destinations, have survived by catering to foreign visitors.

Craft workers are not confined to the old royal centres but are found in many rural regions. Most agricultural villages possess a variety of craft skills, though there does tend to be some specialisation as certain areas become closely associated with particular products. It is not unusual to encounter a village where many of the inhabitants are engaged in making cloth, and then to come across a settlement which is known for baskets or pottery. Place-names may reflect such long-established practices. Sometimes there is even specialisation within a craft, as in the case of eastern Sumbawa where the highland weavers of Wawo take their yarn to be dyed with indigo in neighbouring lowland villages. Rural villages may also perform specialist services for urban centres, and in Yogyakarta the first waxings for batik are often undertaken in outlying areas.

While textile workers in urban areas are usually employed on a full-time basis, many of their rural counterparts can be regarded as semi-professionals. Although weaving and dyeing may provide important sources of income, rural women have the opportunity to make cloth often only during lulls in the agricultural cycle. Much rural production centres on the household rather than in purpose-built weaving sheds, and consequently overheads are low. The body-tension loom, which has remained popular in the outlying

areas, is well adapted to domestic modes of production: it can be brought into operation very swiftly and can be rolled up easily and stored when not in use.

There are whole regions where people do not produce cloth at all and therefore obtain it by trade from their neighbours. On Lembata Island, for example, the villagers of Lamalera are not farmers and depend on fishing and whaling for much of their livelihood. Lamalera women exchange part of the catch for agricultural produce grown inland. According to Ruth Barnes (1989), they also spend much of their time preparing textiles and supply most of the cloth needed in the west of the island.

Textiles are traded by local people in many parts of the archipelago. The weaver or dyer may be the person who sells the goods, but often it is a trader who is known to the craftswoman and may be related. Peddlars may take goods from door to door (and occasionally around government offices), and it is not uncommon to see traders laden with textiles walking between villages or going to the local market. In a traditional context fixed prices are not attached to these goods and bargaining is common, this being a rapid but easy-going affair since most local people have a shrewd idea of the rough value of the textiles. Whole families (and to some extent, as in south Bali, complete villages) may become involved in textile trading.

The most valued textiles are often stored, along with other prized items, in a trunk in a secure part of the home. Cloths are easy to pack and may be folded around other valuables such as ceremonial daggers and jewellery. The textile wrapped around an heirloom kris remains a symbol of both prosperity and the complementary character of men and women. The economic value of cloth has long been appreciated among mobile populations, especially those dependent on seafaring or shifting cultivation. Textiles are readily portable and may be exchanged for other goods or converted into cash during difficult times. Inexpensive fabrics may also be given as wrappings to transport other goods such as food, baskets and firewood, and in the northern Philippines a man's loincloth can serve as a rope to lead away newly acquired livestock.

As trade goods Indonesian textiles were historically much in demand in regions where the art of weaving was not practised. In Irian Jaya, for example, the Mejprat people devised a complex method for classifying imported cloths, on which a whole system of exchange was based. Social obligations, general payments and fines could be discharged with cloth, and a man's status became closely connected with the number of textiles he had both at home and in circulation. There were even cloth brokers who displayed their wares, arranged loans and provided receipts; but the system got out of control, and in 1954 the Dutch colonial authorities attempted to bring the system of cloth exchanges to an end.

Black-and-white-checked cloth, representing the balance between conflicting forces in overall harmony, is draped over shrines and is used to clothe temple guardians in Bali. Ubud, 1989.

So close has been the association between textiles and wealth that in some Indonesian societies cloth came to represent money. Basic striped and checked fabrics were circulated as currency on the island of Buton and had limited distribution in neighbouring Sulawesi. The noblemen who issued these textiles and backed them financially each had their own distinctive colours and stripes. Originally only the high-born were permitted to make and distribute the cloths, but over the course of time lesser officials began to issue their own cloth money. According to Mattiebelle Gittinger (1979) the use of these textiles, which was first noted in the seventeenth century, continued until well into the twentieth. Payment by means of cloth is known elsewhere in the archipelago, and in the northern Philippines textile exchanges are still included in the transfer of certain kinds of property.

Textiles are not only estemed on account of their financial worth but are widely attributed with magical and protective powers. This is especially the case with the double-ikat *geringsing* cloths of Bali (see Chapter 4), which are made with the aid of special purifying rituals. *Geringsing* textiles are decorated with semicircular designs that are believed to keep illness at bay, and traditionally the sick are wrapped in these cloths. The Balinese display double ikats during ceremonies, place them on pillows for tooth-filing rituals, and include them among the cloths used to cover the dead. Statues of Hindu deities and guardians may be draped with black-and-white-checked textiles known as *poleng* to ward off evil, while white banners are suspended over sacred areas of temples.

Protective cloths are known among the Toraja of Sulawesi, who place them over the bier of the deceased. Their traditional priests also

wear cloths imbued with talismanic properties, and textiles are included in the offerings made to the old Torajan deities to ensure health, fertility and sufficient rainfall. Among the sacred textiles used by the Toraja are imported *patola* cloths and copies of these, locally made batik and *pelangi* fabrics.

The Sasak people of north Lombok ascribe health-preserving qualities to certain striped textiles which are presented during rites of passage. Weavers commence work on these cloths on auspicious days, and offerings are made both prior to and during the process of weaving. Other peoples who value the protective properties of cloth include the Yakan of Basilon, who wore shirts decorated with Arabic writing for defence against bullets, and the Javanese, who traditionally placate the Goddess of the South Seas with offerings covered in textiles.

The propitious qualities of cloth are appreciated by house-builders, who attach fabrics to house posts during the process of construction. In many eastern islands these cloths are said to represent sails,

Balinese checked cloth purchased by Lewis Hill in Denpasar, 1975. 293.5 × 60 cm. Hull University, CSEAS 75.22.

Girl guides wearing batiks decorated with traditional *kawung* patterns. Yogyakarta, 1990.

nautical imagery being often associated with houses among people whose way of life is closely linked with the sea. Sometimes yarn, as opposed to cloth, is used in the context of house-building. The Wawo highlanders of Sumbawa, for example, pour water from a pot containing white cotton yarn into the post-holes during a ritual held before the erection of a new building.

Textiles attributed positive connotations are widely used during festivals that mark each stage of a person's transition through life. Rites of passage such as birth, coming of age, marriage and death often involve the preparation, presentation and display of sacred textiles. The public affirmation of a person's promotion to a higher rank may also involve the use of elaborate cloths. During the liminal stages that separate different social positions a human being is held to be especially vulnerable, hence the use of textiles with protective powers. On such occasions special foods, including coconut cakes and glutinous rice, may be eaten; and in the case of Muslims there may also be a reading from the Koran.

Among some peoples rituals that include the use of textiles are held before the commencement of the life cycle. A Batak woman, for example, is traditionally presented with a 'soul cloth' during the seventh month of her pregnancy. The protective power of these textiles, which extends to the woman's children, is said to derive from the life force of the lineage. The seventh month of a pregnancy is also significant in Java, where the husband cuts a thread tied around the mother-to-be so that the baby can emerge. A shuttle symbolising the baby is traditionally dropped from inside the sarong and is caught by the mother-in-law. The Tinguian of Luzon are another group who possess pre-birth rituals involving textiles. During these ceremonies the shaman customarily wears a warp-striped blanket which is laid on the floor towards the end of the festival. The blanket is then covered with gifts to show the spirits that all the correct formalities have been observed.

Birth is the occasion on which sacred textiles are brought out in many Indonesian societies. The Iban lay a newborn child on a special fabric, as do the Bimanese who use a white cloth that symbolises goodness and purity. The Sasak of Lombok present textiles which are saved for the newborn's future life-cycle festivals (Sasak midwives traditionally receive part of their payment in cloth), and Batak grandparents customarily provide cloths that are credited with talismanic properties. In some Timorese regions women used to be secluded in their homes for a month or more after giving birth. At the end of this period a woman would wear the trappings of a head-hunter, including a male shoulder-blanket, during her coming-out ceremony.

Fabrics frequently appear at festivals held later in childhood and are associated with coming of age. In north Lombok, as Sven Cederroth (1983) notes, textiles are washed before they are placed in a

19th-century Bimanese royal sarong decorated with *tumpal*, star, deer and house designs. Silk, cotton and gold supplementary weft.

sacred pavilion where the boys' hair-cutting ritual is performed. On nearby Hindu Bali cloths embellished with gold leaf, *kain perada*, are used during tooth-filing rituals. Among Muslim peoples, particularly the Malays, the circumcision bench and the bed which is used afterwards may be covered with special textiles.

In addition to coming-of-age festivals textiles feature prominently in the customs associated with courtship and marriage. Until the early twentieth century such was the importance of weaving among peoples like the Sundanese and Sasak that young women were expected to prepare certain cloths before they could get married. According to Batak tradition, the potential success of a union could be gauged from the amount of cloth that had been woven. Should a suitor enter a village and find that the girl he had come to visit was weaving a textile which she had only just begun, then a marriage would be unsuitable; if, however, the fabric was nearly finished, then the converse would be true.

Textiles are widely used in the gift exchanges that precede marriage, and only when all the requirements have been met does the wedding take place. Loosely woven fabrics, to which magical qualities are attributed, traditionally serve as the medium of exchange in Sulawesi, whereas in Sangir distinctive red cloths are used. The latter are carried in a procession to the house of the bride-to-be by the senior relatives of the groom. Red cloths are also known on Roti, where they are wrapped around the ceremonial offerings used during the wedding negotiations. In Kupang in Timor a man may send a letter of engagement in a folded textile.

Ruth Barnes (1989) discusses the customs in Lamalera where tusks, cloth and bracelets are given as gifts. The woman's family set a date by which the bride-to-be should receive gifts from members of her own clan and clans of a similar status, and everyone who attends the next gathering brings some cloth or thread which will remain for her own use. Women take the bride to the man's clan house, where gifts and refreshments are exchanged. The rituals are completed when men from the husband's clan pay a return visit bearing tusks, cooked food and palm wine, and on this occasion the bearer of the tusk receives the gift of a man's shirt and sarong from the bride's clan.

While marriages are usually arranged between families, this procedure occasionally breaks down, and a young couple may elope before the traditional prestations have been completed. Young Indonesians elope for a variety of reasons ranging from the inability of one family to adhere to the customary rules regarding gift exchanges to unrestrained ardour. One solution to the problem of unfulfilled gift exchanges has been noted in Lampung by Mattiebelle Gittinger (1976): the normal processes were reversed and the suitor would leave a special 'elopement textile' in his lover's home, a gesture that would aid the couple's later readmission into society.

Right The daughter of Massir Q. Abdullah with younger sisters acting as handmaidens in front of an heirloom textile during a pre-marriage ritual. Pané, Bima. 1981.

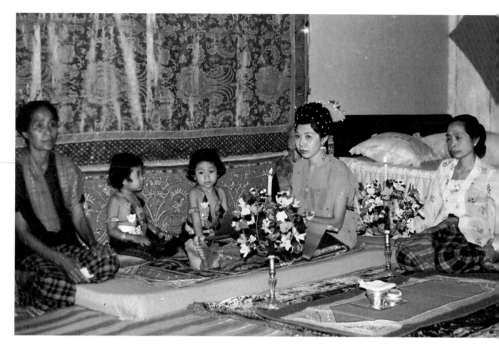

Below In Bima the groom's wedding costume is based on court dress. The bright colours of the outfit symbolise health and prosperity. Bpk Abbas, a silversmith who also works as a tailor, is shown here demonstrating a costume. Naé, Bima, 1981.

Textiles are prominently displayed during wedding celebrations in many Indonesian regions. On these occasions it is common, particularly among Malay peoples, for the newly-weds to dress as a prince and princess and receive their guests while standing or sitting on a raised platform, behind which cherished heirloom textiles are often hung. It was traditional in Lampung in south Sumatra to place a bamboo structure representing the tree of life near the marriage platform. The 'tree' would be hung with baskets, mats and textiles which, according to Gittinger (1979), would be plundered by boys at the close of the ceremony. The marriage bed may also be covered with cloth and festooned with textile hangings. According to T'boli custom, the bride is covered with blankets which are removed by the groom's kinswomen. Relatives are allowed to keep the textiles but are obliged to give a gift of equivalent value in return. The Ifugao traditionally perform marriages under a sacred textile, and among the Yakan the groom is expected to give the bride his mantle during the course of the ceremony. It is the custom for Batak couples to receive the gift of a textile from the bride's father; a prestige cloth may also be wrapped around the groom's mother by the bride's family to symbolise the union of the lineages.

Fine textiles are frequently worn or displayed when celebrating the attainment of a higher position. In Lampung, for example, a ship cloth used to be carried by two women at the head of a procession marking the investiture of a new sultan. In south Sumatra a ship cloth known as a *pelapai* would be hung up when a man obtained a higher rank, whereas on Nias cloths embellished with gold yarn were traditionally worn on this occasion. Distinctive tie-dyed head-cloths

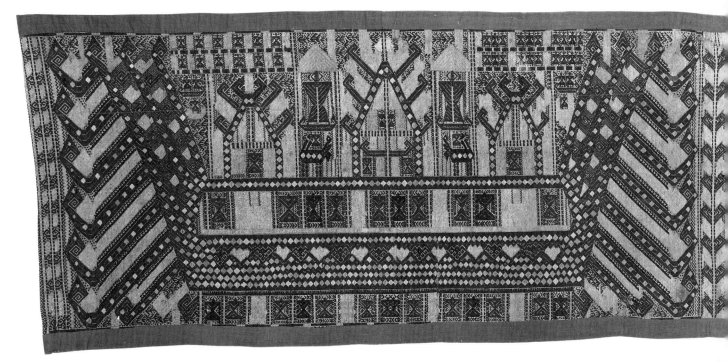

Supplementary weft ceremonial textile, *pelapai*, decorated with a large ship, house forms, banners and hooked patterns. Lampung, Sumatra. 343 × 80 cm. National Museums of Scotland, 1976.284.

In the past the taking of heads was considered necessary to restore cosmic order. This reconstruction of a skull tree bound with an ikat textile was photographed by Edward Parker in Sumba, 1990.

were worn in the past by Bagobo and Mandaya warriors, and among the latter group acclaimed head-hunters were entitled to a special red and brown shirt. After sponsoring a ritual feast, involving the slaughter of livestock, an Ibaloy man is permitted to wear a red head-cloth, while his wife may adopt a many-layered skirt.

Not only are textiles used to indicate changes in social status but they may be exhibited in a variety of other public contexts. Isneg elders, for example, sit flanked by special cloths during ceremonies, and among the Kalinga hosts would place blankets in front of their guests when drawing up a peace pact. When wishing to take up residence in another town, a Kalinga man traditionally displays a blanket in a public place and announces his intentions. The Iban may delineate a sacred area by hanging *pua* cloths to form an awning. Iban women also wear shoulder- and *pua* cloths during festivals; in the past the latter were used to receive the severed heads brought back amid great ceremony by war parties. The taking of heads was considered to be necessary to restore cosmic order and ensure fertility. The women's roles of childbearing and preparation of textiles were seen as analogous to the men's creative roles in head-hunting; according to W. Howell (1912), certain stages in the production of yarn were known as the 'warpath of women'.

One of the most important public occasions in which a textile is displayed is during a funeral. Cloth is used in a variety of ways to commemorate the dead, and many South-East Asian peoples prepare special burial shrouds. The Ifugao, for example, make ikat-patterned loincloths for the deceased, while the Kankanay make loosely woven blue burial jackets decorated with human figures in ikat. On Roti a

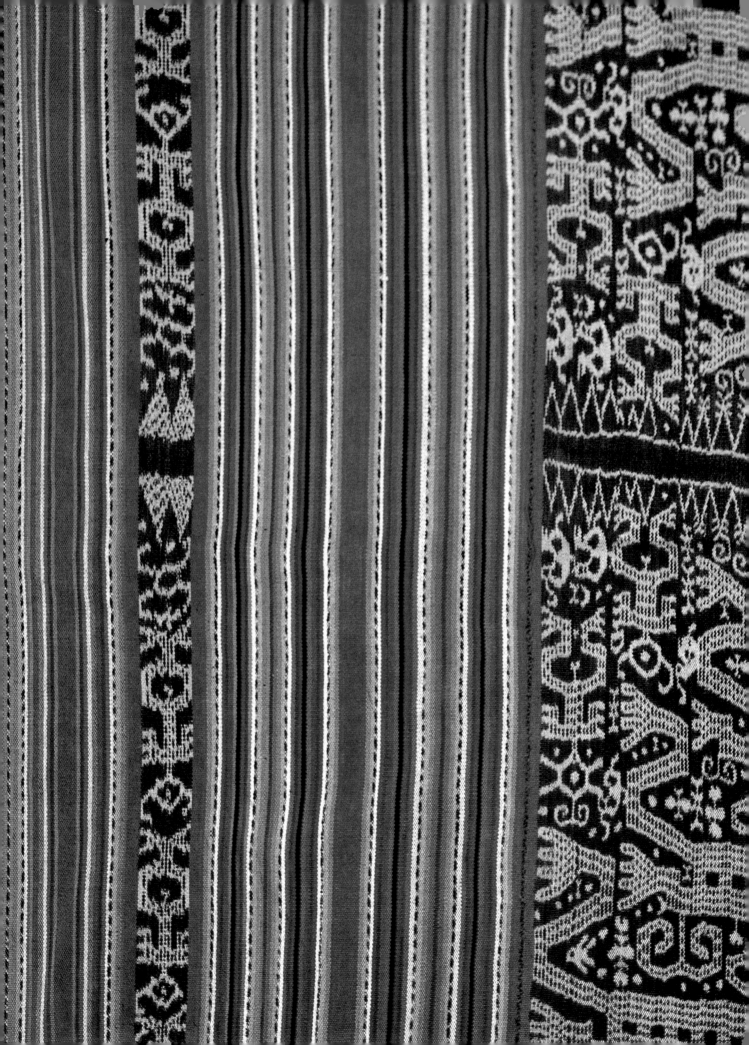

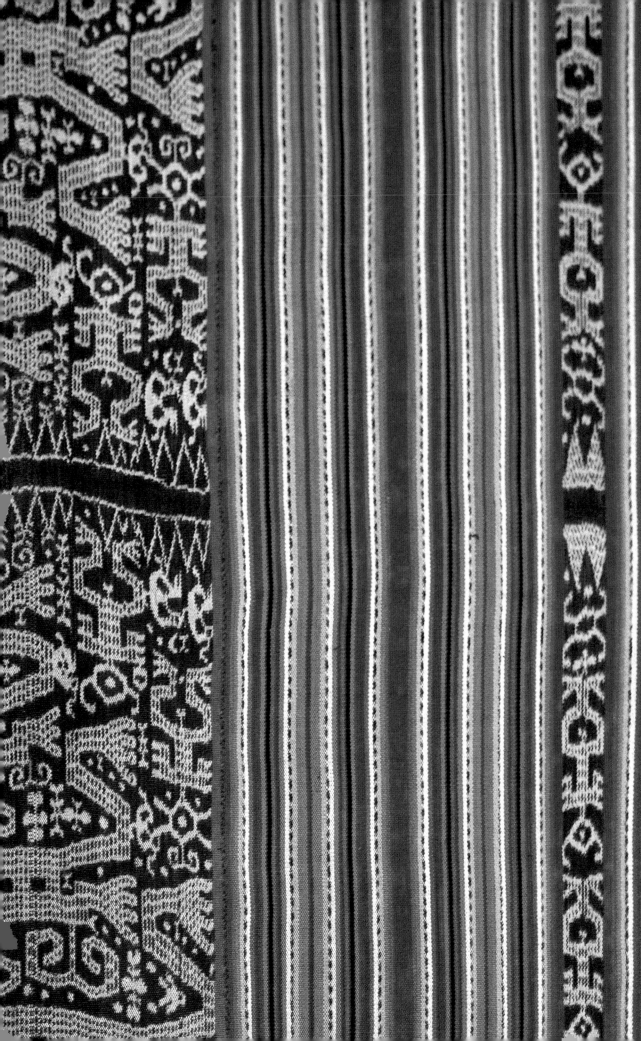

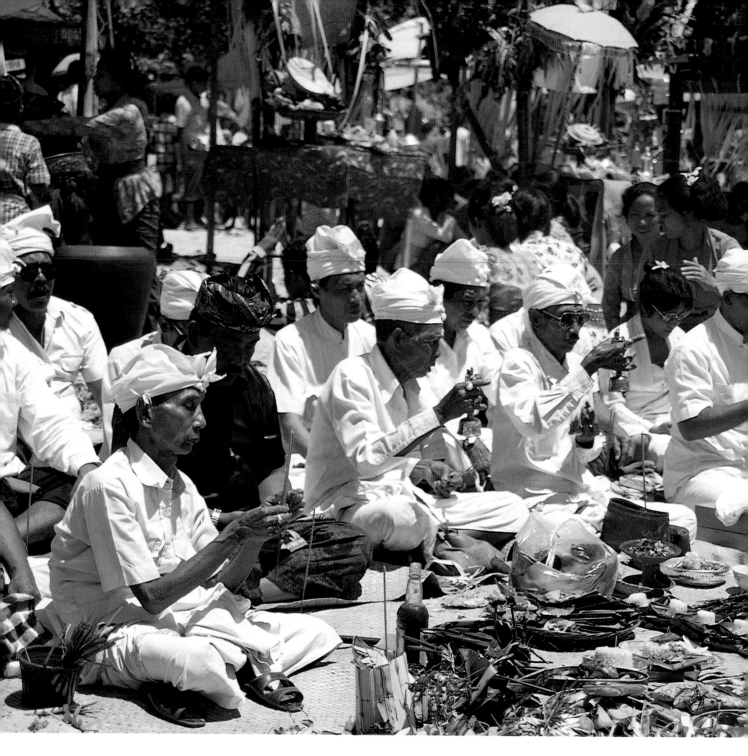

Atoni man's mantle, *selimut*, with warp-ikat panels separated by warp stripes, made from three strips sewn together and decorated with fringes. Anthropomorphic figures, often interpreted as representations of ancestors, dominate the central panel. The bird forms may also symbolise the afterlife; according to Atoni beliefs the deceased metamorphose into birds. Collected in Bali, 1982. 204 × 118 cm.

funeral may be held well before death, in which the elderly try out their coffins, lining them with elaborate ikat textiles; in contrast some Timorese peoples place warp-ikat textiles over the coffin before interment. The completion of the life cycle in Bima is marked by wrapping the corpse in a white shroud, a symbol of purity that is likened to the white cloth used for a newborn child. In the context of funerals it is often the protective qualities of textiles that are valued: the Tinguian believe that an evil spirit must first count all the threads in the cloths and all the holes in the nets if it wishes to harm the family. In some societies restrictions are placed upon who is permitted to weave burial-cloths, as is the case among the Kalinga where

Balinese Hindus take the ashes of the deceased after cremation and throw them to the wind. This represents the cleansing of the material body and is marked by noisy parades. Prayers are offered by men dressed in white to symbolise their purity. Kuta Beach, 1989.

death blankets may be woven only by women who are barren or past childbearing age. Special funeral cloths are not made by all Indonesian peoples, though the dead are invariably treated in a dignified manner. Ruth Barnes (1989) notes that in Lamalera the dead have to be dressed appropriately and are usually buried with a new set of clothes. Lamalera mourners are known to place small scraps of white cloth in the coffin to sever the ties with the living and ward off misfortune.

Because Indonesian peoples subscribe to a variety of different belief systems and religions the body may be treated in different ways after death. Nevertheless, despite these differences common themes can be detected, particularly with regard to the use of textiles. The non-Muslim Batak, for example, lay the body in state on red and blue ikat cloths, whereas the Jolo Muslims of the southern Philippines show the body in public on a cloth decorated with *appliqué* tree-of-life designs. The Ibaloy traditionally embalm the body before wrapping it in a cloth, while the Ifugao, who traditionally practise secondary burial, place the corpse under the eaves until sufficient funds for a funeral have been acquired. After a few years the remains are disinterred and are wrapped in a new textile.

The mourners themselves may adopt a specific form of dress in order to attend a funeral. On the morning of a funeral the Balinese wear white head-cloths, while the Batak tie indigo-dyed ikat fabrics around their heads. Cloth hoods are worn by female mourners in Torajaland, whereas the men adopt a narrow braided headband decorated with a tassel. The Toraja also hang large ikat textiles around the pavilions that are specially built for the mourners. A funeral may be an occasion on which social ties between the different mourners and their relationship to the deceased are expressed. Robert Barnes (1974) has noted that the people of Kédang hold a large black cloth over the corpse, and this textile is cut into the same number of strips as there are surviving siblings of the deceased. The colours of the pieces of cloth brought to the graveside by the relatives of the dead person indicate their clan affiliation and relationship by marriage. The Batak distinguish between male and female children by placing them on different sides of the grave: men on the right and women on the left. Among some Timorese peoples a funeral is remembered in terms of the number of animals that were slaughtered and the number of textiles that were buried. The status of the deceased in Sumba can also be deduced from the number of textiles which are interred, and it is the custom for an equal number of cloths to be distributed among the participants in the funeral rites. Cloths known as *hinggi* are often among those used in funerals in Sumba: these textiles are likened to sails and are placed on the huge boulders traditionally dragged to the ritual centre of a village and used as an ancestral shrine.

143

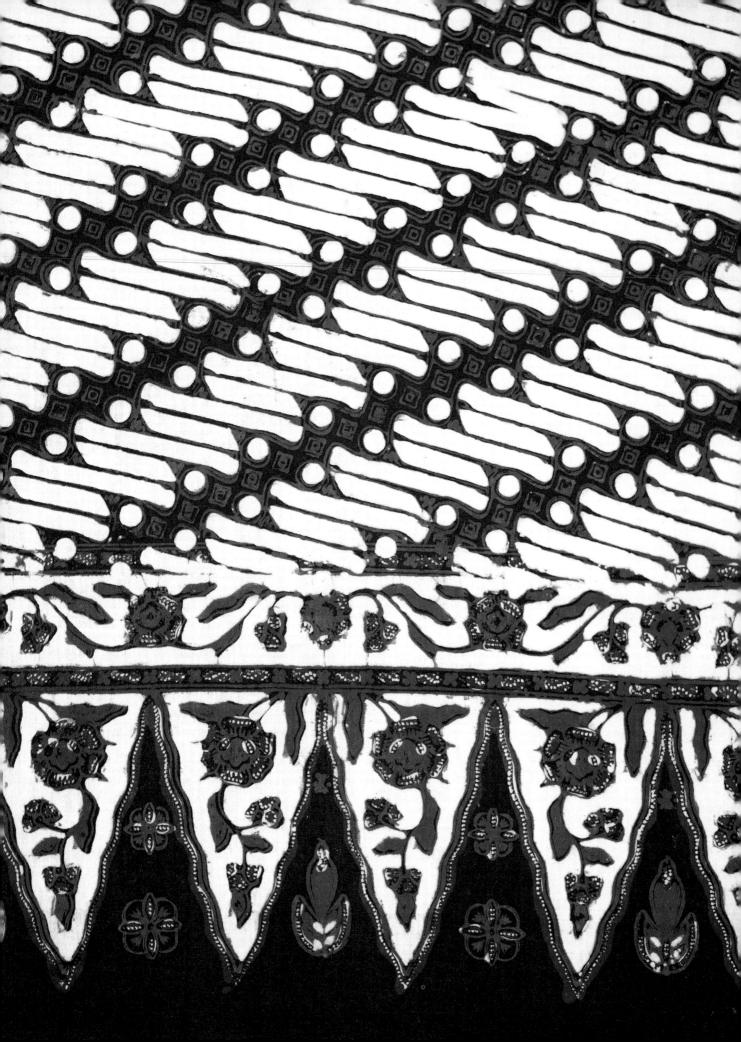

7

Dress, Design
and Colour

✳

Cotton batik *selendang* with diagonal parang designs and a *tumpal* border. Purchased in Jakarta, 1980. 153 × 33.5 cm.

Traditional Indonesian clothing is usually fairly simple owing to the heat and humidity of the climate. Designed for maximum comfort, many garments are made from lengths of cloth which are folded, draped or tied around the body. Clothes are often untailored, but because of the narrowness of fabrics woven on many handlooms larger garments have to be made by stitching together several textiles, carefully matching up the designs. In spite of the simplicity of many of the basic elements Indonesian styles of dress can be both varied and highly complex. Textiles are often combined with jewellery and ceremonial weapons so that the fabric designs are shown to their best advantage and the overall effect is often visually striking. Clothing is also communicative in many societies and traditionally a person's rank or occupation could be deduced at a glance. Although Western-style garments are now worn on a daily basis on many islands, locally woven textiles are still donned to mark special occasions, especially rites of passage. Regional fabrics have remained important symbols of ethnic affiliation and are still worn in public to reaffirm traditional bonds and loyalties.

Dress

Some of the finest examples of traditional costumes are found on Java, the most densely populated island. Javanese dress comprises essentially untailored, rectangular pieces of cloth, typically decorated with batik designs. These garments, which are often based on court styles, are usually reserved for formal occasions, particularly in the major towns and cities.

The term *kain panjang* ('long cloth') is given to the flat textile worn

145

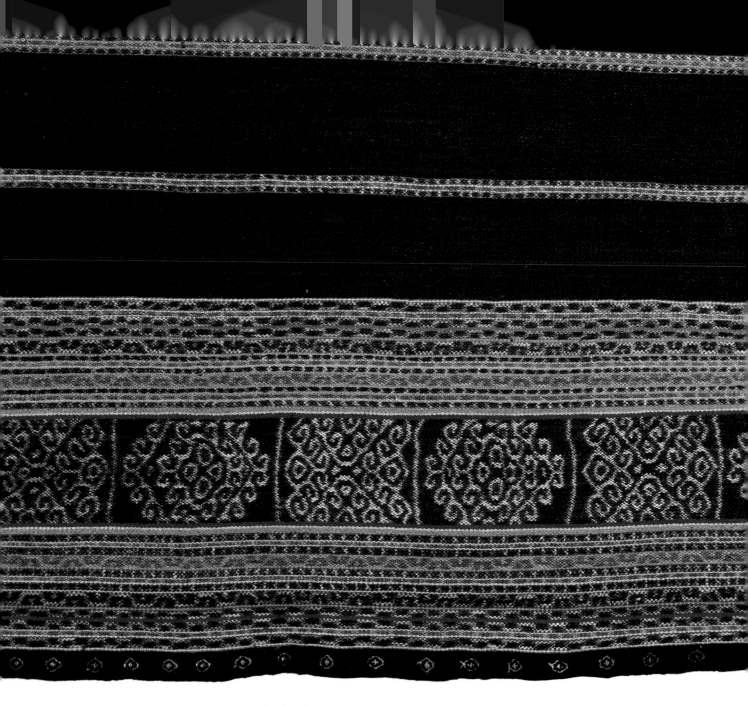

Heavy cotton textile decorated with warp stripes and warp ikat. East Timor (formerly Portuguese Timor). British Museum, 1970 As6.6.

by both sexes in Java. When used by men it is known as *bebed*; when worn by women it is called *tapih*. This garment is characteristic of the old courts of Surakarta and Yogyakarta. The *kain panjang* is wrapped around the hips to cover the wearer from the waist to the ankles, and one end may be folded so that it hangs in a series of elegant pleats to the front or to one side. Men keep the 'long cloth' in place with either a knot or a belt, whereas women use a stiff fabric band called a *stagen*.

Different batik designs are sometimes executed on each half of the 'long cloth'. Known as *pagi-sore* ('morning and evening'), these garments can be reversed so that the darker side is seen during the day and the lighter at night. Some batik cloths are referred to as *kain dua negri* ('cloth of two countries') because they incorporate patterns from two separate regions. A textile which has been partially completed in central Java may be sent to the north coast for finishing. In

146

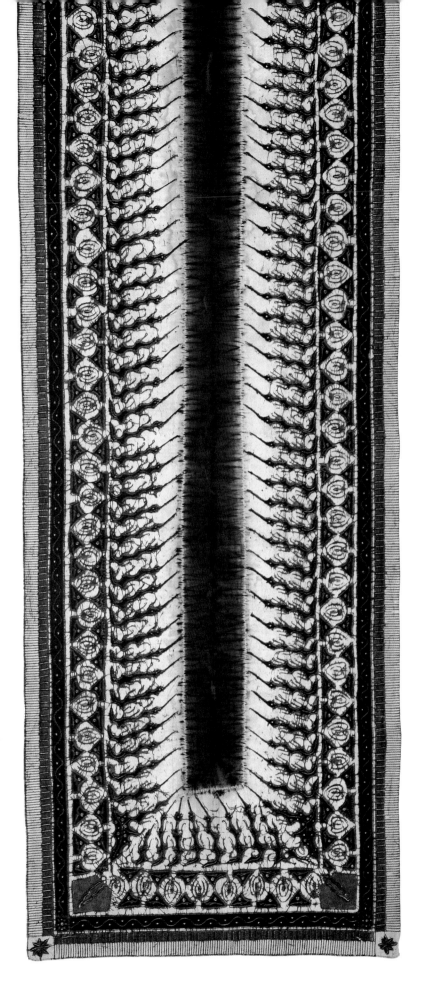

Cotton breast-cloth, *kemben*,
decorated with *batik tulis*. A
village-produced revived court
pattern dating from the late 19th
century. Central Java, 1930s.
British Museum, 1934.3–7.3.

addition to being a garment the *kain panjang* may be used in a variety of other ways: it may serve as a table-cloth or bedspread and when old and faded can be used to bundle up market produce.

Javanese women traditionally wrap a long narrow textile, a *kemben*, around the chest, leaving the shoulders bare. This cloth is sometimes decorated with an elongated plain-coloured diamond or oval shape, which may be surrounded by stylised leaf designs. The *kemben* is now worn only as part of the dance costume or on special occasions and has largely been supplanted by the Malay blouse, *kebaya*. This tight-fitting though modest garment is usually made in either lace or a semi-sheer material. A richly embroidered long version, tailored in silk or velvet, is often worn during ceremonies, particularly marriages. The long Malay blouse may be gathered at the waist with a silver belt, as is the case in west Java, or left open at the front to reveal a fabric panel inset. On formal occasions a Javanese man wears a short jacket with the batik waist-cloth and, in accordance with local etiquette, tucks a kris into a sash or belt behind his back.

Aristocrats traditionally wear a long ceremonial cloth known as the *dodot*. Made from two lengths of fabric sewn together, these textiles are often completely covered in batik patterns, though some have a plain-coloured diamond-shaped central field. The *dodot* is draped around the body in various ways, there being different court styles. Men wear this garment at knee length over trousers decorated with *pelangi* and *teritik* designs, whereas women use it as a kind of dress which is secured around the chest. The *dodot* may be worn during a wedding when the bride and groom dress as a prince and princess for the day, though today it is used mainly by court dancers.

The Javanese woman's costume is completed with the *selendang* (or *slendang*), a kind of sash or shawl which is often made to match the batik waist-cloth. Each end of the *selendang* may have a *tumpal* border, and especially fine varieties are made in silk and have fringes. The *selendang* can be used either to cover the head or may be draped around the body in various ways. Court dancers wear a longer version of this cloth known as a *sonder*, which is tied around the hips with the ends trailing on the ground. During the performance the dancer may lift and flick the ends of the *sonder*. The *selendang* can also be knotted and used as a sling to carry both babies and large wickerwork baskets.

On formal occasions a Javanese man may wear a turban, made from a starched batik cloth, known as an *iket*. The turban can be folded in various ways, and in the past it was possible to tell a man's rank and where he came from by the style of his headgear. Today turbans are usually made by specialists and are bought ready-made in stiffened fabric. *Iket* head-cloths are either completely covered in batik designs or have a monochrome diamond-shaped centre field surrounded by patterned borders.

Batik used as a baby-carrier. Yogyakarta, 1990.

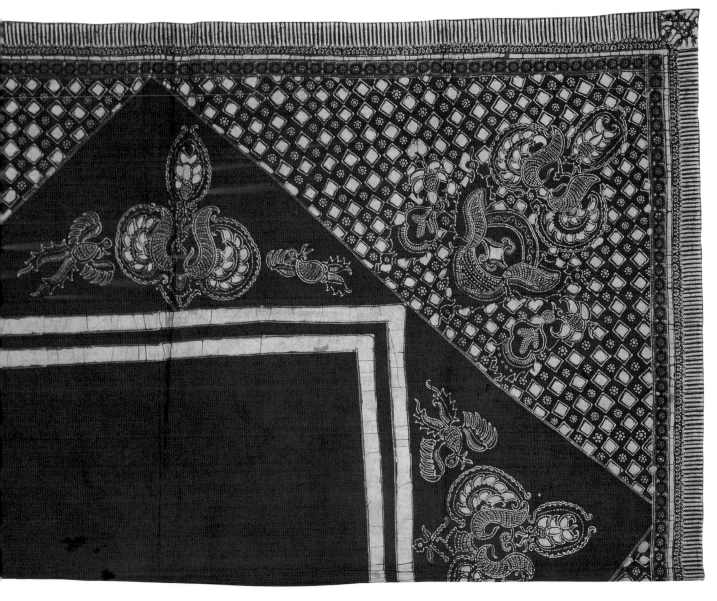

Cotton batik table-cloth decorated with garuda wing and phoenix designs. 108 × 108 cm.
Hull University, CSEAS PDT8.

In addition to being made into traditional garments Javanese fabrics are used in a variety of other contexts. During the late nineteenth and early twentieth centuries loose-fitting batik trousers were adopted as leisure wear by Chinese and Dutchmen living in Indonesia. Colonial women often wore long batik skirts with European-style blouses and jackets. Short-sleeved batik shirts, which resemble the famous Hawaii shirt, have been popular since the 1960s. Men wear a long-sleeved version on formal occasions. In the 1980s the Javanese began to use traditional fabrics to make a wide range of fashion garments including T-shirts, blousons, kimonos and waist-coats. Carved wooden puppets, *wayang golek*, are also clothed with batik and checked waist-cloths. Interior furnishings such as cushions, wall-hangings and screens may be made from Javanese fabrics; sometimes cloth is placed in front of a light source, such as a

149

window or an electric bulb, to show off the batik designs. Batik banners and altar-cloths, decorated with Chinese designs, can be seen in Chinese temples, reflecting the long involvement of the Chinese in the textile industry.

Madura has a batik industry centred on Tanjung Bumi, and the Madurese, like their Javanese neighbours, traditionally wear the *kain*. According to Jan Wisseman Christie, Madurese women living in East Java wear distinctive blue bodices with shoulder-straps. Madurese men also wear a head-cloth which is folded into a triangle and tied around the head so that the flap projects upwards at the back.

Like the Javanese, the Balinese wear rectangular pieces of cloth which are tied and draped around the body. The *kain* is common in Bali where men wear it at knee length with elaborately gathered folds at the front. In contrast women use the waist-cloth as an ankle-length wrap-around skirt secured with a fabric band. Hindu women in Bali were traditionally not expected to cover the upper halves of their bodies in public; but as a result of increasing contact with Christians and Muslims since the mid-nineteenth century, Balinese mores have been changing. Today the majority of Balinese women wear the Malay blouse in conjunction with the traditional waist-cloth.

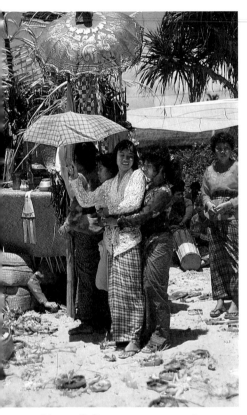

Young Balinese women wearing waist-cloths, *kain*, Malay-style blouses and festive sashes beneath an umbrella and *perada*-cloth parasol. Kuta, 1989.

The Balinese calendar has 210 days, and festivals are held on auspicious days during the Balinese year. Public holidays are often marked with parades of people bearing offerings, dressed in their finest jewellery and garments. Both men and women wear expensive batik, ikat or *songket* waist-cloths, as well as colourful sashes. Women wear either Malay blouses or breast-cloths, whereas men wear mainly tailored shirts. The man's head-cloth, which is often white, is folded into a triangle before it is wound around the head and knotted on the forehead. High-born Balinese men also wear *songket* hats made from sewn head-cloths. The priests who officiate during religious festivals wear white to symbolise their purity.

Some of the most resplendent Balinese costumes are seen during weddings when both the bride and the groom wear gilded *perada* fabrics. The man's outfit usually comprises a vividly coloured waist-cloth, the corner of which falls over his left foot. The garment is worn under another gilded textile which is secured around the chest with a hand-woven sash. A kris is tucked into the band at the back so that its decorative hilt projects above the right shoulder. A *perada* head-cloth, folded into a triangle, is tied around his head; flowers are invariably placed behind the groom's ears. The bride may be sheathed from her armpits to her feet in a silk and silver *songket* textile, over which is worn a gilded waist-cloth. The latter is held in place by a broad band which is wound around her hips and waist. Precious-metal arm-bands, rings, earrings and necklaces are worn, and the bride's hair is usually adorned with both real and gilded flowers.

Bali is renowned for the vitality of its indigenous performing arts

and the dazzling richness of its dance costumes. Gilded leather tabards and collars are worn, as well as *perada* cloths in vivid colours such as magenta, turquoise and orange. According to Walter Spies and Beryl de Zoete (1938), who researched Balinese dance in the 1930s, dancers are carefully bound, tied and pinned into their costumes. In order to perform the *djanger* dance, for example, a young girl is wound into two metres of yellow webbing, about five centimetres wide, which, in turn, is covered by two metres of yellow silk and an equal length of *perada* cloth. The dancer's 'skirt', the *wastra*, is folded tightly in such a way as to allow her to step out in front. An important feature of the man's costume is a long piece of white cloth, the *kanjoet*, which may flow along the ground as a train, or can be gathered into the belt to form a loop between the legs, or is tightly girt up like a loincloth.

The Balinese conquered Lombok in the eighteenth century, and the west of the island is populated by people of Balinese descent. The latter group, like the Balinese, traditionally wear the batik *kain*. In addition the Balinese, Javanese and Madurese may wear the sarong, a garment which is known throughout the archipelago, particularly among Malay peoples. The sarong – derived from the Malay-Indonesian word *sarung* – comprises a sewn fabric tube which covers the body from the waist to the ankles. The wearer may slip the sarong over the head before securing it around the waist, or may step into the tube, pulling up the sides around the body.

The methods of tying the sarong may vary according to region and gender, though the basic principles are broadly similar. Men commonly secure the garment with the use of simple, though ingenious, tucks and folds. First, the man inserts both thumbs into the top of the tube, pulling it taut away from the body. Second, he presses the fabric against his stomach with the fingers of his left hand, while maintaining his hold on the gathered cloth with his left thumb. Third, a fold of cloth is brought across the stomach with his right hand, which is then used to hold the garment in place as the left hand is withdrawn. Fourth, the remaining fold of cloth on the left is pulled tightly to the right with the left hand, and finally the top of the sarong is rolled over to keep the tucks in place. If secured correctly, this is reasonably long-lasting, though it is usually adjusted from time to time to ensure that it stays in place.

In contrast to men women do not usually tie the sarong above the navel. Instead they press the cloth with the left hand on to the right hip and then use the right hand to pull a large fold of cloth across the stomach to the left hip. The end of the fold is then fastened by tucking it under the tightly wrapped top of the sarong. When engaging in active pursuits such as fishing or agricultural work, both men and women may wear the sashes to help keep their sarongs in place.

The sarong can also be worn by tucking it under the armpits or by

Young dancer dressed in a batik *kain*, gilded leather ornaments and jewellery. Taman Mini, Jakarta, 1989.

151

tying it over the shoulder in a knot. In Timor and west Flores a long tubular sarong may be knotted over the breasts, whereas in Savu and Roti the garment may be tied around the upper chest with a belt. In Flores sarongs may be secured over the shoulders with the aid of thorns, and in neighbouring Bima they are occasionally worn over the head as a veil.

Like the ubiquitous *kain* the sarong can have many uses: it is commonly worn as nightwear and may provide protection on the decks of ships at night from cool sea breezes; when hung across the body as a diagonal sling it can be used to carry merchandise; and it can be slung from a convenient tree branch to serve as a baby's cradle while the parents work in the fields nearby. An old sarong may be worn for bathing in public; sometimes, however, the garment may gradually be pulled upwards as the wearer wades into a river, and when the body is almost submerged the sarong is tied around the head. It is let down in stages, to preserve modesty, as the bather re-emerges from the water. Seamen, craftsmen and farmers often wear a sarong over a pair of shorts so that during work it can be tucked around the waist leaving the legs exposed, and upon returning home or attending business it can be lowered to provide more formal dress. Businessmen, civil servants and teachers frequently wear lightweight suits to work but prefer the more comfortable sarong when relaxing at home or in the village. A good sarong is usually quite roomy and can even accommodate two people at once – especially lovers.

Because the fabrics woven on handlooms are usually quite narrow, it may be necessary to sew together different lengths of cloth to make

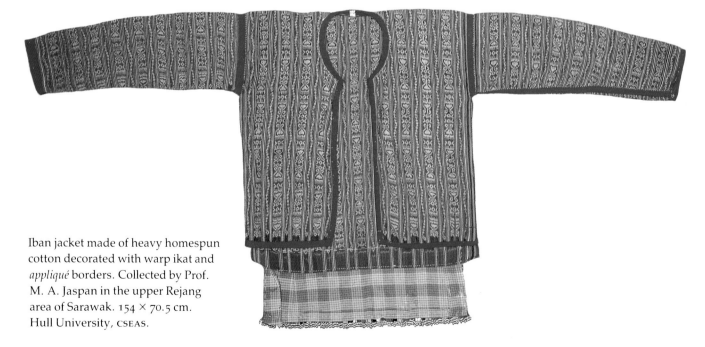

Iban jacket made of heavy homespun cotton decorated with warp ikat and *appliqué* borders. Collected by Prof. M. A. Jaspan in the upper Rejang area of Sarawak. 154 × 70.5 cm. Hull University, CSEAS.

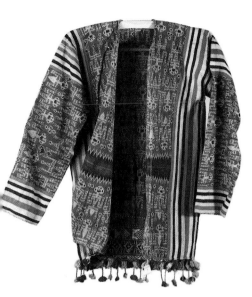

Man's jacket made of heavy homespun cotton and decorated with warp stripes, warp ikat (anthropomorphic figures), twining and tassels. Sarawak, north Borneo.

Shirt made from an imported flour sack dating from the 1960s, a period of economic and political strife. Collected by Prof. M. A. Jaspan in the central market, Yogyakarta. w. 44 cm. Hull University, CSEAS 69.28.

a long sarong. In regions where the discontinuous warp is used a sarong is often made from a single bolt of cloth taken from the loom. The textile is cut in half along the weft, and two selvages are stitched together to make a large rectangle, which is later sewn into a tube. Because checked and *songket* sarongs usually have a central decorative panel, known as the *kepala*, the selvages have to be matched carefully before they are sewn. Some Indonesian peoples, however, do not traditionally wear long sarongs and may, therefore, make waist-wrappers without recourse to tailoring. This is true of the non-Malay inhabitants of Borneo, such as the Iban, who weave with a continuous warp and simply use the tubular lengths of cloth produced on their looms as women's sarongs. These garments usually have a thin strip down one side which has to be completed by hand with a needle. This is because a small section of unwoven warp is left when the heddle and shed-stick are removed after the weaving process is complete. These sarongs from inland Borneo, which are today worn mainly for festivals and traditional dance performances, are often decorated with ikat designs and may have coin and bead-work fringes. Other varieties of short, knee-length sarongs are known in the northern Philippines.

Long sarongs, commonly decorated with simple checked patterns, are used on a daily basis in rural areas throughout the archipelago. Usually worn in conjunction with cheap blouses, T-shirts and sandals, many of these waist-wrappers are mass-produced in factories, particularly in Java. The long sarong, however, is not simply an inexpensive workaday garment, and more elaborate varieties, often handmade, are included as part of festive dress in many Indonesian

FOR EXPORT

TIGER BRAND

TIGER

TIGER

ALL PURPOSE AMERICAN FLOUR

MANUFACTURED BY
FISHER FLOURING MILLS COMPANY

regions. Some of the finest sarongs, woven in prized silk and metallic yarns, are reserved for weddings, especially in Sumatra and coastal Borneo, and on the Malay peninsula.

Among the Malays and related peoples it is customary for the bridal pair to dress as a prince and princess for the day, and though there is some regional variation, the different costumes have much in common. Generally speaking the bride wears a knee-length tunic with a *songket* sarong, while her hair is bedecked with flowers and gilded hairpins. The groom's sarong is often shorter than the woman's and is usually worn over a shirt and loose-fitting trousers. Men also wear an unstarched head-cloth, known in Malay as a *destar*, which is either tied around the head or worn around a hat.

Malay styles of dress are closely associated with the Riau

Decorative panel with tassels on a pair of trousers, *sawal*, made for a Yakan child. Purchased by Gavin Patterson in Lamitan, Isabella Basilan, Philippines. 92 × 12.5 cm. Hull University, CSEAS 1989.1–3.

Archipelago, where the bride's costume comprises a brocaded sarong and a long red tunic that is gathered at the waist with a filigree belt. She may also wear a deep-blue collar encrusted with medallions, and a crescent-shaped forehead ornament with numerous pendants. The groom usually wears a scarlet and silver sarong with gold-coloured pyjamas, over which is worn a long open-fronted coat. A *songket* textile tied around a conical, basketry hat is used to cover the head.

In many respects the wedding costumes of the Minangkabau of west Sumatra resemble those of the Malays. The Minangkabau bride's costume consists of a knee-length tunic worn over a *songket* sarong and a long textile which is criss-crossed over the breasts. She also wears rings, bangles, necklaces and an elaborate head-dress made of gilded flowers and pendants (Minangkabau dancers are

Shoulder-blanket used in ritual gift exchanges in north Sumatra. Handwoven cotton decorated with supplementary wefts, tapestry, twining and beaded fringes. Angkola (Mandailing) Batak, early 20th century. British Museum, 1970. AS6.6.

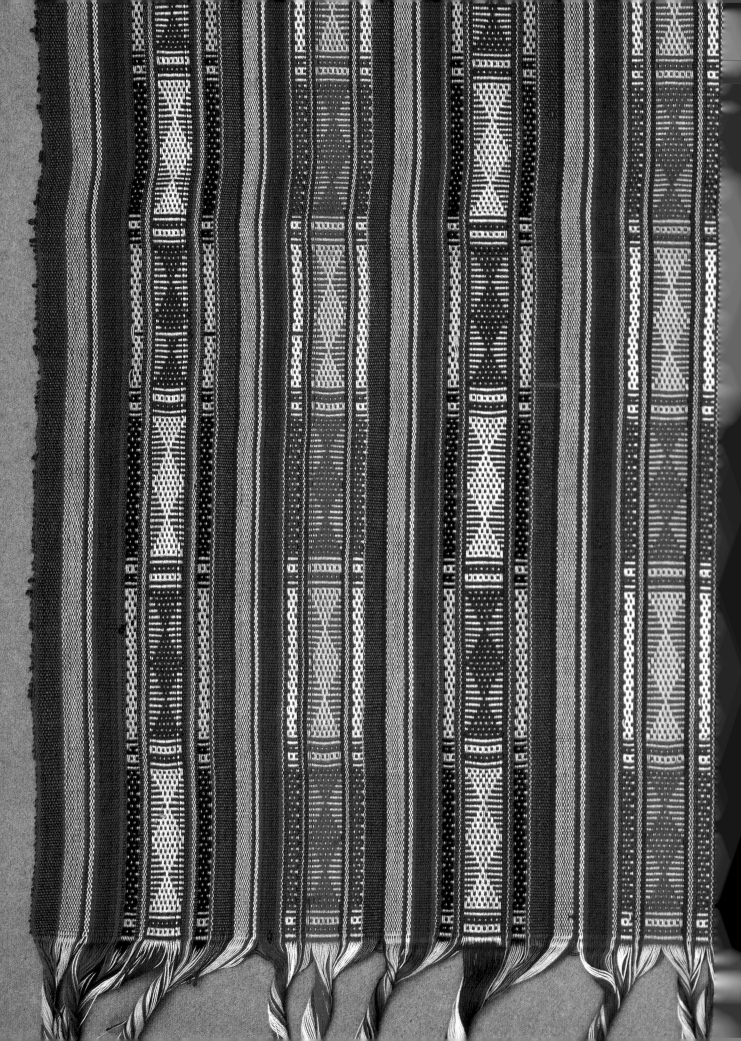

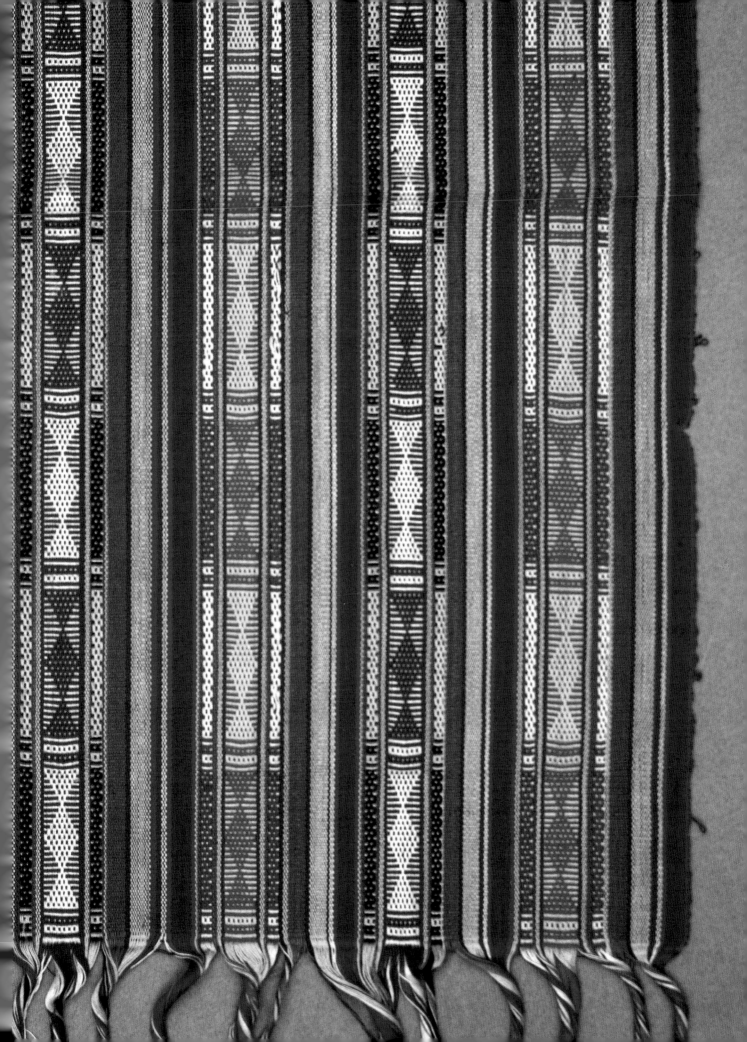

Pages 156–7 Festival sash with float-woven designs. Southern Philippines. 85 × 38 cm. Hull University, CSEAS TBT26.

known for their distinctive horned *coiffures* made from folded cloth). The groom may wrap a flat brocaded textile, rather than a sarong, over breeches, and his outfit is completed with a short jacket and a high-crowned head-cloth. Broadly similar patterns of dress, usually incorporating *songket* textiles, are found elsewhere in Sumatra, notably in Lampung, south Sumatra and Aceh.

Also worth mentioning in the context of Malay costume are the Muslim peoples of southern Sulawesi and Sumbawa. Although linguistically separate, these eastern Indonesians had long-standing trade and political links with the Malays, and share with them many aspects of dress, especially brocaded and checked sarongs. A characteristic feature of the bridal wear of these islanders is the short-sleeved tunic made of an almost sheer material. Distinctive handmade sarongs are found elsewhere in eastern Indonesia, especially in Lombok, Sumba and Lembata, as well as in the Philippines. Of particular interest are the ikat and embroidered Maranao sarongs, which are decorated with ship motifs.

In addition to sarongs, sashes and head-cloths other kinds of garments are made from textiles, especially noteworthy being the shoulder-cloth or -blanket, the *selimut*, some of the finest examples of which are found on the islands of eastern Nusa Tenggara. Traditionally worn as a badge of rank, the *selimut* is usually embellished with elaborate ikat patterns and has fringes at either end. In Timor it is draped over one shoulder and tied at the waist with a belt, whereas in Sumba matching blankets are worn around the hips and over the shoulder. The long narrow loincloth, known in Indonesian as the *cawat*, is another important item of clothing. This cloth, which may be fringed with beadwork and tassels, is known in central Borneo and northern Luzon.

Design

Many Indonesian peoples traditionally use clothing, combined with ceremonial weaponry and jewellery, to indicate social status. Not only is the style of dress important, but so is the design of the fabrics;

and in some regions the colour of cloth is also significant. Until the early twentieth century the highest members of society, especially the nobles of the old Indonesian courts, restricted access to the most prized patterns and richest materials. Certain batik patterns, for

example, in the sultanates of Yogyakarta and Surakarta were reserved exclusively for royal attire. Similar practices were also observed in small-scale societies. On the islands of Sumba and Roti it is possible to distinguish commoners from nobles by their textile motifs. Marie J. Adams (1971) tells us that on Sumba the upper classes restricted access to the most complex ikat patterns and may have been able to punish violations of dress rules until the 1920s and 30s.

Certain textile designs may be owned by members of the same kinship group, especially in Nusa Tenggara. In both Savu and east Flores there are patterns which belong to particular lineages, and in Solor it is forbidden to wear designs belonging to an unrelated group. Sometimes designs may belong to individuals, as is the case among the Iban where a woman may either pass on her designs to her daughter or sell them to another weaver. The most esteemed patterns are traditionally recorded on lattices of palm leaf and bamboo, though graph paper and photographs are widely used today. Old textiles and fragments of cloth bearing interesting motifs may be referred to when designing new fabrics. The owners of ikat and batik factories, who have to be commercially attuned, also record successful designs for future reference. There are patterns books, with pages made from batik cloth, which show the different stages in the preparation of design elements.

The design process is often quite eclectic, because although traditional guidelines regarding the choice of colour and pattern may be adopted, innovation is also appreciated. Existing designs may be rearranged and sometimes new elements are introduced. It is perhaps this willingness to experiment that has enabled the introduction of new motifs from a wide variety of different sources. The preparation of textiles on commission usually involves long discussions between the craftswoman or designer and the customer. Personal touches, such as the name of the purchaser, may be incorporated in the design. Occasionally, as is the case with special *songket* fabrics, the customer is expected to supply silk and precious metal yarns which may not be available locally.

Batik book showing different stages in the preparation of a design. Yogyakarta. Hull University, CSEAS. Prof. M. A. Jaspan.

A vast range of textile motifs are known in the Indonesian Archipelago, and in Java alone there are thought to be over 3,000 batik designs. Some motifs appear to date from prehistoric times, suggestive of ancient pan-Indonesian traditions. For example, the angular

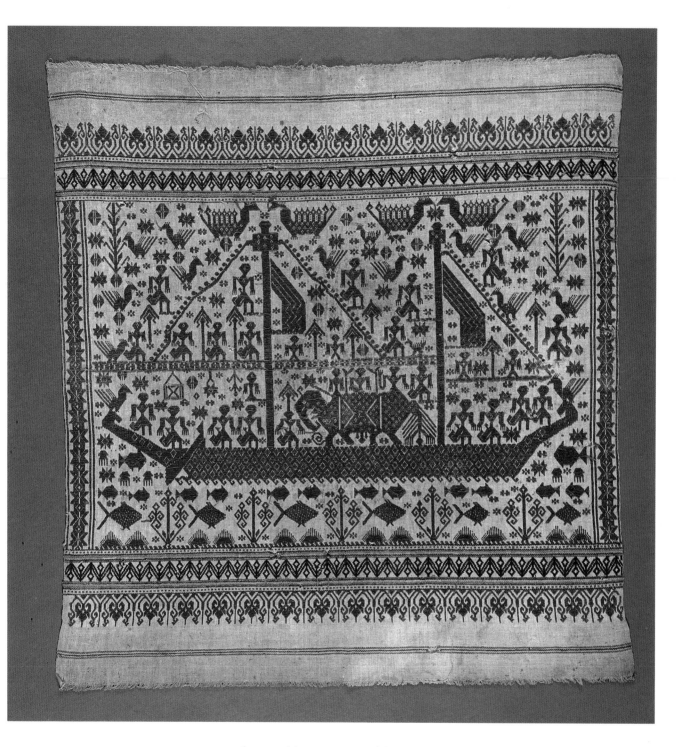

and maze-like patterns of Sumatra and central Borneo have been compared with large bronze kettledrums of the so-called Dong-son type. These drums have been associated with the spread of metallurgy, and perhaps other craft skills, throughout South-East Asia over 2,000 years ago. Von Heine-Geldern (1937) was the first scholar to associate designs that survive today with the bronze objects found in insular and mainland South-East Asia. The site of Dong-son in northern

160

Left Tampan textile from Lampung, Sumatra, depicting a two-masted ship with sails and streamers. On the deck there are men with kris tucked into their sarongs and an elephant. The sea is rich in fishes and the sky is replete with birds and mythical creatures. Cotton supplementary weft in crimson, blue and beige. 75 × 70.5 cm. National Museums of Scotland, 1982.765.

Vietnam, in the light of more recent excavations, is now seen as part of a continuum within a broader South-East Asian framework.

Another important design is the frontal representation of a human figure. Found in Flores, Lembata, Kisar, Sumba, Tanimbar and Timor, these anthropomorphic motifs resemble certain Iban designs from Sarawak; they can also be seen, though not invariably in full frontal view, in the ceremonial *pelapai* ship cloths of Sumatra. The frontally shown human figure, often described as a representation of an ancestor, is closely associated with warp ikat, a technique that may be one of the most ancient. There are also geometric designs which, although abstract, have names that link them to real objects. Some of the simplest batik motifs, such as *nam tikar* ('woven bamboo'), imitate mat and basket weaves and are considered to be among the oldest traditional designs.

The *tumpal* border, which comprises a row of isosceles triangles, is held to be another old Indonesian motif. Each triangle is usually filled with floral patterns, and the area between the rows may contain geometric and eight-pointed star designs. Among some Indonesian peoples the *tumpal* is held to have talismanic properties and is likened to a young bamboo shoot, a symbol of fertility. *Tumpal* motifs have

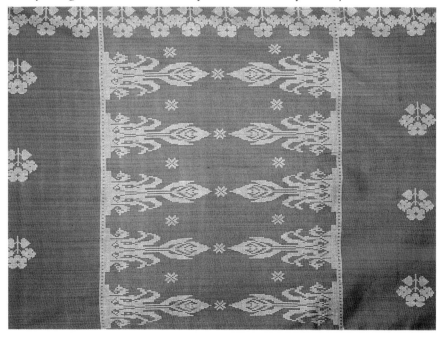

Right Tumpal, star and botanical designs can be seen on this unsewn Bimanese sarong cloth, *tembé.* Synthetic supplementary weft. 1982. 198 × 59 cm.

been found on bronze drums and appear as stucco ornaments on the walls of a temple stairway near Blitar in east Java. The *tumpal* was, however, a popular border element in the Indian cloths imported into insular South-East Asia. Although it has long been known in the archipelago, its arrangement on Indonesian textiles, as has been suggested by Sylvia Fraser-Lu (1988), has been influenced by Indian trade designs. Often seen on *songket* textiles from the Malay peninsu-

la, coastal Borneo, Sumatra, southern Sulawesi, Sumbawa and Mindanao, the *tumpal* is also used on batik sarongs from Java.

The archipelago lies astride the trade routes between India and China, and Indonesian weavers have incorporated many design elements from the rich traditions of both these countries. One of the most important foreign influences has been that of *patola* cloths from Gujarat in west India. *Patola* cloths are double-ikat silk fabrics which are worn as wedding saris in their country of origin. These textiles were known in insular South-East Asia from the sixteenth and seventeenth centuries, through some scholars, such as Alfred Bühler (1959), have suggested that the *patola* trade is much older, perhaps dating from as early as the fourteenth century. The original cloths introduced to the Indonesian islands were held in high esteem and were used as models for indigenous versions, though the way in which *patola* designs were adopted varies considerably. Mattiebelle Gittinger (1979) has argued, for example, that the *songket* textiles of Palembang resemble Gujarati fabrics in both the overall arrangement and the individual patterns. Similar observations can be made with regard to some Rotinese ikat fabrics. In contrast the people of Kodi in west Sumba appear to have borrowed the overall structure of *patola* while retaining local motifs. Likewise the Iban *pua* cloths resemble *patola* cloths in basic design but not in terms of pattern.

Designs taken from Chinese artefacts, especially ceramics and brocaded textiles, can also be detected in Indonesian textiles. In Javanese batik, for example, one finds the well-known lattice patterns, particularly the T, key and thunder designs. Among the most famous Chinese-Indonesian-style batiks are the *megamendung* fabrics of Ceribon, which bear cloud motifs in graded blue tones. A wide variety of Indonesian fabrics, ranging from landscape and garden themes to certain kinds of bird patterns, owe much to Chinese inspiration. Some botanic motifs of west Flores also appear to be derived from Chinese sources, in this case imported porcelain jars.

Some Indonesian fabric designs can be traced to early European contact. Many Sumba cloths, for example, are decorated with heraldic animals such as lions and eagles, which have been modified to suit local tastes. Converts to Christianity were also sometimes taught sewing and embroidery by missionaries of European extraction. Even the Japanese occupation left its mark on Indonesian textile design. *Hokukai batik*, with its intricate floral patterns, was developed during the Second World War to combat a shortage of cloth and, according to Sylvia Fraser-Lu (1986), reflects definite Japanese influences.

Nationalism and increasing exposure to a variety of Western art movements has also had an impact on Indonesian textile design. Initially post-independence leaders such as Achmad Sukarno (1902–70), the first President of the Republic of Indonesia, encouraged local people to look to their own heritage for inspiration rather than

simply imitate imported foreign ideas. In more recent years a more open attitude has prevailed, particularly in Java where there are many studios which specialise in either abstract or surrealist batik 'paintings'.

In addition to foreign-derived designs there are numerous motifs that merely reflect the possibilities inherent in the arts of weaving and dyeing and could, therefore, have been developed independently in separate locations. For example, patterns based on simple triangles, diamond shapes and zigzags are found in many regions and should not necessarily be taken as evidence of historical contact. There are also motifs that are drawn from local experience, such as the whaling boats on the cloths of Lamalera. Designs may record contemporary issues, particularly the novelty of foreign imports: north coast batiks from the early twentieth century may depict steamships, bicycles and record players; and more recently helicopters have appeared on textiles from the Philippines.

A wide range of both foreign-derived and locally developed designs are found in Javanese batik, the largest of the Indonesian fabric traditions. Javanese batik is, however, a vast topic about which it is difficult to generalise. There are thought to be over 3,000 batik patterns in existence, and given the complexity of the subject, it is helpful to refer to the broad categories identified by Sylvia Fraser-Lu in *Indonesian Batik: Processes, Patterns and Places* (1986). By using this author's system it is possible to group together different, though related, patterns under four main headings: *isen*, or background designs; geometric designs; *semen*, or non-geometric designs; and proscribed designs.

Javanese background patterns comprise repetitive designs based on lines, squares, dots, botanical patterns and crosses. Although an *isen* motif is often used as a filler pattern, it may be the sole design on some of the plainer batik. Background designs often consist of a series of circles or semicircles placed close together which are given names such as 'pigeon's eye', 'shining scales', the 'seven dots', 'buttonholes' and 'rice grain'. *Geringsing*, or 'fish-scale', is one of the most famous background patterns and was at one time attributed with protective qualities, being worn in order to ward off sickness. There are also *isen* designs based on straight, wavy and diagonal lines with names that can be translated as 'chequer-board', 'river fish', 'roof-tile' and 'petal veins'. Other background motifs include stylised representations of rice stalks, tendrils, buds, simple flower patterns and curling leaves, as well as Chinese lattice patterns.

Geometric batik patterns are very varied and can be divided into many subgroups. One of the best known categories, *ceplokan* (repetitive motifs), comprises polygons, crosses, lozenges, rosettes and stars – symmetrical elements which are either placed at intervals or are combined to make complex mixed designs. *Ceplokan* patterns may

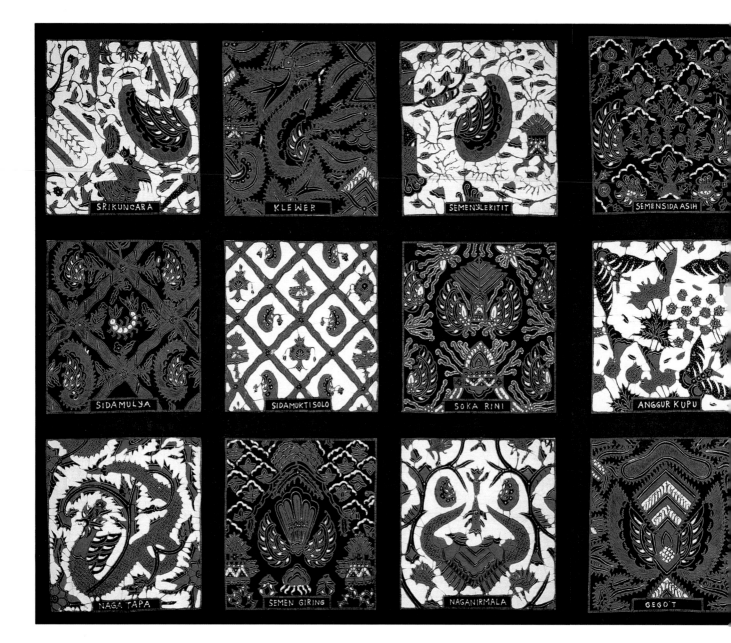

Sampler showing different batik patterns from the Batik Research Centre, Yogyakarta. 240 × 102 cm. Collected by Lewis Hill. Hull University, CSEAS.

include highly conventionalised representations of flowers and fruits, as well as members of the animal kingdom, and therefore accord well with Muslim prohibitions on idolatry. One of the most historically significant geometric patterns is the *kawung*, which comprises parallel rows, sometimes interlocking, of circular designs. There are many kinds of circular patterns, some of which are shaped like flower petals or cross-sections of fruit. Motifs that resemble the *kawung* can be seen on the walls of the temple of Prambanan in central Java and on stone sculpture from Kediri in east Java. The *jelamprang* motif, which has much in common with the *kawung*, consists of an eight-pointed rosette set within a square, rhombus or circle. Gujarati influence can be detected in the form of the *jelamprang* design. Many

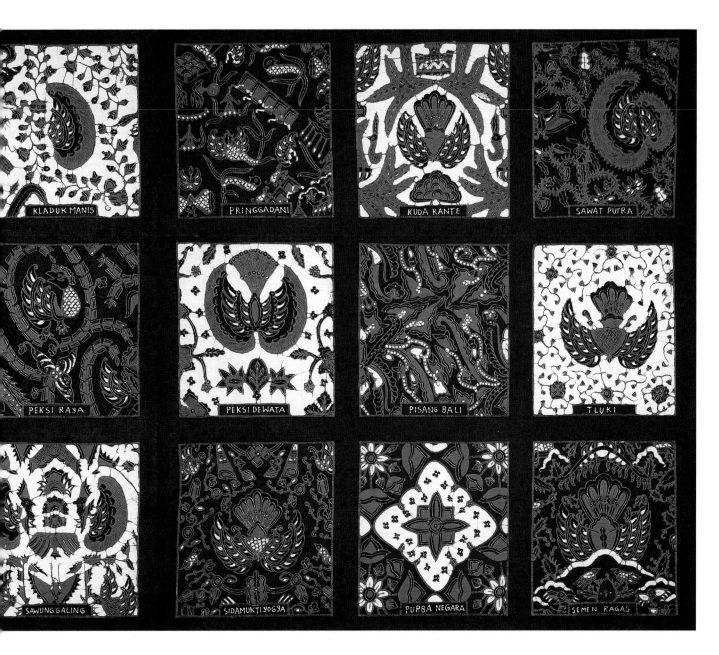

of these motifs contain lines and dots which resemble woven designs known as *nitik*.

Some of the most highly regarded geometric patterns are those belonging to the group known as *garis miring* (parallel diagonal designs), the most famous of which are based on the scroll shape known as *parang*. These designs are usually set in light-coloured bands with undulating edges which are separated by strips of a darker hue. There may be in excess of forty different kinds of *parang* design, the most famous being *parang rusak*. Also included among the diagonal running designs are those known as *udan liris*, or 'light rain', which comprise numerous diagonal bands containing different batik motifs rendered in linear form. Other geometric designs include

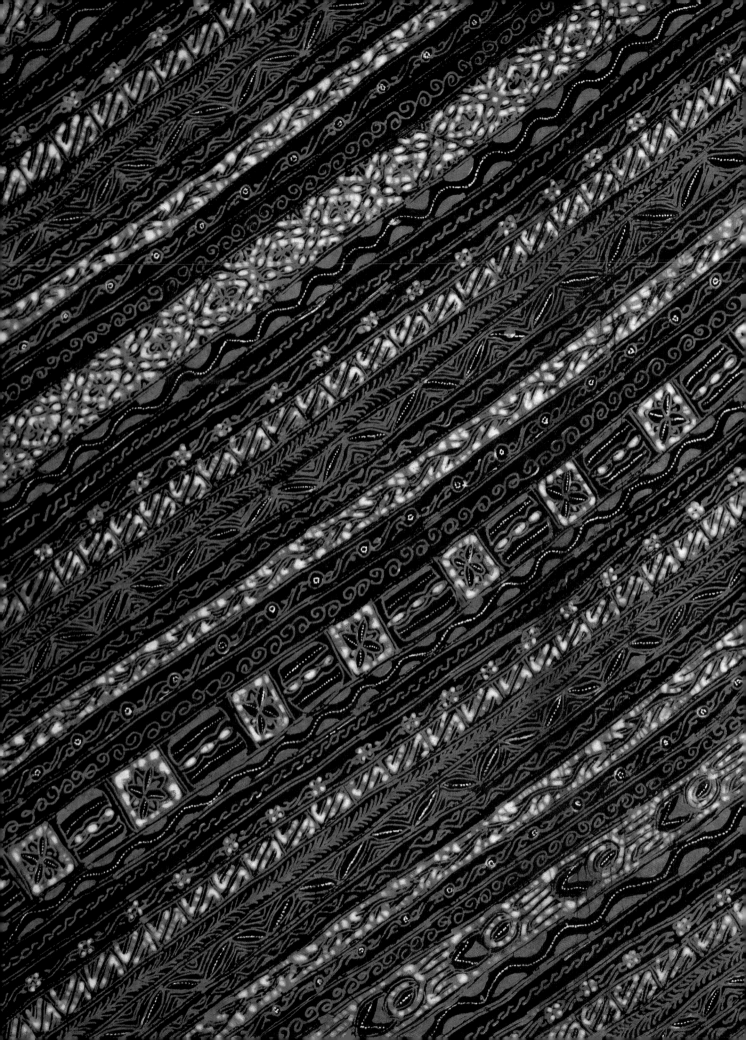

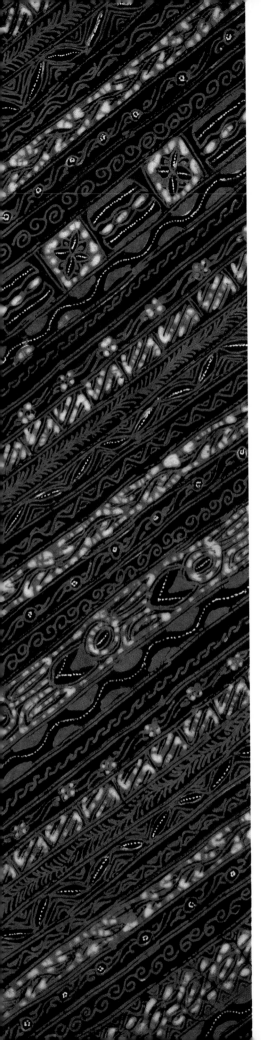

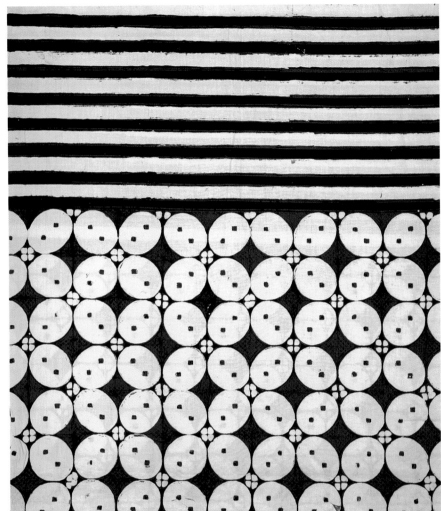

Above Javanese *kain* decorated with circular *kawung*
designs and stripes. Cotton, *batik cap*. Collected by
Dr Jan Wisseman Christie in Yogyakarta, 1980.
226 × 102 cm.

Left Javanese waist-cloth, *kain*, decorated with
diagonal *garis miring* designs (*udan liris*). Cotton, *batik tulis*.
Collected by Dr Jan Wisseman Christie in
Yogyakarta, 1980. 240 × 102 cm.

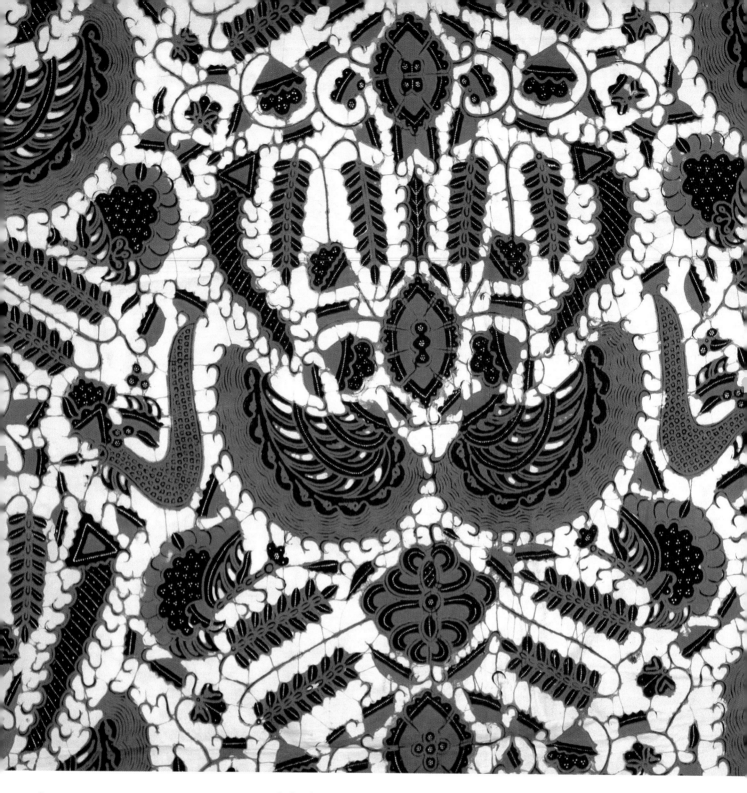

Javanese waist-cloth, *kain*, decorated with garuda wings, insects and ears of rice. Srikuntjoro, central Java. 248 × 105 cm. Hull University, CSEAS.

tambal miring, montages of batik that resemble patchwork, and the *tumpal*, an isosceles triangle which serves as a border element (see pp. 96, 108, 112).

In addition to geometric designs there is a wide range of non-geometric patterns, known collectively as *semen*, which may include many botanical elements such as creepers of taro, fern and ivy, and representations of banana flowers. There is an entwined plant design, sometimes decorated with gold, which represents wealth, as well as a pattern made from leaves, fruit and tendrils that symbolises

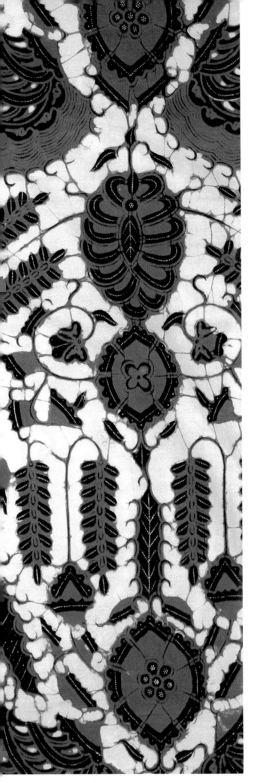

excellence. A design based on the unripe pomegranate serves as a symbol of promise.

Many kinds of birds also appear in *semen* designs, though they are often depicted in a generalised rather than a species-specific form. Garuda, the man-eagle who served as the mount of Vishnu in Hindu mythology, is represented in several ways. He may appear as a whole bird, a single wing (*lar*), a double wing (*mirong*) or a double wing with a spreading tail (*sawat*). The Chinese-inspired *lokcan* bird and the phoenix can be seen in Javanese batik, along with the peacock which is found in both Chinese and Indian legends. The rooster – a traditional symbol of the sun, life force, fertility and bravery – is also shown on batik. In addition *semen* motifs may include the owl, crow, parrot, pigeon and peafowl.

Animals, too, appear in Javanese *semen* designs, most notably the elephant (an ancient symbol of strength and wisdom), the horse (speed and endurance) and the water buffalo (agriculture). As well as higher animals such as tigers, monkeys and deer batik patterns may feature insects and arachnids (beetles, butterflies and scorpions) and various marine creatures (jellyfish, turtles, lobsters, shrimps, etc.). The Indian lion is often depicted as a *kala* mask on borders, whereas the Chinese lion is shown as a dancing figure with a flowing tail. Another important Chinese motif found in batik is the *chi-lin* (Chinese unicorn), a symbol of longevity and happiness. The dragon or snake, *naga*, sometimes has a large crest or wings and may be depicted in opposed pairs. The *naga*, prevalent motif throughout Indonesian arts, symbolises fertility, water and the underworld.

Representations of natural phenomena are also included in *semen* motifs. Although rocks and clouds are significant in Javanese mythology and symbolise the union of heaven and earth, their form in batik has been strongly influenced by Chinese designs. Similar observations can be made with regard to depictions of mountains and landscapes. Stylised human figures taken from shadow theatre, which are thought to have evolved as a result of Muslim restrictions, may be seen in batik. These have become increasingly popular with the growth of tourism, as have more realistic designs showing scenes from daily life, especially people at work in villages and in the fields.

Although batik designs were drawn from a broadly based Javanese tradition, the courts issued decrees, especially during the eighteenth century, that forbade commoners from wearing specific patterns. In Surakarta, for example, only the sultan and his close relatives were permitted to wear designs such as *parang rusak*, *sawat*, *udan liris* and *cemukiran* foliage borders. Likewise *parang rusak*, *sembangen* and large garuda patterns were reserved for the ruler's family in Yogyakarta.

Many of the designs which are encountered in Javanese batik are found elsewhere in the archipelago, though they vary stylistically and may be made with different techniques. One of the most im-

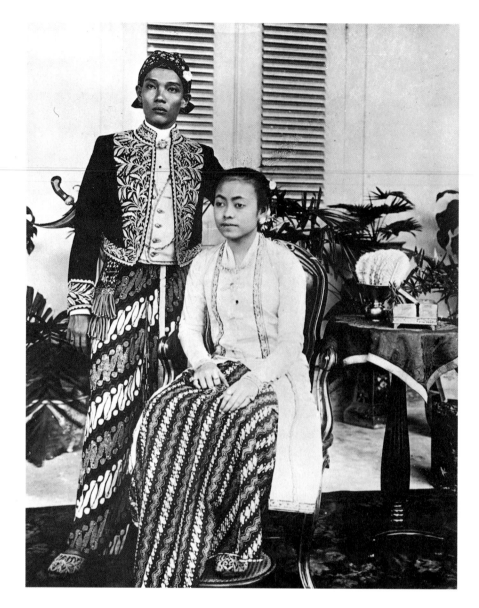

Prince and Princess Pakualam of the junior line of the Yogyakarta royal family in 1910. The *parang rusak* patterns on their batik waist-cloths, *kain*, were restricted to members of the court. An essential part of male Javanese dress is the kris, the hilt of which can be seen projecting from behind the prince's back.
Royal Anthropological Institute.

Opposite Waist-cloth, *kain*, bearing the clucking chicken, *ayam puger* design, a symbol of fertility. Cotton, *batik cap*. Collected by Prof. M. A. Jaspan in Banyumas, south-west Java (Kwee Djie Siqe brand).
254 × 207 cm. Hull University, CSEAS 74.85.

portant motifs is the ship, which is sometimes represented in Java as a beached vessel containing a pair of facing birds. In Lampung particularly elaborate varieties of sailing craft are woven in supplementary weft. The ship is shown transporting the souls of the deceased, along with elephants, across seas rich in fish and skies replete with birds and mythical creatures. Supplementary-weft fabrics bearing 'ships of the dead' are known in Kroë, south Sumatra and west Sumbawa.

The bird motif is popular in Java and may be used to decorate textiles in Kisar, Roti and Flores. Birds representing the soul can be seen on Rejang cloths from Sumatra and on Atoni blankets from Timor. The Bimanese weave bird patterns with supplementary weft, and though the patterns are regarded as purely decorative, they may have at one time been symbolically significant. The rooster, another

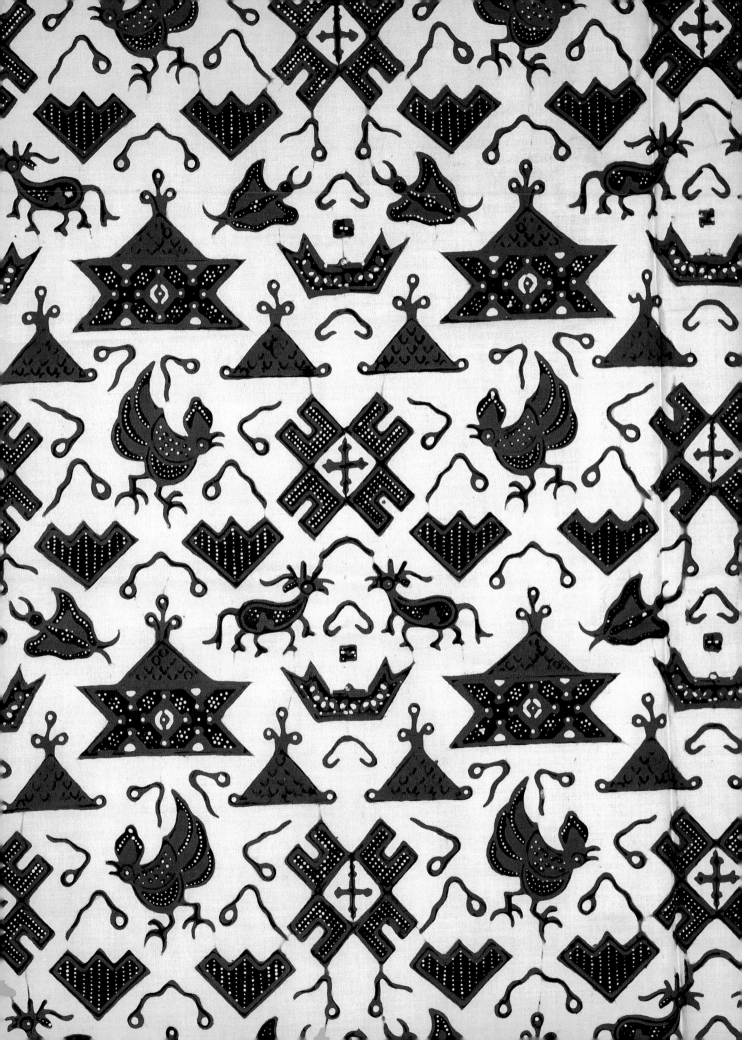

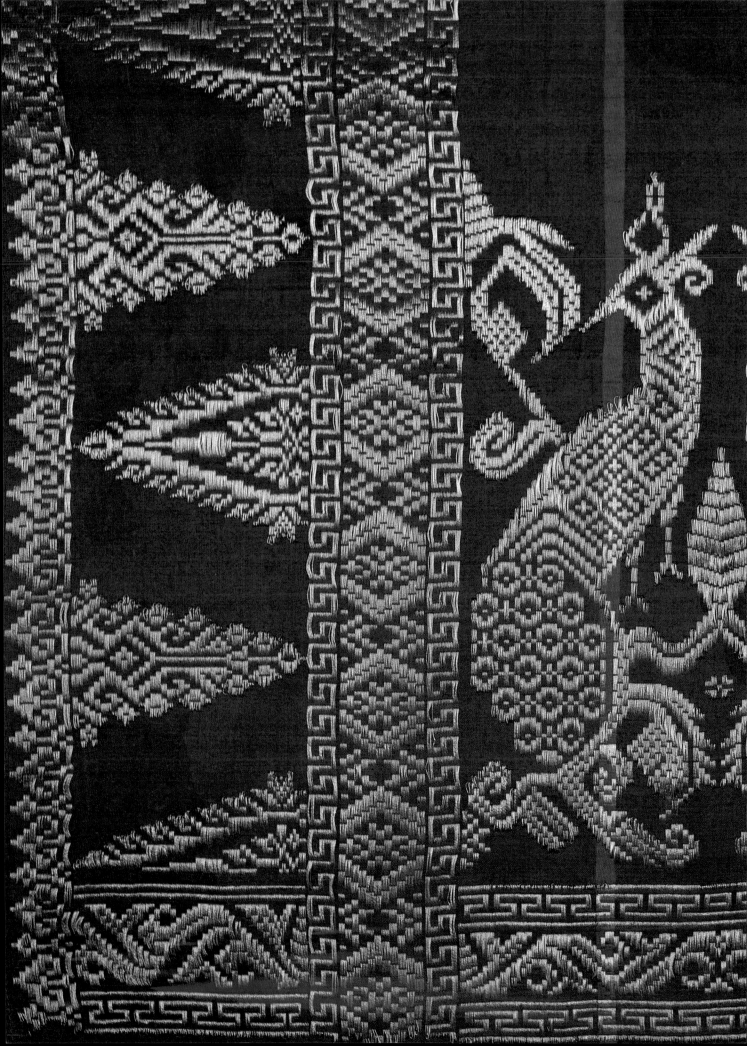

important symbol, can be seen on warp-ikat fabrics from Sumba and Timor. In Bali the peacock, which serves as a divine mount in Hindu mythology, is depicted in both *perada* and in supplementary weft.

Representations of deer can be seen in early Indonesian art from both the prehistoric and Hindu-Javanese eras. Today deer motifs, especially the stag, are made in batik from Java, warp ikat from Sumba and supplementary weft from Bima. The elephant is also an ancient motif, included not only in 'ship of the dead' designs from south Sumatra but also on warp-ikat textiles from Sumba. On certain textiles the water buffalo, like the elephant, is associated with the hereafter. Ancestor figures are depicted standing on buffalo on cloths from the Lake Ranau region in Sumatra. Similar notions are encountered in central Sulawesi: during the traditional funeral feasts of the Toraja buffalo are slaughtered, and one serves the deceased as a mount in the afterlife. In Toraja cloths pairs of buffalo are shown harnessed to ploughs, whereas in Timor they appear in supplementary-warp panels alongside other animals. The horse and rider, another man-animal design, is used in warp ikat in central Flores and in supplementary warp in east Sumba. The prancing horse is also known in Sumba.

Trees have strong mythic-symbolic associations in insular South-East Asia. Large trees in many societies are traditionally venerated as the sacred dwelling-places of guardian spirits. The 'wishing tree', or 'tree of heaven', can be seen on bas-reliefs at Borobudur, its trunk surrounded with pots containing offerings and its branches full of ornaments. 'Tree of life' patterns are woven with supplementary wefts in Kroë, south Sumatra, and in west Sumbawa, and with supplementary warps in east Sumba. The people of Sumba also make skull-tree designs in warp ikat and supplementary warp (skulls used to be displayed in trees outside the homes of successful head-hunters).

Shrimp, lobster and crayfish designs are associated with death and resurrection. The manner in which crustacea shed their skins is likened to the dangerous passage of the soul as it leaves the body. On Sumba warp-ikat fabrics decorated with these motifs are used as shrouds. Other marine creatures that appear on Sumba cloths include crabs, octopi and fish.

Outside Java snake and dragon motifs are made with a variety of methods. Embroidery and couching are used in Bali, supplementary warp in east Sumba, and *sungkit* in west Borneo. The people of Sumba also make lizard designs in supplementary warp, whereas in Timor

Balinese sarong decorated with peacock and *tumpal* designs woven in silver supplementary wefts on a silk ground weave. Ubud, Bali. 179 × 101 cm.

these creatures are executed in warp ikat or embroidery. Reptiles such as snakes, lizards and crocodiles can be seen in Iban textiles from Sarawak, as well as various kinds of spiders and centipedes.

Colour

Not only are textile designs meaningful, but so are many of the colours in which they are executed. Colour is both aesthetically and symbolically significant, and in many Indonesian societies it may be used to express differences in age, rank, occupation and ethnic affiliation. In central Java, for example, indigo blue, brown, cream and green are considered to be among the most refined colours. Generally speaking central Javanese hues are restrained, though the central lozenge on the *kemben*, or breast-cloth, may be brightly coloured. Batik makers from the north coast also traditionally use a wider range of hues than their counterparts in central Java.

Colour symbolism is especially important in east Java, particularly in villages where traditional dyes are used. According to Rens Heringa (1989), the Javanese distinguish four main colours – white, red, yellow and blue-black – each of which is associated with the cardinal points, the stages of the day and night, and the life cycle. In this system life is thought to originate in the east, which corresponds with white, and runs clockwise towards youth and adolescence, passing the south in gradually darkening shades of red. Life moves on to yellow, the colour of maturity in the west, and then through green and finally blue-black (north). Shades of greyish-blue lie between the north and the east which, in accordance with ancient Indonesian notions of reincarnation, are connected to the invisible period between death and rebirth.

Heringa has also described the sequence of east Javanese cloths that serve as a metaphor for the life journey. Life commences in the east with a plain white cloth which is wrapped around the abdomen of the mother during the seventh month of her pregnancy when the baby is thought to come into existence (see p. 136). At the time of delivery the young woman is presented with a coloured fabric, *putihan*, by her own mother. This cloth has bright blue designs on a white background and is wrapped around the baby to protect it from evil. The next important generational cloth is received at puberty when the girl is considered to be ready for marriage. Known as a *bangrad*, this textile has bright red motifs that stand out against the white base. Once married the woman wears a cloth, given by her husband's family, which is decorated with dark blue botanical patterns, whereas her spouse adopts a textile with red designs that symbolises his junior position in relation to his new father-in-law. On becoming a mother the woman wears a *pipitan* cloth bearing bright red, blue and black motifs. The black on *pipitan* designs is perceived as a combination of red and blue and symbolises the union of the

husband and wife. The *pipitan* cloth also has a ritual or esoteric meaning in which yellow, the western direction associated with maturity, is stressed. The next stage is achieved when the woman becomes a grandmother and wears the dark *irengan* cloth, indicating that she has left the fertile stage of life. Though not visible, the dyes that are mixed to produce the dark *irengan* patterns are also ascribed symbolic value. A brief phase of procreation is associated with greenish-yellow, belonging to the north-west, the first dye that is used. Dark red, the second dye, represents the woman's declining fertility in comparison with her daughter's and granddaughter's, while dark blue, the final dye, adds the essence that will ensure the continuity of life beyond the grave.

Other Indonesian peoples also associate age and gender with colour. Among the Balinese of west Lombok, for example, old men wear colours that are blackish, whereas women wear colours that are reddish. As has been noted by Andrew Duff-Cooper (1984), the Lombok Balinese liken males and females to the gods Wisnu and Brahma whose colours, red and black respectively, are related as superior (male) and inferior (female). Colour is also used to indicate age in west Lombok where the young wear light shades and the old darker hues.

Differences in age, especially among women, are represented by colour among the Bimanese of neighbouring Sumbawa. One of the most significant hues is *bako*, a rose-pink that is associated with young women and is worn by brides. The wedding reception is the last time a woman wears rose-pink; thereafter she adopts *onggu* (brown/purple), the colour of restraint and sagacity. Men are said to find rose-pink irresistible, a point that is emphasised in an old Bimanese tale. The story concerns a carpenter who when distracted by a passing maiden in a rose-pink sarong fails to complete his allocated task. As a consequence numerous projects are delayed throughout the realm until even the sultan himself is inconvenienced. The ruler angrily demands to know the cause of the hindrance, and his dutiful retainers trace the problem back through the system to the carpenter. When asked for an explanation, the hapless craftsman blames the girl, who in turn blames the sarong. These excuses are received sympathetically by the sultan and in the final outcome nobody is punished. The colour of the textile is held to be responsible for the problems and therefore everybody saves face. Rose-pink is still esteemed by the Bimanese, and blouses in this colour are worn by young dancers belonging to cultural organisations that keep alive local court traditions.

Bright colours are also perceived as 'youthful' by seafaring peoples such as the Malays, Buginese and Makasarese. Among the Malays, for example, the colour red is associated with vitality, and yellow (as a form of gold) with health, wealth and success. These hues are often

The daughters of members of La Mbila, the Bimanese cultural organisation, wearing handwoven local sarongs, *tembé*, during a rehearsal for a presidential visit in 1981. The oldest girl wears a rose-pink blouse to show that she is approaching marriageable age. Bima Airport.

175

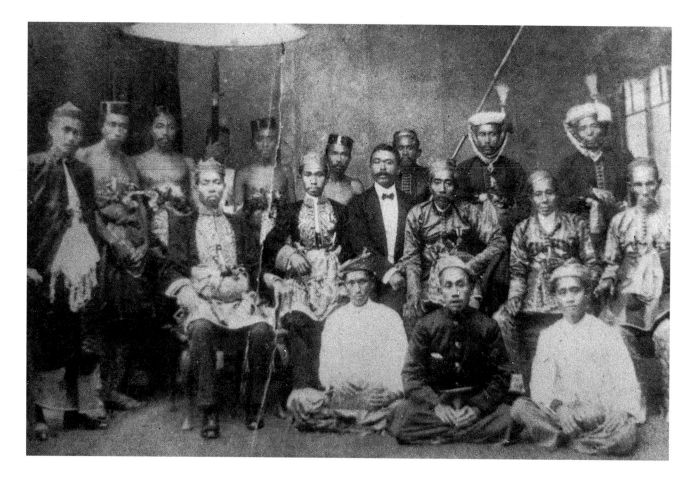

A portrait of the Sultan of Bima and his retinue taken shortly after the annexation of eastern Sumbawa by the Dutch in 1905. The three seated ministers to the right of the colonial representative would probably have worn blue-black sarongs, *weri*, decorated with silver supplementary wefts. The military personnel with turbans in the back row wore red to symbolise their bravery. (Published with kind permission of the Royal Family of Bima.)

worn by brides and grooms during wedding receptions when they dress as royalty for the day.

In addition to age, rank and occupation can be communicated through the use of colour. Until the early twentieth century, for instance, yellow clothes were often associated with gold, especially among Malays, and were therefore reserved for royalty. Similar notions are found among other coastal peoples. The Bimanese traditionally link the symbolic value of colour to humoral fluids in the body that are thought to influence behaviour. Sultanate troops in eastern Sumbawa used to wear red, the colour of blood, as an indication of their bravery, whereas courtiers wore blue-black-checked sarongs to symbolise their loyalty. The latter fabrics were decorated with *tumpal* motifs woven in silver yarns, and these sarongs were meaningful not only in terms of colour but also in relation to their designs and materials.

Concepts of relative purity can be conveyed with the aid of colour. The Inner Badui of west Java, for example, who traditionally shun contact with the outside world, wear white; the Outer Badui, however, wear black because they act as mediators and therefore have more dealings with neighbouring populations who are regarded as impure. White is also worn by the Hindu priests of Bali and west

Lombok, who are deemed to be ritually pure, and by Muslim pilgrims on their way to Mecca. On feastdays in eastern Sumbawa the sultan traditionally wore white clothes to show that he was incapable of sin. Other Indonesian peoples who attach religious significance to colour include the Toraja who conceive of the universe in terms of four hues – red (the blood of sacrificial animals), black (death), yellow (fertility) and white (the supreme deity).

The use of colour may be closely connected with notions of ethnicity, as is sometimes the case in Nusa Tenggara where coastal populations may differ from those living inland. The descendants of trading and seafaring peoples, who historically had access to both imported fabrics and a wide range of dyes, can be distinguished from up-country dwellers whose fabrics are often traditionally dyed only with indigo. The Javanese also differentiate between the colours worn by inland people and the more ethnically diverse coastal dwellers. The former tend to wear hues belonging to a restricted palette that is considered to be refined, whereas the latter have access to a wider range of more vivid colours. Although the Balinese culturally have much in common with the Javanese, their textiles are often characterised by the use of bright colours. Sometimes one group will imitate the colours worn by another, as is the case in eastern Sumbawa where textiles known as *tembé bugis* ('Buginese sarong') are woven in pink and mushroom hues that resemble checked cloths made in southern Sulawesi.

The festive attire of this young Balinese boy eating refreshing ices includes two different kinds of waist-cloths and a head-cloth. Kuta, 1989.

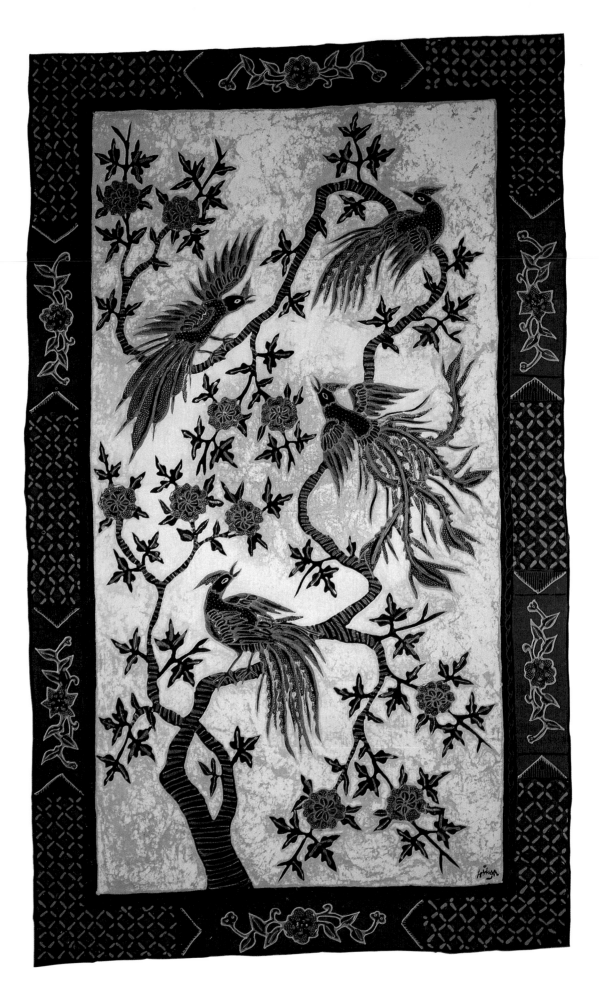

8

Conclusion

Batik 'painting' showing birds on a
tree branch with blossoms. Cotton,
batik tulis. 149 × 93 cm.
Yogyakarta, 1989.

Although the Indonesian archipelago is famed for fabrics decorated with batik and ikat, it possesses numerous other fascinating textile traditions. The peoples of this chain of islands make use of a wide range of techniques to produce fabrics of great elegance and ingenuity. Their designs reflect not only native ethnic diversity but many foreign influences, especially from India and China. As well as being items of trade and inheritance, Indonesian textiles are ritually important and may be displayed during rites of passage such as coming of age and marriage. By studying textiles it is possible to learn much about traditional skills and knowledge, and gain a deeper understanding of the region.

Indonesian textiles are immensely varied, and the fabrics made by different peoples can usually be distinguished from one another. In spite of this diversity, however, scholars have detected common themes, some of which have been attributed to the prehistoric origins of the inhabitants of the Indonesian Archipelago. Much of the debate concerning Indonesian prehistory has revolved around the question of the existence of a link between the Austronesian languages and the ancient material culture of Indonesia, the Philippines and many of the Pacific Islands. Von Heine-Geldern (1932, 1938, 1945), for example, accounted for the overlap between Austronesian language and certain material remains in terms of identifiable waves of migrations from the Asian mainland. His critics, however, have argued that the history of the migration of speakers of Austronesian languages to the area is more complicated and cannot be described as having occurred in waves. Furthermore, some technical and linguistic elements could also have been acquired through interaction and possibly trade between different groups.

179

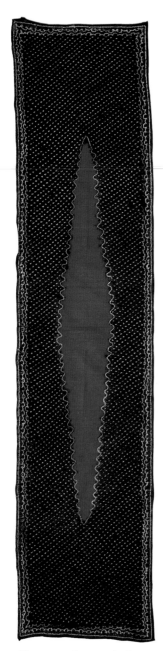

Central Javanese breast-cloth, *kemben*, decorated with *batik tulis*. British Museum.

When applied specifically to the study of Indonesian textiles von Heine-Geldern's 'wave theory' is also problematic, especially with regard to the correlation between language and weaving technology. 'Indonesian'-style looms are, for example, found among non-Austronesian peoples on the Asian mainland, whereas they are not encountered among the speakers of Austronesian languages in the east and south Pacific. Nevertheless, as is demonstrated by the presence of both Austronesian languages and 'Indonesian'-style weaving skills on the island of Madagascar, which was settled by Indonesian seafarers, migration theories cannot be discounted entirely. It does seem reasonable to assume, therefore, that both interaction between prehistoric peoples and migration, with the emphasis on the former, have influenced the development of Indonesian textiles over time. The inhabitants of the Indonesian Archipelago possess a common heritage which dates back to the neolithic and bronze/iron ages.

The archipelago lies astride the ancient trade routes between India and China, and Indonesian design has been enriched through contact with these civilisations. Aspects of Indonesian textile technology can also be traced back to Chinese and Indian sources. Arab and Indian Muslims, and later Christian Europeans, have all exerted an influence upon Indonesian textiles. Foreign influences are, however, more apparent in the coastal communities that had contact with the outside world than among the more isolated upriver and highland peoples who were historically more reliant on indigenous design registers. Post-colonial nationalism has also affected the Indonesian textile tradition, particularly in the ways in which different governments have encouraged local industries. Many new designs reflect national values; regional fabrics, however, remain important symbols of cultural affiliation in modern multi-ethnic states.

Common themes can be detected not only in Indonesian fabric design but in the way textiles are used in different social contexts. Throughout insular South-East Asia textiles are symbolically female and it is usually the women who are the makers of cloth. Textiles are also widely attributed protective properties and redisplayed or exchanged during festivals that mark transitional stages in the life cycle when the individual is held to be especially vulnerable to malevolent forces. Cloth is ritually important in societies that do not traditionally produce textiles, though this valued commodity has to be obtained by trade. Textiles are also associated with wealth and prestige, and in many regions cloth is used to indicate rank, occupation and marital status. However, access to the most esteemed designs is no longer restricted to the high-born, as was the case until the early twentieth century.

The process of modernisation and development in insular South-East Asia has affected traditonal ways of life. As beliefs and customs

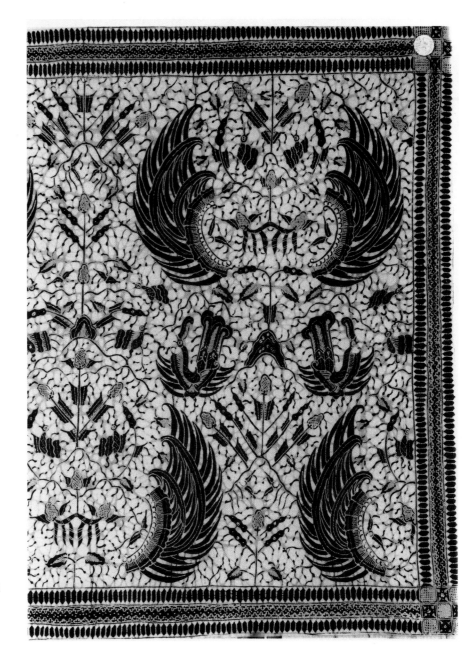

Javanese waist-cloth, *kain*, decorated with garuda wings, phoenix and botanical patterns. 257 × 51 cm. Horniman Museum.

have changed, some textiles have ceased to be made, their original purpose having become redundant. The textiles which are no longer produced include the ship cloths of South Sumatra; the cotton textiles, known collectively as *kain bentenan*, of Minahassa; the court sarongs, *weri*, of Bima, Sumbawa; and Isnai warp-ikat fabrics from the Philippines. Some Indonesian textiles can now be seen only in museums, and antique cloths are eagerly sought by private collectors. Old fabrics are, however, an important design resource in their countries of origin, and there is increasing concern both in South-East Asia and the West regarding the illicit removal of cultural property.

Some crafts, including weaving, have declined as a result of

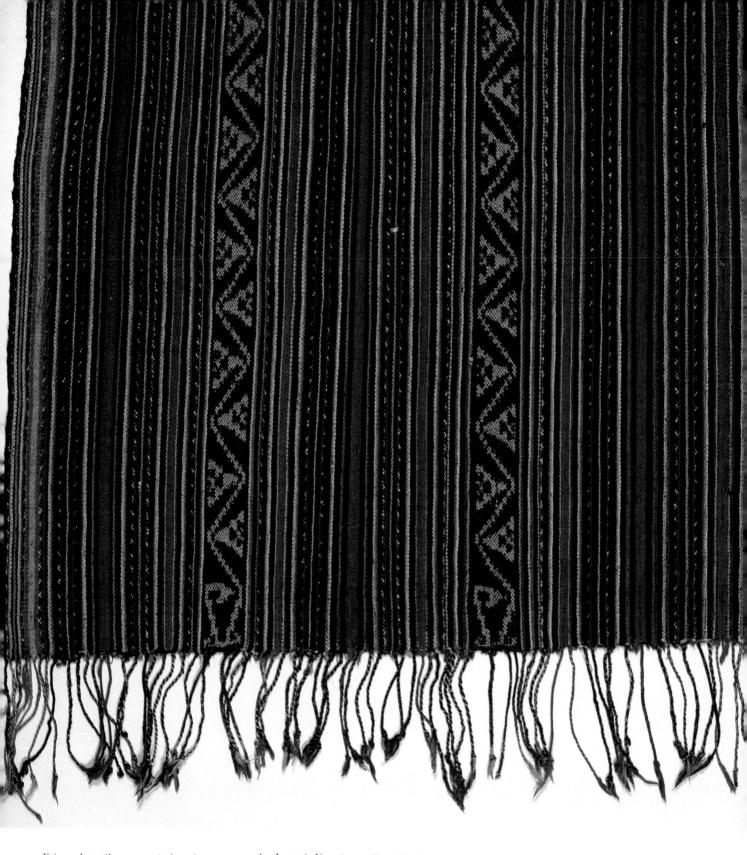

Fringed textile woven in handspun cotton and decorated with warp stripes and warp ikat. Early 20th century. East (formerly Portuguese) Timor. British Museum, 1927.2–15.2.

industrialisation. Textile factories provide the greatest challenge to the indigenous handloom industries of the Indonesian Archipelago. A factory can produce in a day what a skilled worker may take many months to achieve. Some factories make use of traditional designs, and though their textiles may not match the original in terms of craftsmanship, they are cheaper and are appreciated by those with

lower resources. Many domestic producers have gone out of business, and skilled people have been lost to the expanding factories. Some craft industries, however, have survived by exploiting regional and custom-made markets that are not so easily penetrated by large-scale concerns. Tourism has also provided a boost for craft industries in some regions, especially in Java and Bali. In spite of their difficulties craft workers make an important contribution to national development. The domestic producer has low overheads and can adapt to changes in market conditions without a great deal of investment.

The Indonesian Archipelago historically possessed two major, though interrelated, textile traditions: that of the courts and that of the countryside. Although royal patronage declined during the postcolonial era, former court weavers and dyers, and their descendants, can still be found in workshops surrounding the old palaces. Many of these specialists survive today by making cloth for local businessmen and administrators, as well as tourists. Some independence leaders, however, who formerly regarded the ancient traditions as a handicap to economic and political development have realised the important role played by handicrafts in promoting cultural and national values. Today the new patrons are increasingly government, business and community leaders who are concerned with the maintenance of traditional skills. Textile schools and academies, and museums, are all an integral part of the Indonesian craft revival. Given urban unemployment and the ongoing migration to the cities, the significance of rural industries is also beginning to be appreciated. Although the returns are low, cloth can be woven during lulls in the agricultural cycle, providing a much-needed additional source of income.

Within the context of rapidly dwindling resources the Indonesian Archipelago is increasingly being regarded as a vast storehouse of knowledge. Much international debate has concerned the value of traditional knowledge in medical research, and tropical rainforests are now widely seen as 'natural pharmacies'. But what should not be overlooked is the fact that the archipelago is also one of the world's richest sources of natural fibres and dyes. In view of the difficulties faced in trying to dispose of or recycle some synthetic fabrics more attention is being paid to traditional textile skills. Researchers are now interested in investigating natural fibres that have similar properties to synthetics but which have the advantage of being more readily biodegradable. Some of the qualities of traditional dyes are also not always easy to replicate by chemical means. Although recognition of the value of traditional skills is to be welcomed, care should be taken with regard to the intellectual and cultural rights of the weavers and dyers who provide much of this information.

Indonesian textiles are now being promoted as export items.

Traditional weavers have been adapted for different purposes and are used to make fashion garments, bags, kimonos, belts, underwear, curtains, hats, upholstery fabrics, table-cloths, bed-linen, wall-hangings and lampshades. As well as traditional yarns a wide variety of other materials are used such as wool, canvas and synthetics. Traditional designs have been modified to suit customers from

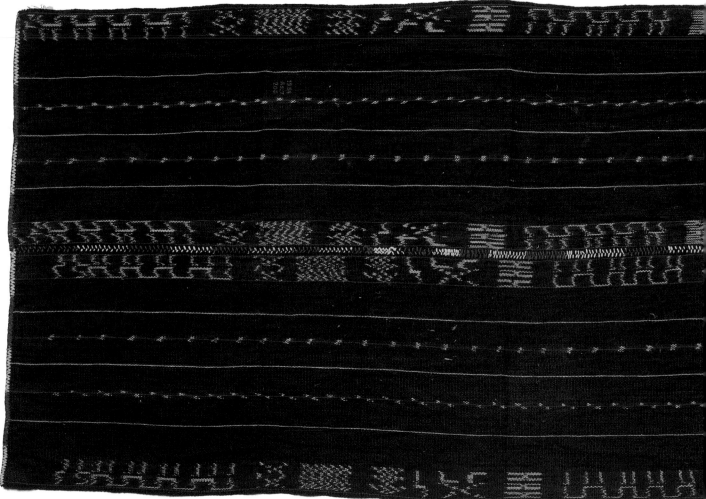

Textile woven in handspun cotton and decorated with warp stripes and warp ikat, thought to have been used in rituals associated with head-hunting. Ifugao, Philippines. British Museum, 1954. AS7.206.

different cultural backgrounds, and foreign companies often commission fabrics for their own purposes. European, Australian, American and Japanese designers have also worked with local dyers and weavers to create new kinds of textiles. There are increasing numbers of South-East Asian designers who prepare fabrics for international markets, and Indonesian textiles can be found in craft shops throughout the world. Exhibitions mounted by Western museums and galleries have helped to bring the subject of Indonesian textiles to a wider audience. Textile enthusiasts, design and art students, and teachers in many different countries are developing an interest in the complex world of Indonesian textiles.

In a broad-ranging account such as this it has not been possible to

deal with every topic in detail. The subject of Indonesian textiles is vast, and this book is intended to provide an overview that draws attention to certain issues rather than provide an encyclopedic record. Although the amount of information concerning Indonesian textiles has increased dramatically over the last decade, many important areas remain relatively unresearched. Some traditions have

Above right Batik-style print showing Arjuna and Kresna in a chariot on their way to fight the forces of evil. Collected by Prof. M. A. Jaspan in Yogyakarta, 1969. 92 × 86.5 cm. Hull University, CSEAS 69.44.

also fallen into disuse before they could be fully documented, leaving gaps in the available knowledge. There is still much to be learned about the meaning and interpretation of designs, the social use of cloth, and the value of traditional dyes and fibres in a modern context. The study of Indonesian textiles is also multi-disciplinary in character and embraces research in anthropology, developmental sociology, botany, history, textile technology, art and design. The meeting-point of these different subjects, though difficult to define, is ultimately rewarding. Finally, this field is not static, and new methods and designs are constantly being introduced as new ways of combining materials are being explored, enriching a tradition that is forever changing.

Bibliography

1 Introduction

BARBOSA, Duarte, 1921. *The Book of Duarte Barbosa*, ed. Mansel Longworth Dames, 2 vols, London, Hakluyt Society

BARNES, Ruth. 1989. *The Ikat Textiles of Lamalera: A Study of an Eastern Indonesian Weaving Tradition*, Leiden, E. J. Brill

BÜHLER, Alfred. 1954. 'Plangi – the tie and dye work', *Ciba Review*, 104: 3722–48

BÜHLER, Alfred. 1959. 'Patola influences in Southeast Asia', *Journal of Indian Textile History*, 4: 4–46

BÜHLER, Alfred, and FISHER, Eberhard. 1979. *The Patola of Gujarat: Double Ikat in India*, 2 vols, Basle, Krebs

CHAU JU-KUA. 1966. *His Work on the Chinese and Arab Trade in the Twelfth and Thirteenth Centuries Entitled Chu-fan-chi*, trans. and annot. F. Hirth and W. W. Rockhill, New York, Paragon Book Reprint Corp.

CRYSTAL, David. 1987. *The Cambridge Encyclopedia of Language*, Cambridge, Cambridge University Press

FOX, R. R.. 1970. *The Tabon Caves: Archaeological Explorations and Excavations on Palawan Island, Philippines*, Manila, National Museum

HALL, D. G. E. 1968. *A History of South-East Asia*, 3rd edn, London, Macmillan Press Ltd

HEINE-GELDERN, Robert von. 1932. 'Urheimat und früheste wanderungen der Austronesier', *Anthropos* 27: 543–619

HEINE-GELDERN, Robert von. 1937. 'L'art prébouddhique de la Chine et de l'Asie Sud-est et son influence en Oceanie', *Revue des Arts Asiatiques* 11: 177–206

HITCHCOCK, Michael. 1987. 'Colonial images in textile research', *Indonesia Circle*, 42 (March): 92–6

JASPER, J. E., and MAS PIRNGADIE. 1912. *De Weefkunst*, vol. 2, De Inlandsche Kunstnijverheid in Nederlandsch Indië, The Hague

JASPER, J. E., and MAS PIRNGADIE. 1916. *De Batikkunst*, vol. 3, De Inlandsche Kunstnijverheid in Nederlandsch Indië, The Hague

LOEBER, J. A. 1926. *Das Batiken: Eine Blute Indonesischen Kunstlebens*, Oldenburg, O. G. Stalling

MA HUAN. 1433. *Ying-yai Sheng-lan* (The Overall Survey of the Ocean's Shores), trans. and ed. Feng Ch'eng-Chun with introd. by J. V. G. Mills, 1970, Cambridge, Cambridge University Press

MAXWELL, John R. and Robyn J. 1976. *Textiles of Indonesia: an Introductory Handbook*, exh. cat., Indonesian Arts Society and National Gallery of Victoria, Australia

NETTLESHIP, M. A. 1978. 'Weaving in its social context among the Atayal of Taiwan', in *Art and Society*, ed. M. Greenhalgh and V. Megaw, London, Duckworth and Co.

PICTON, John, and MACK, John. 1989. *African Textiles*, London, British Museum Publications

RAFFLES, Thomas Stamford. 1817. *The History of Java*, 2 vols, London, Black, Parbury and Allen, Booksellers to the Hon. East India Company, and John Murray

SOLHEIM, W. G. 1957. 'The Kalanay pottery complex in the Philippines', *Artibus Asiae* 20: 279–88

VAN HEEKEREN, H. R. 1957. *The Stone Age of Indonesia* (1972, The Hague, Martinus Nijhoff, Verhandelingen van het Koninklijk Instituut voor Taal-, Land- en Volkenkunde 61)

WALLACE, Alfred Russel. 1869. *The Malay Archipelago*, London, Macmillan and Co. (1962, New York, Dover)

WISSEMAN CHRISTIE, Jan. 1990. 'Ikat to batik? epigraphic data on textiles in early Java between the ninth and the fifteenth centuries A.D.', unpublished conference paper, ASEASUK AGM, University of Kent

2 The Raw Materials

ALMAN, John and Elizabeth. 1968 (repr. 1973). *Handicrafts in Sabah*, Kuching, Borneo Literature Bureau

BACKER, C. A., and BAKHUIZEN VAN DEN BRINK, R. C. 1963 (vol.1), 1965 (vol. 2), 1968 (vol. 3). *Flora of Java*, Wolters-Noordhof

BARNES, Ruth. 1989. *The Ikat Textiles of Lamalera: A Study of an Eastern Indonesian Weaving Tradition*, Leiden, E. J. Brill

BÜHLER, Alfred. 1941. 'Turkey red dyeing in South and Southeast Asia', *Ciba Review* 39: 1423–6

BÜHLER, Alfred. 1951. 'Indigo dyeing among primitive races', *Ciba Review* 85: 3089–90

BURKILL, I. H. 1966. *A Dictionary of the Economic Products of the Malay Peninsula*, 2 vols, Kuala Lumpur, Ministry of Agriculture and Co-operatives

CASAL, Gabriel, REGALDADO, T. José, CASINO, Eric S., ELLIS, George R., and SOLHEIM, Wilhelm G. 1981. *The People and Art of the Philippines*, Los Angeles, Museum of Cultural History, University of California

CRYSTAL, Eric. 1979. 'Mountain ikats and coastal silks: traditional textiles in South Sulawesi', in *Threads of Tradition: Textiles of Indonesia and Sarawak*, ed. J. Fischer, Berkeley, Lowie Museum of Anthropology, University Art Museum, University of California

FRASER-LU, Sylvia. 1988. *Handwoven Textiles of South-East Asia*, Singapore, Oxford University Press

GITTINGER, Mattiebelle. 1979. *Splendid Symbols: Textiles and Tradition in Indonesia*, Washington DC, Textile Museum

HADDON, A. C., and START, L. E. 1936. *Iban or Sea Dayak Fabrics and Their Patterns*, Cambridge, Cambridge University Press (1982, Carlton, Ruth Bean)

HANNON, Farrell. 1983. 'Sumbanese ikat', *The Weaver's Journal* 8:1 (summer): 38–40

HERINGA, Rens. 1989. 'Dye process and life sequence: the coloring of textiles in an East Javanese village', in *To Speak with Cloth: Studies in Indonesian Textiles*, ed., M. Gittinger, Los Angeles, Museum of Cultural History, University of California

HITCHCOCK, Michael. 1983. 'Technology and Society in Bima, Sumbawa, with Special Reference to House Building and Textile Manufacture', unpublished D.Phil. thesis, University of Oxford

MABBERLEY, P. J. 1987. *The Plant Book*, Cambridge, Cambridge University Press

NOOY-PALM, Hetty. 1962. 'Dress and ornament of the Sa'dan Toradja (Celebes, Indonesia), *Tropical Man* 2: 162–94

PARKER, Luther. 1913. 'Primitive looms and weaving in the Philippines', *The Philippine Craftsman* 2:6: 376–97

SKEAT, W. W. 1902. 'Silk and cotton dyeing by Malays', *Journal of the Straits Branch of the Royal Asiatic Society* 38: 123–7

SUVATABANDHU, Kasin. 1964. 'Buddhist rules prescribe dyes for monks' robes', *Brooklyn Botanic Garden*:45–6

WARMING, Wanda, and GAWORSKI, Michael. 1981. *The World of Indonesian Textiles*, Tokyo, Kodansha

WESTPHAL, E., and JANSEN, P. C. M. (eds). 1989. *Plant Resources of South-East Asia: A Selection*, Wageningen, Pudoc

WINGATE, Isobel. 1974. *Fairchild's Dictionary of Textiles*, New York, Fairchild Publications Inc.

WISSEMAN CHRISTIE, Jan. 1982. 'Patterns of Trade in Western Indonesia: Ninth Through Thirteenth Centuries A.D.', unpublished Ph.D. thesis, School of Oriental and African Studies, University of London

ZERNER, Charles. 1982. 'Silks from Southern Sulawesi', *Orientations* (February): 46–55

3 Traditional Looms

ADAMS, Marie Jeanne. 1977. 'A "forgotten" bronze ship and a recently discovered bronze weaver from eastern Indonesia', *Asian Perspectives* 22: 87–109

ALMAN, John H. 1960. 'Bajau weaving', *Sarawak Museum Journal* 9, 15–16: 603–18

ALMAN, John H. 1962. 'Dusun weaving', *Sabah Society Journal* 2

BARNES, Ruth. 1989. *The Ikat Textiles of Lamalera: A Study of an Eastern Indonesian Weaving Tradition*, Leiden, E. J. Brill

BOLLAND, Rita. 1956. 'Weaving a Sumba woman's skirt', in *Lamak and Malat in Bali and a Sumba Loom*, Th. P. Galestin, L. Langewis and R. Bolland, Amsterdam, Royal Tropical Insitute

BOLLAND, Rita. 1970. 'Three looms for tablet weaving', *Tropical Man* 3: 160–89

BOLLAND, Rita. 1971. 'A comparison between the looms used in Bali and Lombok for weaving sacred cloths', *Tropical Man* 4: 171–82

BOLLAND, Rita. 1977. 'Weaving the pinatikan, a warp-patterned kain bentenan from North Celebes', in *Studies in Textile History in Memory of Harold B. Burnham*, ed. V. Gervers, Toronto, Royal Ontario Museum

BÜHLER, Alfred. 1940. 'The essentials of handicrafts and crafts of weaving among primitive peoples', *Ciba Review* 30: 1064–85

BURNHAM, Dorothy K. 1981. *A Textile Terminology: Warp and Weft*, London, Routledge and Kegan Paul

FRASER-LU, Sylvia. 1988. *Handwoven Textiles of South-East Asia*, Singapore, Oxford University Press

GITTINGER, Mattiebelle. 1979. 'An introduction to the body-tension looms and simple frame looms of Southeast Asia', in *Looms and Their Products: Irene Emery Roundtable on Museum Textiles, 1977 Proceedings*, ed. I. Emery and P. Fiske, Washington DC, Textile Museum

HECHT, A. 1989. *The Art of the Loom*, London, British Museum Publications

HILL, A. H. 1949. 'Weaving industry of Trengganu', *Journal of the Malayan British Royal Asiatic Society* 22, 3: 75–84

HITCHCOCK, Michael. 1984. 'Thesis research and collecting: a fieldworker's view', in *The General's Gift: A Celebration of the Pitt Rivers Museum Centenary (1884–1984)*, ed. B. A. L. Cranstone and S. Seidenberg, Oxford, *Journal of the Anthropological Society of Oxford*/Pitt Rivers Museum

HITCHCOCK, Michael. 1985. *Indonesian Textile Techniques*, Princes Risborough, Shire Publications Ltd

LING ROTH, H. 1977. *Studies in Primitive Looms*, Carlton, Ruth Bean, repr. from the original Bankfield Museum Notes, 1918

MACK, John. 1987. 'Weaving, women and the ancestors in Madagascar', *Indonesia Circle* 42: 76–91

NEWMAN, Thelma. 1977. *Contemporary Southeast Asian Arts and Crafts*, New York, Crown Publishers Inc.

RAFFLES, Thomas Stamford. 1817. *The History of Java*, 2 vols, London, Black, Parbury and Allen, Booksellers to the Hon. East India Company, and John Murray

WALLACE, Lysbeth. 1953. *Handweaving in the Philippines*, New York, United Nations Publications, Philippines 3, 1954 11, H3

4 Ikat, Batik and other Resist-dye Methods

ADAMS, Marie Jeanne. 1971. 'Tiedyeing, an art on the island of Sumba', *Handweaver and Craftsman* (winter): 9–11, 37

BOLLAND, Rita, JAGER GERLINGS, J. H., and LANGEWIS, L. 1960. *Batiks from Java*, Amsterdam, Royal Tropical Institute

BÜHLER, Alfred, RAMSEYER, Urs, and RAMSEYER-GYGI, N. 1975. *Patola and Geringsing*, Basle, Museum für Völkerkunde und Schweizerisches Museum für Volkskunde

COURTENAY, P. 1987. 'Coloniser and scholar', *The Geographical Magazine* (June): 284–7

DYRENFORTH, Noel. 1988. *The Technique of Batik*, London, B. T. Batsford Ltd

FORMAN, Bedřich. 1988. *Indonesian Batik and*

Ikat, London, Hamlyn, and Prague, Artia

FOX, James J. 1977. 'Roti, Ndao and Savu', in *Textile Traditions of Indonesia*, ed. Mary Hunt Kahlenburg, Los Angeles County Museum of Art

FRASER-LU, Sylvia. 1986. *Indonesian Batik: Processes, Patterns and Places*, Singapore, Oxford University Press

FRASER-LU, Sylvia. 1988. *Handwoven Textiles of South-East Asia*, Singapore, Oxford University Press

HIMPUNAN WASTRAPREMA. 1966. *Kain Adat (Traditional Textiles)*, Jakarta

HIMPUNAN WASTRAPREMA. 1980. *Puspita Warni*, exh. cat., batik collection of Gusti Kanjeng Putri Mangkunegoro VIII (1923–78), Jakarta, Museum Tekstil

IKLE, Charles F. 1931 (repr. 1934). 'The ikat technique and Dutch East Indian ikats', *Bulletin of the Needle and Bobbin Club* 15, 1 and 2: 1–59

IRWEN, John, and MURPHY, Veronica. 1969. *Batiks*, Victoria and Albert Museum large picture books 28, London, Her Majesty's Stationery Office

KERN, R. A. 1926. 'Tjinden en plangi in Gresik', *Djawa* 6: 193–4

KOPERBERG, S. 1922. 'De Javaansche batikindustrie', *Djawa* 2: 147–56

LANGEWIS, Laurens, and WAGNER, Frits. 1964. *Decorative Art in Indonesian Textiles*, Den Haag, N. V. Mouton & Co.

LARSEN, Jack Lenor, BÜHLER, Alfred, SOLYOM, Bronwen, and SOLYOM, Garrett. 1976. *The Dyer's Art: Ikat, Batik, Plangi*, New York, Van Nostrand Reinhold

ONG, Edric (ed.). 1986. *Pua: Iban Weavings of Sarawak*, exh. cat., Atelier Society, Sarawak, East Malaysia

PEACOCK, B. A. V. 1977. *Batik, Ikat, Pelangi and Other Traditional Textiles from Malaya*, exh. cat., Hong Kong Urban Council

ROUFFAER, G. P., and JUYNBOLL, H. H. 1900. *Die Indische Batikkunst und ihre Geschichte*, Haarlem, H. Kleinmann

SOLYOM, Bronwen, and SOLYOM, Garrett. 1977. 'Java', in *Textile Traditions of Indonesia*, ed. Mary Hunt Kahlenburg, Los Angeles County Museum

VAN NOUHUYS, J. 1925–6. 'Was-batik in Midden-Celebes', *Nederlansch Indië Ond en Nieuw* 10: 110–22

VELDHUISEN-DJAJASOEBRATA, Alit. 1972. *Batik op Java*, Rotterdam, Museum voor Land- en Volkenkunde

WARMING, Wanda, and GAWORSKI, Michael. 1981. *The World of Indonesian Textiles*, Tokyo, Kodansha

WISSEMAN CHRISTIE, Jan. 1982. 'Patterns of Trade in Western Indonesia: Ninth Through Thirteenth Centuries A.D.', unpublished Ph.D. thesis, School of Oriental and African Studies, University of London

5 Decorative Weaving, Embroidery and Related Techniques

BOLLAND, Rita. 1977. 'Weaving the pinatikan, a warp-patterned kain bentenan from North Celebes', in *Studies in Textile History in Memory of Harold B. Burnham*, ed. V. Gervers, Toronto, Royal Ontario Museum

EMERY, Irene. 1966. *The Primary Structure of Fabrics*, Washington DC, Textile Museum

FISCHER, Joseph. 1979. 'The value of tradition: an essay on Indonesian textiles', in *Threads of Tradition: Textiles of Indonesia and Sarawak*, ed. J. Fischer, Berkeley, Lowie Museum of Anthropology, University Art Museum, University of California

FORGE, A. 1978. *Balinese Traditional Paintings, A Selection from the Forge Collection of the Australian Museum, Sydney*

FRASER-LU, Sylvia. 1988. *Handwoven Textiles of South-East Asia*, Singapore, Oxford University Press

HIMPUNAN WASTRAPREMA. 1981. *Lurik: Suatu Pengantar*, Jakarta

HITCHCOCK, Michael, 1987. 'Fabrics for a Sultan', *HALI* 35, 9, 3: 14–21

HITCHCOCK, Michael. 1987. 'Tapestries from Indonesia', *The Weaver's Journal* (summer) 12, 1. 45: 55–7

JAGER GERLINGS, J. H. 1952. *Spreekende Weefsels: Studie over Onstaan en Betekenis van Weefsels van einige Indonesische Eilanden*, Mededling 99, Amsterdam, Koninklijk Instituut voor de Tropen

KARTIWA, Suwati Dra. 1986. *Kain Songket Weaving in Indonesia*, Jakarta, Penerbit Djambatan

KING, Victor T. 1985. 'Symbols of social differentiation: a comparative investigation of signs, the signified and symbolic meanings in Borneo, *Anthropos* 80: 125–52

McREYNOLDS, Pat Justiniani. 1980. 'The embroidery of Luzon and the Visayas', *Arts of Asia* (January–February): 128–33

McREYNOLDS, Pat Justiniani. 1982. 'Sacred cloth of plant and palm', *Arts of Asia* (July–August): 94–100

MALAYSIAN HANDICRAFT DEVELOPMENT CORPORATION. n.d. *Serian Songket*, Kuala Lumpur, Perbadan Memajuar Kraftangan, Malaysia

MARRISON, Geoffrey A. 1990. 'Balinese cloth painting', unpublished paper, seminar series (February), Centre for South-East Asian Studies, University of Hull

MAXWELL, John R., and MAXWELL, Robyn J. 1976. *Textiles of Indonesia: An Introductory Handbook*, exh. cat., Indonesian Arts Society and National Gallery of Victoria, Australia

PELRAS, Christian. 1962. 'Tissage balinais', *Objets et Mondes* 2, 4: 215–40

PELRAS, Christian. 1967. 'Lamak et tissus sacrés de Bali', *Objects et Mondes* 7, 4: 255–78

RAMSEYER, Urs. 1977. *The Art and Culture of Bali*, Oxford, Oxford University Press

RODGERS, S. 1985. *Power and Gold: Jewellery from Indonesia, Malaysia and the Philippines*, Geneva, Barbier-Müller Museum

SOLYOM, Bronwen and Garrett. 1973. *Textiles of the Indonesian Archipelago*, exh. cat., Honolulu, University Press of Hawaii

VAN NOUYHUS, J. W. 1918–19. 'Iets over Indische en oud – Peruaansche weeftechniek', *Nederlansch Indië Oud en Nieuw* 3: 33–5

VAN NOUYHUS, J. W. 1921–2. 'Een autochthoon weefgebied in Midden-Celebes', *Nederlansch Indië Oud en Nieuw* 6: 237–43

6 Textiles in Society

ADAMS, Marie Jeanne. 1965–6. *Leven en Dood op Sumba (Life and Death in Sumba)*, exh. cat., Museum voor Land- en Volkenkunde te Amsterdam

ADAMS, Marie Jeanne. 1973. 'Structural aspects of a village art', *American Anthropologist* 75, 1: 265–79

BARNES, R. H. 1974. *Kédang: A Study of the Collective Thought of an Eastern Indonesian People*, Oxford, Clarendon Press

BARNES, Ruth. 1989. *The Ikat Textiles of Lamalera: A Study of an Eastern Indonesian Weaving Tradition*, Leiden, E. J. Brill

BOLLAND, Rita, and POLAK, A. 1971. 'Manufacture and use of some sacred woven fabrics in a North Lombok community', *Tropical Man* 4: 149–70

CASAL, Gabriel. 1978. *T'boli Art*, Ayala Museum, Makti, Manila

CEDERROTH, Sven. 1983. 'The use of sacred cloths in the Wetu Telu culture of Bayan', *Ethnographical Museum Gothenburg, Sweden, Annual Report*, 1981/2

CRYSTAL, Eric. 1979. 'Mountain ikats and coastal silks: traditional textiles in South Sulawesi', in *Threads of Tradition: Textiles of Indonesia and Sarawak*, ed. J. Fischer, Berkeley, Lowie Museum of Anthropology, University Art Museum, University of California

DUFF-COOPER, Andrew. 1985. 'The family as an aspect of the totality of the Balinese form of life in western Lombok', *Bijdragen tot de Taal-, Land- en Volkenkunde* 141: 230–52

ELMBERG, John-Erik. 1968. 'Balance and circulation: aspects of tradition and change among the Mejprat of Irian Barat', *Stockholm, The Ethnographical Museum, Monograph Series* 12

FIEDLER, Hermann. 1929. *Die Insel Timor*, Friedrichssegen, Folkwang Auriga

FOX, James J. (ed.). 1980. *The Flow of Life: Essays on Eastern Indonesia*, Cambridge, Harvard University Press

GITTINGER, Mattiebelle. 1976. 'The ship textiles of South Sumatra: functions and design system', *Bijdragen tot de Taal-, Land- en Volkenkunde* 132: 207–27

HOWELL, W. 1912. 'The Sea-Dayak method of making thread from their home-grown cotton', *The Sarawak Museum Journal* 2 (February): 62–6

KAHLENBURG, Mary Hunt. 1979. *Rites of Passage: Textiles of the Indonesian Archipelago from the Collection of Mary Hunt Kahlenburg*, San Diego, Mingei International Museum of World Folk Art

KEITH, Gabriel Pawd, and KEITH, Emma Baban. 1983. *A Glimpse of Benguet, Kebayan Mummies*, Bagnio, Hilltop Printing Press

LOS REYES, Roberto. 1975. *Traditional Handicraft Art of the Philippines*, Manila, Casalinda Books

MOSS, Laurence A. G. 1979. 'Cloths in the cultures of the Lesser Sunda Islands', in *Threads of Tradition: Textiles of Indonesia and Sarawak*, ed. J. Fischer, Berkeley, Lowie Museum of Anthropology, University Art Museum, University of California

NIESSEN, Sandra A. 1985. *Motifs of Life in Toba Batak Texts and Textiles*, Verhandelingen van het Koninklijk Instituut voor Taal-, Land- en Volkenkunde 110, Dodrecht, Foris Publications

ROBSON, Stuart Owen. 1971. 'Waŋbaŋ Wideya: A Javanese Pañji Romance', D. Litt. thesis, The Hague, N. V. de Nederlansche Boek-en Steendrukkerij V/H H. L. Smits

ROCES, Marian Pastor. n.d. 'Fabrics of life, in *Habi: The Allure of Philippine Weavers*, brochure, Manila, Museum Division of the Intramuros Administration

SCHNITGER, F. M. 1964. *Forgotten Kingdoms of Sumatra*, Leiden, E. H. Brill

SHERFAN, Andrew D. 1976. *The Yakans of Basilan: Another Unknown and Exotic Tribe*, Cebu City, Fotomatic

SKEAT, W. W. 1900. *Malay Magic – Being an Introduction to the Folklore and Popular Religion of the Malay Peninsula*, London, Macmillan (1967, New York, Dover)

SOLYOM, Bronwen and Garrett. 1979. 'Notes and observations on Indonesian textiles', in *Threads of Tradition: Textiles of Indonesia and Sarawak*, ed. J. Fischer, Berkeley, Lowie Museum of Anthropology, University Art Museum, University of California

7 Dress, Design and Colour

ACHJADI, Judi. 1976. *Indonesian Women's Costumes*, Jakarta, Penerbit Djambatan

ACHJADI, Judi. 1976. 'Traditional costumes of Indonesia', *Arts of Asia* (September–October): 74–9

ADAMS, Marie Jeanne. 1971. 'Designs in Sumba textiles, local meanings and foreign influences', *Textile Museum Journal* 3, 2: 28–37

BERNET KEMPERS, A. J. 1959. *Ancient Indonesian Art*, Cambridge, Harvard University Press

BÜHLER, Alfred. 1959. 'Patola Influences in Southeast Asia', *Journal of Indian Textile History* 4: 4–46

DUFF-COOPER, Andrew. 1984. 'An essay on Balinese aesthetics', *University of Hull, Centre for South-East Asian Studies, Occasional Papers* 7

ENTWISTLE, L. 1975. *Kroë – Ceremonial Textiles from South Sumatra*, London, Textile Gallery

FRASER-LU, Sylvia. 1986. *Indonesian Batik: Processes, Patterns and Places*, Singapore, Oxford University Press

GITTINGER, Mattiebelle. 1979. *Splendid Symbols: Textiles and Tradition in Indonesia*, Washington DC, Textile Museum

HEINE-GELDERN, Robert von. 1937. 'L'art prébouddhique de la Chine et de l'Asie Sud-est et son influence en Oceanie', *Revue des Arts Asiatiques* 11: 177–296

GUY, John S. 1987. 'Commerce, power and mythology: Indian textiles in Indonesia', *Indonesia Circle* 42 (March): 57–75

KING, Victor T. 1985. 'Symbols of social differentiations: a comparative investigation of signs, the signified and symbolic meanings in Borneo', *Anthropos* 80: 125–52

KOOIJMAN, S. 1963. *Ornamented Bark-cloth in Indonesia*, Mededelingen van het Rijksmuseum voor Volkenkunde 16, Leiden, E. J. Brill

SPIES, Walter, and DE ZOETE, Beryl. 1938. *Dance and Drama in Bali*, London, Faber and Faber Ltd

STEINMANN, Alfred. 1946. 'The ship of the dead in textile art', *Ciba Review* 52: 1870–96

STEINMANN, Alfred. 1958. *Batik: Survey of Batik Designs*, Leigh-on-Sea, Essex, F. Lewis Publishers Ltd

SWALLOW, Deborah A. 1987. 'Javanese batiks: meaning, interpretation and change', *Indonesia Circle* 42 (March): 33–55

VAN DER HOOP, A. N. J. Th. à Th. 1949. *Indonesische Siermotieven, Ragam-Ragam Perhiasan Indonesia, Indonesian Ornamental Design*, Koninklijk Bataviaasch Genootschap van Kunsten en Wetenschappen, Bandung

WAGNER, F. A. 1949. *Sierkunst in Indonesië*, Groeningen

WAGNER, F. A. 1959. *Indonesia: The Art of an Island Group*, Methuen

8 Conclusion

FISK, E. K. 1959. 'The economics of the handloom industry of the east coast of Malaya', *Journal of the Malayan Branch of the Royal Asiatic Society* 4, 188

FRASER-LU, Sylvia. 1988. *Handwoven Textiles of South-East Asia*, Singapore, Oxford University Press

GITTINGER, Mattiebelle (ed.). 1989. *To Speak with Cloth: Studies in Indonesian Textiles*, Los Angeles, Museum of Cultural History, University of California

HEINE-GELDERN, Robert von. 1932. 'Urheimat und früheste wanderungen der Austronesier', *Anthropos* 27: 543–619

HEINE-GELDERN, Robert von. 1938. 'Ein betrag zur chronologie des Neolithicums in Sudost-Asien', *Festschrift*, F. W. Schmidt

HEINE-GELDERN, Robert von. 1945. 'Prehistoric research in the Netherlands Indies', *Science and Scientists in the Netherlands Indies*: 129–67

MAJLIS, B. K. 1984. *Indonesische Textilien*, Cologne, Rautenstrauch-Joest-Museum für Völkerkunde

PALMER, Ingrid. 1972. *Textiles in Indonesia: Problems of Import Substitution*, New York, Praeger

PARNWELL, Michael J. G. 1990. 'Rural industrialisation in Thailand', *Hull Papers in Developing Area Studies* 1, University of Hull, Centre of Developing Area Studies

SWALLOW, Deborah A. 1982. 'Production and control in the Indian garment export industry', in *From Craft to Industry: The Ethnography of Proto-Industrial Cloth Production*, ed. E. N. Goody, Cambridge, Cambridge University Press

Museums to Visit

AUSTRALIA
Australian National Gallery, Canberra, ACT
Australian Museum, Sydney, New South Wales
University Museum, James Cook University, Townsville, Queensland

AUSTRIA
Museum für Völkerkunde, Vienna

BRUNEI
Brunei Arts and Handicraft Training Centre, Kota Batu, Banda Seri Begawan
Brunei Museum, Kota Batu, Banda Seri Begawan
Malay Technology Museum, Kota Batu, Banda Seri Begawan

CANADA
National Museum of Man, Ottawa
Royal Ontario Museum, Toronto

CZECHOSLOVAKIA
Museum of the Cultures of Asia, Africa and America, Prague

DENMARK
National Museum of Denmark, Copenhagen

FRANCE
Museum of the History of Textiles, Lyon
Museum of Man, Paris

GERMANY
Deutsches Textilmuseum Krefeld, Krefeld
Hamburg Museum of Ethnology and Prehistory, Hamburg
Museum für Völkerkunde, Berlin
Museum für Völkerkunde, Frankfurt am Main
Rautenstrauch-Joest-Museum, Cologne

HUNGARY
Néprajzi Museum, Budapest

INDONESIA
Bali and Nusa Tenggara
Museum Negeri Bali, Denpasar, Bali
Museum Negeri Nusa Tenggara Barat, Mataram, Lombok
Museum Negeri Nusa Tenggara Timur, Kupang, Timor
Museum Seni, Denpasar, Bali

Java
Museum Batik Yogyakarta, Yogyakarta
Museum Indonesia, Taman Mini, Jakarta
Museum Negeri Jawa Barat, Bandung
Museum Negeri Jawa Timur, Surabaya
Museum Tekstil, Jakarta

Kalimantan
Museum Dara Yuanti, Sintang, west Kalimantan
Museum Negeri Kalimantan Selatan Lambung Mangkurat, Banjarmasin
Museum Negeri Kalimantan Tengah, Palangkaraya
Museum Negeri Kalimantan Timur Mulawarman, Tenggarong

Maluku
Museum Negeri Maluku Siwalima, Ambon

Sumatra
Museum Asserajah El Hasyimiah, Riau
Museum Negeri Aceh, Banda Aceh
Museum Negeri Sumatera Barat 'Adityawarman', Padang
Museum Negeri Sumatera Utara, Medan

ITALY
Luigi Pigorini Museum of Ethnography and Prehistory, Rome
Museum of Far Eastern Art and Ethnography, Milan

JAPAN
National Museum of Ethnology, Osaka

MALAYSIA
Lembaga Muzium Melaka, Melaka
Muzium Negara, Kuala Lumpur
Muzium Negeri Sembilan, Seremban
Muzium Perak, Perak
Muzium Sabah, Kota Kinabalu, Sabah
National Art Gallery, Kuala Lumpur
Sarawak Museum, Kuching, Sarawak

NETHERLANDS
Museum voor Volkenkunde, Delft
Museum voor Volkenkunde, Rotterdam
Rijksmuseum voor Volkenkunde, Leiden
Tropenmuseum, Amsterdam

PHILIPPINES
Aga Khan Museum, Marawi City
Bayanihan Folk Arts Museum, Manila
Museo de Oro Foundation, Cagayan de Oro City
Museo Ng Kalingang Pilipino, Manila

National Museum Branch at Cagayan, Cagayan
National Museum Branch at Magsingal, Ilocos Sur
National Museum Branch at Tayum, Abra
National Museum of the Philippines, Manila
University of San Carlos Museum, Cebu City

POLAND
Asia and Pacific Museum, Warsaw

PORTUGAL
Overseas Ethnography Museum, Lisbon

SINGAPORE
National Museum, Singapore

SPAIN
Museum of Ethnology, Barcelona
National Museum of Anthropology and Ethnology, Madrid

SWEDEN
Ethnographical Museum, Gothenburg
Ethnographical Museum, Stockholm

SWITZERLAND
Museum für Volkerkünde, Basle

UNITED KINGDOM
Cambridge University Museum of Archaeology and Anthropology
Horniman Museum, London
Liverpool Museum
Museum of Mankind (British Museum), London
Pitt Rivers Museum, University of Oxford
Victoria and Albert Museum, London

UNITED STATES OF AMERICA
American Museum of Natural History, New York
Los Angeles County Museum, Los Angeles
National Museum of Natural History, Smithsonian Institution, Washington DC
Peabody Museum of Archaeology and Ethnology, Cambridge, Mass.
Textile Museum, Washington DC
University Museum, University of Pennsylvania, Philadelphia

USSR
Hermitage Museum, Leningrad
Museum of Oriental Art, Moscow

Index

PHOTOGRAPHIC ACKNOWLEDGEMENTS

The author and publishers are grateful to the following for permission to reproduce photographs:

Trustees of the British Museum: 2–3, 6, 35, 36, 37, 58, 59, 64, 67, 75, 76 all, 77 top, 80 bottom, 97, 106, 111, 113 bottom, 117, 118–19, 120–1, 146–7, 153 top, 155, 180, 182–3, 184–5; Cambridge University Museum of Archaeology and Anthropology: 128 bottom; Hull University, Centre for South-East Asian Studies: 34–5, 38–9, 44, 48, 50, 51, 52, 66–7, 72–3, 77 bottom, 80 top, 82, 95, 96–7, 98–9, 100, 101, 103, 104, 105, 108, 110, 113 top, 114, 115, 116, 119, 122, 135, 149, 152, 153 bottom, 154, 156–7, 158–9, 164–5, 168, 171, 185; (Michael Hitchcock) 24, 41, 62–3, 70–1, 78–9, 91, 130–1, 140–1, 144, 172–3; (Daina Griva) 92–3, 178; (Jan Wisseman Christie) 10, 26–7, 28, 30, 33, 46–7, 84–5, 166–7; National Museums of Scotland: 139 top, 160; Edward Parker: 139 bottom; Pitt Rivers Museum, Oxford: 31 bottom, 32; Royal Anthropological Institute of Great Britain and Ireland: 31 top, 57, 128 top, 170; Royal Tropical Institute, Amsterdam: 22; Han Snel: 74.

Photographs on the following pages are the author's copyright: 12–13, 15, 16, 17 both, 18, 19, 20, 27, 54 both, 60 both, 69 both, 87, 88 both, 90, 124, 125 both, 126, 127, 132, 134, 136, 137, 138 both, 142–3, 148, 150, 151, 161, 175, 177.

The line drawings on pages 55, 56, 65, 68, 102 and 107 are by Peter Anderson and Lena Filipa De Gouveia.